Retrievals

Wave Books Seattle and New York

Published by Wave Books

www.wavepoetry.com

Copyright © 2014 by Garrett Caples

Wave Books titles are distributed to the trade by

Consortium Book Sales and Distribution

Phone: 800-283-3572 / SAN 631-760X

Owing to limitations of space, permissions

acknowledgments appear on page 281.

Library of Congress Cataloging-in-Publication Data

Caples, Garrett T.

Retrievals / Garrett Caples. — First edition.

pages cm

ISBN 978-1-933517-99-5 (hardback)

ISBN 978-1-933517-98-8 (trade paperback)

I. Title.

AC8.C185 2014

080—dc23

2014006048

Designed and composed by Quemadura

Printed in the United States of America

9 8 7 6 5 4 3 2 1

First Edition

PROLOGUE: WITTGENSTEIN, A MEMOIR

XI

A Man of Firsts: Arthur Jerome Eddy

1

Pamela Colman Smith at the Dawn of Modernism

5

The Exotic Victor Segalen

9

Roger Fry and the Invention of Art History

16

Vachel Lindsay with the Submerged

37

Surrealism's Island: Martinique

40

Gordon Onslow Ford: Cosmos and Death

43

Surrealism and the Abstract Truth

51

A Footnote on Jimmy Ernst

78

Sylvia Fein and the Death of the White Knight

81

Philip Lamantia and André Breton

93

Mysteries of the Six Gallery: Philip Lamantia, John Hoffman

110

Apparitions of Marie Wilson at City Lights

139

Barbara Guest in the Shadow of Surrealism

143

Circles: Richard Tagett and Richard O. Moore

151

Becoming Visible: Jean Conner

165

"Death will be my final lover": The Life of Alden Van Buskirk

175

The Incorrigible Torregian

197

John Anderson, Master

203

The Hyphy Hump

209

*

Theory of Retrieval

221

*

CREDITS

245

ACKNOWLEDGMENTS

247

NOTES

249

BIBLIOGRAPHY

265

INDEX

273

What is the past but a failed retrieval
of what at the time seemed relevant and true

—Richard O. Moore, "Check Point"

PROLOGUE
WITTGENSTEIN,
A MEMOIR

I came to poetry fairly late; that is, I was probably a senior in college before I could read it with anything like enthusiasm. This was a direct result of studying Wittgenstein with James Guetti (1937–2007), an eccentric, disgruntled Professor of English at Rutgers University. Jim's passions seemed to be gambling (horses, cards, dice), fishing, writing, and drinking. (A former football player at Amherst College, he also loved sports, but you didn't bet on sports, because that was unsportsmanlike.) Yet somewhere along the way—after 1980, to judge by his published work—he added Wittgenstein to the mix of his obsessions, culminating in his 1993 book, *Wittgenstein and the Grammar of Literary Experience*, whose publication fortunately coincided with the period during which I studied with him. Would I have become a poet without encountering this man, and through him, Wittgenstein? I'm inclined to say no.

Wittgenstein, of course, wrote very little about literature and even less about poetry. His efforts were principally directed toward clearing up philosophical dilemmas brought about by linguistic confusions. Most often, these confusions result from misleading analogies between different meanings of the same word. This conviction is so strong throughout his later work it compels him to devote much attention to the word "meaning." His most famous remark on the subject occurs in *Philosophical Investigations*:

> For a large *class of cases—though not for all—in which we employ the word "meaning" it can be defined thus: the meaning of a word is its use in the language.*
>
> And the meaning *of a name is sometimes explained by pointing to its* bearer.

The second half of this remark is misleading out of context, for the overall thrust of Wittgenstein's discussion in this portion of the *Investigations* is against the picture of meaning as primarily a matter of names and things. Implicit here is a critique of Saussurean linguistics in making the signifier/signified model the paradigm of meaning. He's not suggesting such a model is never an appropriate explanation of meaning, but rather that it only *sometimes* is. Naming is only one way we use words.

But as Guetti points out in relation to the first half of the remark quoted above, Wittgenstein's sense of "use in the language" is more active than simply equating a name with its bearer:

> It will soon become clear that "use" for Wittgenstein is a quite restrictive concept: it is "use in" specific verbal situations and exchanges and sequences, and "use" to do or to achieve something, "use" that always has consequences. It is this practical and purposive "use in the language" that becomes more and more unquestionably, as his arguments develop, the measure of meaning.
>
> But that observation still does not communicate the strength and even the severity of Wittgenstein's formulation. For if "use in the language" is not, as we might initially have supposed, "all sorts of things," then a great deal of verbal behavior—all such behavior, for example, that seems purposeless or inconsequential or, in Wittgenstein's terms, "idling"—cannot be considered "meaningful."

"The consequences of this exclusion," Guetti continues, "are enormous for how we think about language, and especially for how we conceive linguistic process in literary studies." Certainly they were for me. What Guetti writes above seems very simple, but in the context of literary studies—where interpretation of "meaning," however defined or ill-defined, remains the prime directive—it is difficult to conceive

of a more radical proposition. For it is tantamount to saying, among other things, that works of literature have no meaning; or rather, the "meaning" we speak of in literature is different in kind from the meaning of a word or a sentence in the context of a purposeful, real-world exchange. In the latter, the use of words has consequences, in that it gives rise to action, whereas in literature—even literature that seeks to inspire readers to political action—words lack direct application. When we speak of "meaning" in relation to literature, we quite often mean something like "significance" or "point," but when we speak of, say, the meaning of a line of poetry, or a phrase within a line, we mean something more like interpretation or paraphrase. And this is where confusion is liable to arise, for we *can* also interpret or paraphrase a meaningful expression. But the difference remains, for, absent a need for clarification, we can use a meaningful expression *as is*, and there are "measures of meaning" with such expressions—actions, consequences—that literature lacks.

One caveat: I should be clear that Wittgenstein doesn't purport to have discovered the essence of meaning in any phenomenological sense. Philosophy for Wittgenstein at this point is dealing with words, not things. Yet too, he isn't claiming to have found the *real* meaning of "meaning." Rather, he's restricting the term for philosophical use. The active and purposeful sense of meaning is only one of the ways we use this word, and other ways of using the word aren't incorrect. But these other uses are, again, different in kind from purposeful use and the restriction of the word "meaning" to this latter sense is simply to avoid confusion with them.

Nonetheless, particularly in relation to poetry, Guetti's remark struck me with the force of a revelation. Indeed, at the time, I probably *did* take it as something more like a phenomenological statement. But no matter: the idea of poetry as meaningless proved to be the key that

unlocked the seemingly impenetrable mystery of the art. Previously, I felt "outside" of poetry; it seemed so *full* of meaning, but how, as a reader, could you know if you got this meaning, and how, as a writer, did you put it there? What Jim did for me was turn the problem not so much on its head as inside out. For where literary criticism tends to speak of meaning in poetry as internal, something to be "unpacked," in Jim's classes, the poem was empty, its words reaching out to possible meanings, much as Wittgenstein writes in *Philosophical Investigations* during a series of remarks on "understanding":

Hearing *a word in a particular sense. How queer that there should be such a thing!*

Phrased like this, *emphasized like this, heard in this way, this sentence is the first of a series in which a transition is made to* these *sentences, pictures, actions.*

This sounds very like what occurs when you interpret the meaning of a line of poetry. You make a transition, not to "actions," as Jim pointed out, but definitely to "sentences" and "pictures" against whose backdrop a line of poetry might seem to take on a certain meaning. This is sometimes instructive and interesting to do, but at the same time it leads you away from the poem to other language that is not the poem. If you abandon the search for meaning, however, you're more likely to stay with the poem, and this is the only way, finally, to learn how to understand poetry. And "understand," in the case of a poem, is not the same as an interpretation of its meaning, as Wittgenstein writes in one of his too-few remarks directly touching on poetry:

We speak of understanding a sentence in the sense in which it can be replaced by another which says the same; but also in the sense in which it cannot be replaced by any other. (Any more than one musical theme can be replaced by another.)

In the one case the thought in the sentence is something common to different sentences; in the other, something that is only expressed by these words in these positions. (Understanding a poem.)

To be sure, this remark is not limited to poetry; Wittgenstein is talking about understanding sentences generally. "Understanding a poem" here exemplifies those things we understand about sentences that specifically aren't meanings of words, our comprehension of intonations and structures. Hence the analogy with a musical theme, which is all tones and structures without semantic values. The problem here is that our understanding of musical themes is difficult to articulate, precisely because meaning is not involved. "What is it all about?" Wittgenstein asks of a musical theme. "I should not be able to say. In order to 'explain' I could only compare it with something else that has the same rhythm (I mean the same pattern)."

One of Guetti's strokes of genius was to link this aspect of Wittgenstein's thought to the poetics of a writer who could be no more out of fashion in contemporary considerations of poetry: Robert Frost. In a letter to his friend John T. Bartlett, Frost writes:

A sentence is a sound in itself on which other sounds called words may be strung.

You may string words together without a sentence-sound to string them on just as you may tie clothes together by the sleeves and stretch them without a clothes line between two trees, but—it is bad for the clothes. . . .

The sentence-sounds are very definite entities. . . . They are as definite as words. . . .

They are apprehended by the ear. . . . The most original writer only catches them fresh from talk, where they grow spontaneously.

It seems to me, as it did to Jim, who quotes this passage at even greater length in his book, that Frost is speaking of the very thing Wittgenstein grapples with in his remarks on understanding sentences. When I consider now that Frost wrote this in 1914, as Wittgenstein was just beginning his pre-*Tractatus* MS *Notes on Logic*, it kinda blows my mind. As it was, Jim's juxtaposition of Frost's "sentence-sounds" with Wittgenstein turned my head around, not simply about poetry but about writing period. When I began to write "compositions," as they

were characterized in third grade, I'd learned you didn't write the way you spoke, and this is both true—think of how "non-written" a transcript of conversation reads—and suitable advice for an eight-year-old writer. At a certain point, however, it is false, and bad advice. Writing is not speech, but both use sentences, and thus sentence-sounds— which is to say that written sentences need to be *sayable*, not merely to be elegant or effective but simply to be understood. Sentence-sounds, in other words, aren't meaning but are intimately bound up with our understanding of sentences.

In terms of poetry, what I gleaned from this juxtaposition of ideas was to follow the sentence over the line. The line had me psyched out. With a poet of rhyme and meter like Frost, the line can bully your mind into blank incomprehension, whereas his game is to play his sentences against his lines' almost brutal regularity. With unrhymed poems of variable meter, the line retained for me an aura as a unit that it often doesn't merit. I was looking for reasons where there were none; if a line or a linebreak is noteworthy, it will declare itself, but otherwise, it's not worth worrying about. Following sentences, moreover, was never a problem for me, not since learning to diagram them in fifth grade under the perpetually furious tutelage of an Irish Catholic nun named Sister Timothy. Reading poetry was suddenly easy; I had the grammatical chops, and Frost's concept of sentence-sounds attuned me to those spoken intonations that animated the grammar. And the meaninglessness of poetry had eliminated the intimidation factor, for instead of approaching it with the forlorn hope that I could access its meaning, I let the poem come to me. It's not for me to figure out a poem's meaning but rather for the poem to convince me it has one. Or not, because I don't demand it have a meaning. I assume the poem is meaningless unless it convinces me otherwise. This is a far preferable state of affairs.

Jim Guetti died from lung cancer in early 2007, several months shy of his 70th birthday. In a memoir he self-published on iUniverse in 2005 called *Silver Kings*, he reveals that a cancer specialist saw an ambiguous mark on an x-ray of his lungs and wanted to perform exploratory surgery, but Jim refused. He'd calculated the odds of the occurrence of the rare type of tumor the doctor thought could be there against the odds of dying during surgery and decided he didn't like them. Considering he'd already survived colon cancer before I met him, I was shocked by this decision, though, at the same time, it was very much him, the gambler. I didn't hear about his death until a couple of years afterward. We weren't close and had fallen out of touch. The last time we'd spoken, I'd called him to get his address to mail him my first book of poems, probably around 2000. I was curious to see what he'd think of it, if he'd recognize any of his teaching in it, but I never heard back from him. I figured that meant he didn't like the poems, which didn't surprise me as I knew what I was writing was pretty distant from the poetry he enjoyed, though it occurred to me after reading *Silver Kings* that he may have been dealing with the cancer by then and was too busy trying to stay alive. I'd wanted him to see the book because I felt like my whole process of becoming a poet began by reading Wittgenstein with him. Until recently, I was under the impression I didn't actually start writing poetry until 1994, after I moved to California to enroll in the graduate English program at UC Berkeley. But not long after reading *Silver Kings*, I discovered a notebook filled with poems from my senior year at Rutgers. Not good poems, and few complete ones, but it seems like I started trying out things based on what I was learning in Jim's classes fairly immediately.

Jim had vast reservoirs of bitterness. Though he'd had 30-odd years

 as a full professor at a major research university and written three books of criticism—he's still sometimes cited in studies of Melville, Conrad, Faulkner, Chandler, and indeed Wittgenstein—he felt his career hadn't gone the way he wanted. He didn't like the way literary studies had gone. His one bid for literary glory—a novel about gambling called *Action* (1972) that still has a following among connoisseurs of the genre—was, he claimed, ripped off and made into a film called *The Gambler* (1974) starring James Caan. I can't say whether this is true or not, but how many stories about gambling English professors who end up owing money to the mob are out there? Caan even looks rather like Jim does in his author photo for *Action*. (Jim was doubly offended because the film replaces horse racing with college basketball and, again, betting on sports was unsportsmanlike.) Still, despite his bitterness, he retained his enthusiasm for teaching. A surprising amount of *Silver Kings* is devoted to teaching, not so much about his own endeavors in the classroom as about those significant encounters in his life with teachers and coaches who helped him discover and develop abilities he hadn't been aware he possessed. In the acknowledgments to *Wittgenstein and the Grammar of Literary Experience*, Jim thanks two of his own professors at Amherst—Theodore Baird and Armour Craig—for their role in his development as a thinker and a writer, saying "The best teaching lasts." It does.

2011

RETRIEVALS

A MAN OF FIRSTS ARTHUR JEROME EDDY

The first book written on modern art in the U.S., yet nearly forgotten today, *Cubists and Post-Impressionism* (1914) is a fascinating primary-source account, by one of the period's great collectors. Second-largest buyer at the 1913 Armory Show—after future Joyce/Eliot patron John Quinn—Arthur Jerome Eddy (1859–1920) was a self-made corporate lawyer from Flint, Michigan, friend of Whistler (who painted his portrait), and correspondent of Dove and Kandinsky. As purchaser of Kandinsky's *Improvisation No. 30 (Cannons)* (1913), Gleizes's *Man on a Balcony* (1912), and Duchamp's *Portrait of Chess Players* (1911) and *King and Queen Surrounded by Swift Nudes* (1912), Eddy owned four of the period's most significant paintings, as well as works by the likes of Picabia, Derain, and myriad others.

The eclectic Eddy was a man of "firsts," publishing the first biography of Whistler less than six months after the painter's 1903 death. He was first to travel *Two Thousand Miles on an Automobile* (1902), "on" being the correct word for his absurd open-air machine. Other books include *The New Competition* (1912)—whose advocacy of "open-price associations" earned him a footnote in economic history—and *Ganton & Co.* (1908), a "novel of ideas" about a stockyard strike. As is clear from these last-mentioned, as well as *Cubists*, Eddy was a conservative committed to the class privilege of his corporate clients. Yet his jaunty belief in "progress," particularly technological, made him something like a "utopian capitalist," convinced capitalism could produce social

harmony among all classes if managed intelligently and humanely. It's a type of conservatism that apparently no longer exists.

Cubists and Post-Impressionism, Eddy protests, isn't a defense of cubism: "Because a man buys a few Cubist pictures it must not be assumed he is a believer in Cubism." "If it is a plea for anything," he clarifies, "it is for *tolerance and intelligent receptivity*, for an attitude of sympathetic appreciation toward *everything that is new and strange and revolutionary in life*." Picture a contemporary conservative writing that! Eddy's "intelligent receptivity" embraces extreme movements like futurism—which he finds misguided but not entirely without merit—and even extends to socialism, for which he has mild sympathy, and anarchism, of which he disapproves. But he is undeniably sympathetic to and well informed about modern art. He knows his Roger Fry and his Apollinaire, and his bibliography indicates he read German as well as French. He's familiar with comparatively obscure movements like synchromism, but mainly discusses the titular topics as well as fauvism, futurism, and the Blue Rider. Like Fry, he sees abstraction as an inevitable outcome of modern art but he's more enthusiastic. That he collected Kandinsky and Dove—the first abstract painters—shows his expertise, and among the book's attractions are lengthy excerpts from their letters to Eddy, as well as an appendix by Alfred Stieglitz recounting "Exhibitions at 291 Fifth Avenue." Here we learn 291's first painting show was by Pamela Colman Smith, who turns out to be an unjustly forgotten symbolist, best known today for drawing the most commonly used tarot cards, the so-called Rider-Waite deck. Even there her name was effaced, but *Cubists* records her presence at the dawn of American modernism. She is the type of historical goody the book yields.

Advocate or not, Eddy attempts to soothe readers outraged by the avant-garde, sketching a crude yet broadly accurate formalist history

of art as a dialectic between *observation* and *imagination*—what Fry

calls *vision* and *design*—the difference, for example, between impressionism and post-impressionism. Eddy uses "post-impressionism" in its current sense, but also for modern art in general, hence the *ist/ism* distinction in the title. The word was less than four years old—coined by Fry in 1910—and the handiest one Eddy could find at a time when "modernism" had but slight currency. Such perspective on how an informed contemporaneous observer conceptualized the development of modern art is the type of information that gets lost or distorted after decades of retrospective commentary. In a preface to the second, slightly revised 1919 edition—following a world war that failed to defeat his faith in progress—Eddy articulates the value his book now possesses. Hypothesizing the extent of cultural change experienced by a man of 50 by 1925, Eddy writes: "Above all it will be his good fortune to have seen *all* these movements and accomplishments *in the making*—their *imperfections* which are always so *revealing* as distinguished from their *perfections* which are always so *concealing.*"

To be sure, *Cubists* offers much amusement as a period piece. Presumably based on Eddy's lectures during the Armory Show's stay in Chicago, the book is popular rather than academic in tone. His unflappable good humor, his presumption of shared faith in America's impending dominance, is so at odds with his "revolutionary" subject it's hilarious, even as it illustrates the ease with which a sympathetic conservative can defang the avant-garde. He excels at assessing the present, but his prediction of the future, where American art will attain a synthesis between observation and imagination he calls "virile impressionism," is quite ridiculous, his faith in progress trumping his historical dialectic. Occasionally the book becomes an investment guide. Eddy admonishes museums and collectors that the paintings they scorn today will be tomorrow's priceless masterpieces, tracing,

4 by way of example, the successive sales of Rembrandt's *Toilet of Bath-sheba* from $109 in 1734 to $220,000 in 1913. And he was, of course, right. Unlike Quinn, Eddy wasn't a millionaire, yet he was so shrewd a buyer, his collection today—part of which resides at the Art Institute of Chicago—would be worth millions. His analysis of the conspicuous consumption millionaire's buying Rembrandts simply for prestige, is worthy of John Berger, despite the ideological chasm separating them.

Though poorly bound, *Cubists and Post-Impressionism* is lavish inside, with many color tip-ins of works Eddy owned, including a Dove now lost. No doubt Eddy was trying to boost their value by giving them iconic status. The images make the book hard to come by; an extremely dilapidated 1914 copy with several missing tip-ins set me back $100. But I recently found the 1919 edition online via archive.org. Suddenly the book is widely available, and hopefully its place in the history of modernism will be reassessed.

PAMELA COLMAN SMITH AT THE DAWN OF MODERNISM

When I first read "Exhibitions at 291 Fifth Avenue," Alfred Stieglitz's appendix to Arthur Jerome Eddy's *Cubists and Post-Impressionism* (1914), I was astonished to learn that "the first exhibition not devoted to photography" at that hotbed of modernism was a 1907 show of paintings and drawings by Pamela Colman Smith. For who was Pamela Colman Smith? Surely, she must have been a significant artist to have inaugurated Stieglitz's foray into painting, over the course of which he would discover such American masters as O'Keeffe, Dove, Hartley, and Marin, so why hadn't I ever run across her name in studies of modernist art? My further researches into the matter were for a time retarded by a typographical error—Stieglitz identified her as "Coleman Smith"—so when I finally had a chance to write about Eddy's book in 2009, I was unaware that the first volume on the artist, *The Artwork & Times of Pamela Colman Smith* by Stuart R. Kaplan, had been published that same year by U.S. Games Systems, Inc. Yet even misspelling her name, I'd learned by then her biggest claim to fame was as the artist of the most commonly used set of tarot cards in the English-speaking world, the Rider-Waite deck (1909). Commissioned by British occultist A. E. Waite to accompany his *Pictorial Key to the Tarot* (William Rider, 1911), the deck is presently published by U.S. Games, of which Kaplan is the proprietor, hence *Artwork & Times* is best seen as a labor of love for an artist the author stumbled upon and

clearly made a great deal of money from, though Smith herself died deep in debt in 1951. The fact that you purchase *Artwork & Times* along with *Pictorial Key*, the deck itself, and a handful of small prints and postcards as the *Pamela Colman Smith Commemorative Set* (2009), an exquisitely packaged, cabinet-like box made by a toy company, suggests Smith hasn't quite made the canon yet.

And this is a shame, for Smith is a wonderful artist and her artistic and literary connections are substantial. Chief among these—aside from Stieglitz, who gave her two solo shows at 291 and included her in a group show—is W. B. Yeats, for whom she illustrated a number of plays and poems, as well as his artist brother Jack, with whom she collaborated on the periodical *A Broad Sheet*. Other prominent associates include Celtic Revival poet and playwright Lady Gregory, English poet John Masefield, and *Dracula* author Bram Stoker, whose final novel, *The Lair of the White Worm* (1911), she also illustrated. Such a project may in fact suggest the main stumbling block to her wider reputation in contemporary considerations of the period, for a substantial amount of her art is illustrative by nature. And though it's an anachronistic bias created by subsequent modernist criticism, illustration is no longer taken seriously as a mode of visual art. Yet *Artwork & Times* valuably reveals how vital illustration remained well into the early years of photography. For Smith illustrates things like sheet music or portfolios of theatrical troupes like that of Ellen Terry and Henry Irving, in which she spent several years growing up and designing costumes and scenery. Her illustrations for Stoker's *Sir Henry Irving and Miss Ellen Terry in Robespierre, Merchant of Venice, The Bells, Nance Oldfield, The Amber Heart, Waterloo, and Other Dramatic Works* (1899) are at once the movie-star pinup and the DVD, a vivid attempt to conjure a specific theatrical experience in its absence for a far less image-saturated culture. The stiff nonillusion of the conditions of

1899 photography would have literally paled in comparison with the vivid tableaux into which Smith distills the essence of Terry and Irving's repertoire.

As Kaplan notes, Smith studied at the Pratt Institute in Brooklyn under Arthur Wesley Dow, who introduced her to the concept of synesthesia—the depiction of the items of one sensory experience in the terms of another—and this would become crucial to her work, particularly the paintings and drawings she exhibited at Stieglitz's. Many of these works depicted imagery spontaneously brought to her mind while listening to music by the likes of Beethoven, Bach, and Schumann: "what I see when I hear music-thoughts loosened and set free by the spell of sound," as she wrote in a 1908 article, "Pictures in Music," for *The Strand Magazine*. Like the illustration of text or performance, synesthesia is artistically impure in a way that would be rejected by subsequent modernist art theorists of the inherent separateness of individual art forms and contemporary art history, while rejecting such purism, still hasn't recovered from this fundamental misinterpretation of the actual history of 20th-century American art. Thus a weird symbolist mystic like Smith remains marginalized even as she's cut from the same cloth as O'Keeffe (right down to the tutelage from Dow).

Though I'm more than grateful for Kaplan's efforts, Smith's life seethes with such tantalizing miscellaneous facts that I long for more serious treatment. Along with Yeats, Waite, and Aleister Crowley, she was a member of the Hermetic Order of the Golden Dawn, though she would end her life as a Roman Catholic. Among tarot aficionados—among whom I do not number—she's known for having set the tone of the minor arcana for subsequent decks, for these cards apparently lacked prior standard imagery and later artists have turned to her inventions for their models. Intriguingly, Kaplan suggests she

may have been half black, her Brooklyn-born mother being of possible Jamaican descent, and her "negro" or "oriental" complexion was remarked upon in contemporary accounts of her. What is known is that, after her mother's early death, Smith spent a portion of her childhood in Jamaica as a result of her father's merchant activities, and here she gathered the dialect folktales she would write up in *Annancy Stories* (1899) and *Chim-Chim* (1905). She also performed such stories at both adults' and children's parties, and the flyer Kaplan reproduces on page 85 of *Artwork & Times*, complete with testimonials from Terry, Yeats, and creepy J. M. Barrie, is almost indescribably poignant. For prolonged acquaintance with her artwork, her inkbrush drawing in particular, reveals the hand of the master, who supplies and implies so much through a casual, sensual line. It breaks my heart to think of her hustling such gigs and her career is marked by myriad failed attempts to monetize her miscellaneous talents. The impression I get from her life is ultimately of one who never had the leisure to pursue her art unharried by economic necessity. Still, nearly everything she put her hand to has so much vitality I can't help thinking she would have been some sort of far-out graphic novelist had she lived today. She accomplished much, as it were, *by the way.*

2013

THE EXOTIC VICTOR SEGALEN

O you, will you not translate yourselves? —Victor Segalen, Stèles

The short life of late symbolist/early modernist writer Victor Segalen (1878–1919) was at least as extraordinary as the works he bequeathed to posterity. A French naval doctor, he was sent to Tahiti in 1902 to join the *Durance*, a ship whose beat included the Marquesas Islands where Gauguin had exiled himself. Segalen arrived three months after the painter's death, purchasing several now-priceless paintings for absurdly low sums at auction. When the *Durance* stopped at Djibouti in 1904 on its return trip to France, Segalen gathered some of the first anecdotal evidence of Rimbaud's experiences in Africa after renouncing poetry. In the next few years, Segalen would write major essays on both poet and painter, two unused libretti for Debussy, and the novel *Les Immémoriaux* (translated in 1995 as *A Lapse of Memory*), an attempt to imagine the experience of the colonized Other from the perspective of a Tahitian whose identity disintegrates under European conquest. Whether the attempt succeeds as such is, of course, debatable, but its presentation of an exoticism purged of stereotypes and anxious to preserve cultural difference has earned the novel a certain vogue in contemporary postcolonial criticism.

Yet these are his minor achievements. The decisive encounter of Segalen's life occurred on the way to Tahiti, though some years would pass before the experience bore fruit. Crossing the U.S. by rail in order to join the *Durance*, Segalen was waylaid in San Francisco with a near-fatal attack of typhoid fever. During his recovery, he wandered into

Chinatown and, like Oscar Wilde before him, was entranced by a world which seemed so aesthetically exotic, so utterly distant from his own. Unlike Wilde, however, Segalen went further. Following the 1907 publication of *Les Immémoriaux*, Segalen learned enough Mandarin to be posted to Beijing, with the sole mandate to improve his language skills. Segalen would spend much of his remaining life (1909–13, 1916–18) in China, where, among other achievements, he led several archaeological expeditions to the interior, documented in the posthumously published *Chine: La grande statuaire* (1972) (translated into English in 1978 as *The Great Statuary of China* and into Chinese in 2004). He seems to have discovered the mausoleum of China's first emperor, Qin Shihuang, though the location would be lost again until 1974.

From a literary standpoint, however, Segalen's major accomplishments in China were *René Leys*, a novel unpublished until 1922 (reissued in English by New York Review Books in 2003), and *Stèles*, a book of prose poems published by Segalen in 1912, then expanded for a second edition in 1914. Taking its title and overall conceit from China's ancient, inscription-bearing stone monuments—once funerary, subsequently used for various decrees and memorials—*Stèles* has been previously rendered into English three times: a selection by Nathaniel Tarn (1969); a complete version by Michael Taylor (1987); and a complete British edition by Andrew Harvey and Iain Watson (1990). The fact that the book has been translated into Chinese twice (in 1993 and 1999) suggests some success in Segalen's imaginative portrayal of Otherness, inasmuch as the poems have been accepted into the language that inspired them. For Segalen's knowledge of Chinese, his interest in the diversity of its spoken and written forms, and his use of Chinese source material are as central to the poetry as the steles themselves.

Such, at least, is one of the premises behind the fourth appearance of *Stèles* in English, a critical edition, with a facing-page facsimile of the 1914 printing, translated and annotated by Timothy Billings and Christopher Bush, published by Wesleyan in 2007. Nonscholars might balk at its length, but, in truth, its 64 poems only occupy 200 pages or so, half of which are facsimile; this isn't an imposing epic, in other words, but rather a collection of ordinary length. Yet this is the only thing ordinary about *Stèles*. Even its trim-size startles, an upright rectangle following the book's original proportions, based on the Nestorian Stele in Xi'an. The poems themselves, denuded of the chinoiserie usually accompanying such endeavors, are at once austere and suggestive; discontinuous by nature, though organized under six general themes explained in Segalen's preface, each stele-poem confronts the reader with its opaque, abruptly out-of-context text. Yet the poems also express the most accessible subject matter: desire, friendship, religion, death, and so forth. Segalen speaks through a variety of personae—by turns a lover, a warrior, an emperor, even Qin Shihuang himself—yet Segalen never stops being Segalen. The sincerity concealed by impersonal or flippant tones, the love of uncertainty and contradiction, and the extreme black humor are equally characteristic of, say, *René Leys*, whose narrator is simply "Victor Segalen." *Stèles* is as much an exploration of self as it is of the Other, or, as he wrote in a letter cited by Billings and Bush, "the transfer of the Empire of China to the Empire of the self." The notion that the exotic resides equally within the self as without in fact undergirds his most substantial critical work, the unfinished *Essai sur l'exotisme* (published in 1978 and, as *Essay on Exoticism*, in 2002).

Critical edition or no, first-time readers have a solemn duty to skip straight to the poetry, beginning with Segalen's preface. The deliberate mysteriousness of *Stèles* must be experienced before it's explained.

Annotations, moreover, do not a translation make, nor can they atone for a bad one. But no atonement is necessary; Billings and Bush do an excellent job. If the prose sounds slightly formal, this is consistent with Segalen's desire to suggest the stele's highly specialized language. "Their style," he writes in the preface, "must belong to that which cannot be called a language because it has no echoes among other languages & could not be used for daily exchanges: Wén. A symbolic game, each element of which, capable of being anything, borrows its function only from the present space it occupies, its value from the fact that it is here & not there." Wisely Segalen doesn't push this potentially stilted conceit too far, remembering he's writing French symbolist poetry, which tends toward elegance and music. Billings and Bush must therefore walk a fine line between the poet's conflicting desires, as they do, as, for example, in "The Abyss," one of "The Three Primitive Hymns" imaginatively "recomposed" by Segalen:

Face to face with the deep, a man, with his head bent down, collects himself.

What does he see in the depths of the cavernous hole? Night under the earth, the Empire of shadow.

*

And I, bent upon myself & gazing into my own abyss—O myself!—I shiver,

I feel myself falling, I awaken & no longer want to see only night.

The contradiction between the desire to peer into the abyss and the fear of falling in is very Segalen, as is the relation between the poem's two sections, made ambiguous by the shift from third- to first-person grammar. Here Billings and Bush convincingly convey Segalen's peculiar blend of the impersonal and the impassioned, maintaining a sense of his elevated tone yet avoiding the wooden diction and leaden syntax often marring academic French translations. One can, of

course, endlessly second-guess trifles; should the translators have rendered Segalen's *l'homme* ("the man") as "a man," or simply "man," as Taylor and Tarn have it? There are more controversial examples, but generally speaking, such nitpicking leads nowhere, and if I regret their translating *ô moi!* as "O myself!" instead of "O me!" that's my affair. (Only once in the book are they lured into folly, when they translate *investir* ["to invest"] as "enfeoff," a hopelessly obscure term meaning *to give someone a fiefdom*, which is not only unhelpful but also inaccurate to the poem in which it appears.)

The final line of "The Abyss" poses a more interesting problem. Billings and Bush render Segalen's *ne veux plus voir que la nuit* as "no longer want to see only night," which seemed just to my mediocre French. Taylor, however, gives this an entirely opposite sense with which Tarn essentially agrees: "desire to see nothing but night." Billings and Bush's reading makes more sense in the poem, though others I've consulted on the matter indicate the construction is ambiguous. Such ambiguity certainly fits Segalen's sensibility, and, if true, brings us up against the limits of translation, for it's unlikely any English equivalent could deliver the same two contradictory senses as the French. Given the intractable difficulty, I'm inclined to follow Billings and Bush here.

While I'm more than satisfied with the translation of *Stèles*, I have vigorous objections to the book's critical apparatus. This is not to say I value the book any less, for it's a genuine contribution to poetry and scholarship, and the annotations themselves are tremendously valuable, particularly for those interested in the question of how Segalen's knowledge of Chinese affected the poems' composition, unobtainable information for most readers. The book's chief critical defect—aside from an irrelevant foreword by Haun Saussy—is the translators' attempt to unify *Stèles* by positing a single speaker, the so-called Self-

Emperor, which I find neither necessary nor sufficient to account for the explicit diversity of Segalen's personae. Another objectionable feature is the printing of Segalen's Chinese epigraphs above the poems' French titles; Billings and Bush's rationale for doing so doesn't negate the fact that Segalen himself considered them epigraphs and, at any rate, printed them not above but parallel to the French titles. But, in fairness, if the translators overemphasize the Chinese, they seek to rectify its utter neglect in the critical literature on *Stèles*. Similarly, the translators stress Segalen's modernism at the expense of his symbolism, useful insofar as he's a transitional figure, but seemingly motivated by an anti-symbolist bias. In Anglophone criticism, modernism is "hard," symbolism "soft," but this bias stems from the relative weakness of English and American symbolism (poets like, say, Arthur Symons, though Yeats too was a symbolist modernist). But if you consider symbolism the first wave of modernism—one centered in France, overlapping with and repudiated by futurism, and ending with the First World War—they needn't be opposed so starkly.* The fact that Segalen makes Pound look like an absolute greenhorn in his discussions of Chinese ideograms indicates a need to reevaluate the merits of symbolism in relation to subsequent modernism.

No discussion of Segalen can be complete without mentioning his death. Having survived the rigors of travel to far-flung lands, Segalen wound up dying at age 41 in a forest in Huelgoat, France, not far from his birthplace in Brest. No one knows why. While it's true he'd felt increasingly weak after his final return from China, he could isolate no specific ailment from which he suffered. Some commentators have suggested suicide, but this seems at odds with the letter he wrote to

* See, for example, Garrett Caples, *Quintessence of the Minor: Symbolist Poetry in English*, passim.

his wife on his way back from China, in which he claimed he had over 4,000 more works to write before he could "retire." Yet the works he did write—most published posthumously—would suffice for a much longer life. When Segalen's body was found, the only apparent wound was a cut on his ankle; it's possible he fainted and bled to death. A copy of Shakespeare's complete works lay beside him, opened to the title page of *Hamlet*. His watch had stopped at exactly twelve o'clock. These details have shrouded the event with an air of impenetrable mystery, as if, in death, Segalen had forever been absorbed into the exoticism which he made the study of his life.

2007

ROGER FRY AND THE INVENTION OF ART HISTORY

I now see that my crime had been to strike at the vested emotional interests.

—*Roger Fry*, Vision and Design

Not the least virtue of Ann Banfield's *The Phantom Table: Woolf, Fry, Russell and the Epistemology of Modernism* (2000) is the prominence of Bloomsbury artist, critic, and art historian Roger Fry. Neglected, even vilified as champion of a staid, elitist formalism, Fry has had few defenders or even readers in recent times despite the seminal importance of his critical activities. To me, Fry is one of the defining intellectuals of modernism, one who deserves to be ranked alongside Marx, Freud, and Saussure as an inaugurator of discourse, specifically art history as practiced in the English-speaking world today. The very terms "art-history" and "art-historian" were quite likely coined by Fry, whose much-belated appointment to Cambridge at age 67—a year before his death in 1934—was as Slade Professor of Fine Arts. The fact that neither the *Oxford English Dictionary* nor *Merriam-Webster's 10th Collegiate* includes an entry for "art history" is telling, for the term seems like a fact of grammar rather than etymology; the phrase "history of art" quite naturally becomes "art history," the way "history of sports" might become "sports history" if the clarity of a sentence demands such rearrangement. *Merriam-Webster* does, however, list "art historical," dating it to 1933, which corresponds to the publication of Fry's inaugural Slade lecture, "Art-History as an Academic Study," by

Cambridge University Press.* Reprinted in Fry's posthumous *Last Lectures* (1939), "Art-History as an Academic Study" is the first time Fry settles on the term to denote his conception of the study of art:

For about 100 years German Universities have made courses in Art-history a regular part of their curricula, and yet here ... no opportunities for the study of the visual arts have ever been offered by British Universities until last year, when the Courtauld Institute opened its doors.

We are so familiar with this state of things that we scarcely appreciate how odd it is. The mere fact that we have no convenient word by which to designate that body of studies which the Germans call Kunstforschung—a body of studies of which the actual history of Art is only a part—is significant. I am obliged to use the awkward and inadequate word "Art-history" for it.

Now "Art-history" is inextricably involved in a number of studies which are regarded as eminently worthy of Academic status. ... In the study of pre-history paintings and artefacts form our chief data. In this period and in the study of primitive peoples Art-history is inextricably interwoven with Anthropology. Its importance in the history of the early Empires is paramount, and in the history of religion through all periods it offers indispensable assistance. It has indeed actually gained a footing in the Classical Tripos from the importance of its contribution to the understanding of Greek Life. At many points it is in close touch with Psychology. ...

... If ever there was a liberal education, that of Art-history with its immense range of interests, its vast accumulation of learning and the necessity it imposes for delicacy and refinement of perception might claim to be such.

Aside from aspects of critical theory he couldn't possibly have foreseen, Fry here gives the term "art-history" its current definition, as distinct from the phrase "history of art." If his proposal has an air of the

* Donald Laing's *Roger Fry: An Annotated Bibliography of the Published Writings* (1979) states that "Art-History" was issued simultaneously in the United States by Macmillan in November 1933. "Art-historical" occurs in the lecture's tenth paragraph, though, in fact, the adjective cropped up in Fry's writing at least three years earlier, in a December 1930 letter to *The Burlington Magazine* about the establishment of the Courtauld Institute of Art: "I think we may fairly pride ourselves on having done much to bring about that changed attitude towards art-history of which the establishment of an art-historical faculty in London University is a culminating proof."

self-evident, this is due to the relative success of the lifetime he devoted to transforming the dilations of fine-art connoisseurship into a serious academic discipline. To be sure, the term underwent a long period of gestation. As Christopher Reed notes in his 1996 anthology *A Roger Fry Reader*, Fry had been seeking an English equivalent of *Kunstforschung* as far back as his 1924 essay "Art and the State," which ends with a discussion of the role of the *Kunstforscher*. Here, as in the Slade lecture, Fry is making a case for the study of visual art at the university level, bemoaning the difficulty of explaining a concept which, prior to Fry, had no exact parallel in our culture. "If one could but find an English word for *Kunstforscher*," he concludes, "the battle would be half won." Yet Fry has already found his term earlier in the same paragraph, when he suggests, "If the study of art-history be carried on as a comparative study of all cultures alike, we get an antidote to the kind of orthodoxies and *a priori* judgments which result from a narrow concentration. The *Kunstforscher* under such conditions attains by another route to something of the freedom of the artist, to whom the object in itself is everything, its historical references of no interest." Clearly Fry has hyphenated "art-history" here to signal the term is not being used in a sense equivalent to "history of art," but rather already indicates the activities of the *Kunstforscher*.

Despite already being compelled to use the term, Fry's reluctance to adopt "art-history" outright in 1924 is understandable, due to its liability for confusion with "history of art." His descriptions thus seem to downplay the importance of history; as we saw in the Slade lecture, "the actual history of Art is *only a part*" of Fry's conception of art history. Yet Fry's de-emphasis on history is merely tactical, an "antidote" to what, in a 1924 review of the book *English Pottery*, he calls the "archaeological illusion" that a work of art has aesthetic value simply on the basis of its antiquity. "We shall never really understand the work

of the past," Fry writes, "until we look upon it with exactly the same critical and unbiased apprehension which we ought to give to the works of our own day. We shall never do justice to works of our own day until we have given up an exaggerated and purely romantic respect for the work of the past." Such proposals, however, have led to a distorted sense of what Fry was about, even by so sympathetic a reader as Reed. For Reed footnotes his citation of the aforementioned passage from "Art and the State" as follows: "This definition of the *Kunstforscher* as a connoisseur for whom 'historical references' are of 'no interest' underlies 'Art History [sic] as an Academic Study,' the essay introducing the methodology of the lectures Fry offered at Cambridge in 1933–34, which were published as *Last Lectures*." This gloss, however, isn't borne out by either "Art and the State" or "Art-History." Fry never says in "Art and the State" that "historical references" are of "no interest" to his ideal *Kunstforscher*; according to the grammar of the passage, he attributes this non-interest to artists, who are free to turn to whatever pleases them for appreciation and inspiration, based purely on their own sensibility. Fry's art historian aspires only to the artist's "freedom"—the exercise of sensibility—but "attains" it "by another route." This route is the arduous path of research and study —the "vast accumulation of learning" to which Fry refers in "Art-History"—as well as practice in the exercise of judgment. The art historian must be able to make aesthetic judgments based on sensibility but justified by various forms of evidence, while the sole justification of the artist's opinions, obsessions, and predilections is the art the artist makes.

On its very face, the notion that Fry's conception of "art-history" excludes history is unconvincing, for were this true, he would be under no necessity to select the term. If you could readily substitute "connoisseur" for *Kunstforscher*, moreover, I can't imagine he would

have spent a decade wrestling with this terminology before selecting "art-historian." The fact that "art-history" and "art-historian" ulti- mately force themselves on him suggests how central history is to the critical practice Fry envisions. This is clear from Fry's own criticism, particularly the *Last Lectures*, which are nothing less than a history of art in relation to certain aesthetic questions, or, as he puts it in "Art and the State," "a course of comparative applied aesthetics." That Reed can be so right about the continuity of Fry's conception of the *Kunst- forscher* between "Art and the State" and "Art-History," and yet so wrong about what this conception is, would be curious, were it not for the acknowledged fact that Fry is not, by any means, the happiest of prose stylists. In *Roger Fry: A Biography* (1940), Virginia Woolf notes how uncongenial he found the task of writing:

Nor was Roger Fry a born writer. Compared with Symonds or Pater he was an amateur, doing his best with a medium for which he had no instinctive affection. . . . It was to take him many years and much drudgery before he forged for himself a language that wound itself into the heart of the sensation.

Perhaps no one would know this better than Woolf, for Fry complains to her of his shortcomings as a writer in more than one letter. Indeed, he's not afraid to acknowledge his frustrations in print, asserting in the "Retrospect" to *Vision and Design* (1920) that "language in the hands of one who lacks the mastery of a poet has its own tricks, per- versities and habits." I mention this, not because I think he's a bad writer—on the contrary, like Woolf, I find "these old articles" to be "curiously alive, alert, and on the spot"—but rather because, given the difficult, sometimes unprecedented questions raised in his essays, as well as the unsystematic, occasional nature of their composition, his expression is not always clear or consistent. In the case of the passage from "Art and the State," though I maintain its grammar fails to sup- port such a reading, I can see how Reed misconstrues Fry's sentence

to mean the *Kunstforscher* should be an ahistorical connoisseur; by immediately qualifying "the artist" as someone "to whom the object in itself is everything, its historical references of no interest," Fry makes it seem as though this prerogative were the quintessence of the artist's "freedom," whereas the freedom, once again, is the exercise of sensibility, while the artist's ahistoricism is simply regarded as typical.*

Two other factors contribute to Reed's misinterpretation. Though correct in asserting the continuity between the two texts, Reed's emphasis on the better-known "Art and the State" is mistaken, for here the discussion of the *Kunstforscher* merely concludes a wide-ranging consideration of the essay's titular concepts, while "Art-History" is a more extensive treatment representing Fry's final thoughts on the topic. The second factor stems from another misinterpretation due to Fry's occasional want of facility as a writer. In Reed's note on the *Kunstforscher*, he cites "another definition of the term" in Fry's 1928 text "Words Wanted in Connexion with Art," printed as the conclusion of *A Roger Fry Reader*. While the note is noncommittal, Reed seems to exclude this definition from the continuity he posits between the *Kunstforscher* of "Art and the State" and "Art-History," and if we turn to "Words Wanted," the reason becomes apparent. Reed here character-

* That scholarship is a necessary precondition to the art historian's freedom to make sensibility-based discriminations is also articulated in the "Retrospect" to Fry's *Vision and Design*: "I have certainly tried to make my judgments as objective as possible, but the critic must work with the only instrument he possesses—namely, his own sensibility with all its personal equations. All that he can consciously endeavor is to perfect that tool to its utmost by studying the traditional verdicts of men of aesthetic sensibility in the past, and by constant comparison of his own reactions with those of his contemporaries who are specially gifted in this way. *When he has done all he can in this direction—and I would allow him a slight bias in favor of tradition—he is bound to accept the verdict of his own feelings as honestly as he can*" (my emphasis).

izes the "Words Wanted" definition as "a renewed call for an English equivalent to the German *Kunstforscher*," referring us back to his previous discussion. But he is silent on the fact that this definition seems to contradict that discussion, for the word Fry wants for *Kunstforscher* is "a single word for those who would make a profession of the study of art history as contrasted with aesthetics." The problem here is that Fry's definition is ambiguous. At first glance, it appears to contrast "the study of art history" with "the study of aesthetics," as if the *Kunstforscher* were concerned with history *rather than* aesthetics.* Were this the case, in order for Reed's previous discussion to be true, we would have to believe that Fry considered the *Kunstforscher* an aesthetician as opposed to a historian in 1924, a historian as opposed to an aesthetician in 1928, and then again an aesthetician as opposed to a historian in 1933. Even bearing in mind Fry's frequent protestations as to the provisionality of his arguments,† such an absolute double-reversal is implausible. If, however, we read the entire phrase "art history as contrasted with aesthetics" as object of the preposition "of" in "study of," we must conclude Fry's *Kunstforscher* is concerned with a dialectic between history and aesthetics. If my reading of the *Kunstforscher* in "Art and the State" and "Art-History" as one whose judgments necessarily depend on historical knowledge is correct, more-

* Note that Fry thought the *Kunstforscher* in actual practice at the time in Germany tended to *overstress* the historical at the expense of the aesthetic, "regard[ing] works of art . . . as coefficients of a time sequence, without reference to their aesthetic significance," though his approbation of their "pioneer" suggests no hostility to historical research.

† As Fry writes in "Retrospect," "My aesthetic has been a purely practical one, a tentative expedient, an attempt to reduce to some kind of order my aesthetic impressions up to date. . . . So that even in its latest form I do not put forward my system as more than a provisional induction from my own aesthetic experiences."

over, the violent oscillation of Fry's definition over the sequence of all three texts is replaced by the development of a consistent idea, from *Kunstforscher* to "art-historian."*

The advantage of this reading of the *Kunstforscher*-become-art-historian is that it's consistent with Fry's own critical practice. Take, for example, his 1917 lecture "Art and Life," the opening text of *Vision and Design*. "By life as contrasted with art," Fry writes, he means "the general intellectual and instinctive reaction to their surroundings of those men of any period whose lives rise to complete self-consciousness. Their view of the universe as a whole and their conception of their relations to their kind." Here, considering various examples, Fry notes what he calls a "surprising want of correspondence between art and life," in the sense that "the great revolutions in art and the revolutions in life" seldom "coincide":

What this survey suggests to me is that if we consider this special spiritual activity of art we find it no doubt open at times to influences from life, but in the main self-contained—we find the rhythmic sequences of change determined much more by its own internal forces—and by the readjustment within it, of its own elements—than by external forces. I admit, of course, that it is always conditioned more or less by economic changes, but these are rather conditions of its existence at all than directive influences. I also admit that under certain conditions the rhythms of life and of art may coincide with great effect on both; but in the main the two rhythms are distinct, and as often as not play against each other.

Given the importance contemporary critical theory places on cultural context for the understanding of any work of art, we may be tempted to read such a passage as saying more than it in fact does. For the

* In "Words Wanted," the terms proposed for *Kunstforscher* are "art-expert" and the literal translation "art-researcher," neither of which he finds satisfactory. I suspect Fry still resists "art-historian" here precisely because he's looking for a third term into which to collapse *historian* and *aesthetician*.

"want of correspondence" Fry sees between art and life by no means asserts they have *no* relation. The very thrust of Fry's text is to investigate this relationship, and his answer here is eminently modern. Who today would contest the assertion that art "is always conditioned . . . by economic changes," the very phraseology of which evokes contemporary criticism? Many perhaps would quarrel with the inferences he draws from this statement, and the suggestion that art has "its own internal forces" might easily be taken to correspond with the formalism Clement Greenberg would inculcate into post–World War II American art criticism. But, as Reed insists, there's a "profound disjunction" between the formalisms of Fry and Greenberg, and nowhere is this more apparent than in their respective views of what Fry here calls "the rhythmic sequences of change determined" by art's internal forces.* For Greenberg's conception of these forces is a linear progression of art "being reduced to its viable essence," while Fry's view in "Art and Life" is fundamentally different:

Impressionism marked the climax of a movement which had been going on more or less steadily from the thirteenth century—the tendency to approximate the forms of art more and more exactly to the representation of the totality of appearance. When once representation had been pushed to this point where further development was impossible, it was inevitable that artists should turn round and question the validity of the fundamental assumption that art aimed at representation. . . . From that moment on it became evident that art had arrived at a critical point, and that the greatest revolution in art that had taken place since Graeco-Roman impressionism became converted into Byzantine formalism was inevitable. . . . There is no need here to give in detail the characteristics of this new movement. . . . But we may summarise them as the re-establishment of purely aesthetic criteria in place of the criterion of conformity to appearance —the rediscovery of the principles of structural design and harmony.

* Reed notes the other crucial distinction between Fry's formalism and Greenberg's: Fry's interest in volume as opposed to Greenberg's insistence on flatness.

Unlike Greenberg's pseudo-scientific "law of modernism," art, in Fry's account, has no "essence." Instead, Fry suggests a dynamic, even cyclical model of art history in which rival conceptions of art's purposes compete for emphasis. Perhaps the most surprising yet rhetorically effective phrases in this passage are "Graeco-Roman impressionism" and "Byzantine formalism," for here, by a deliberately ahistorical application of modernist conceptions of art to the art of antiquity, Fry indicates with splendid economy exactly what he's driving at. The turn from "conformity to appearance" to "principles of structural design" that marks the movement in art from impressionism to post-impressionism—and hence, for Fry, the beginning of modernism—has happened before, in the transition from Graeco-Roman to Byzantine art. This is what Fry means by "the readjustment" within art "of its own elements," here, the dialectic between vision and design.* The notion of progress implied by Greenberg's use of terms like "essence" is critiqued by Fry as early as his 1908 lecture "Expression and Representation in the Graphic Arts":

When once we regard the greater or less life-likeness of the image . . . as merely a question of mechanism . . . we are relieved from that tyrannous obsession of the idea of progress in art. It is this idea which has made so many critics speak apologetically of all primitive art as something incomplete in itself and only admirable as a foretaste and adumbration of greater triumphs

* In "Retrospect," Fry acknowledges the congruence of his aesthetic sensibility with the development of modernism: "I think I can claim that my study of the Old Masters was never much tainted by archaeological curiosity. I tried to study them in the same spirit in which I might study contemporary artists, and I always regretted that there was no modern art capable of satisfying my predilections. I say there was no modern art because none such was known to me, but all the time there was one [Cézanne] who had already worked out the problem which had seemed to me insoluble of how to use the modern *vision* with the constructive *design* of the old masters" (my emphasis).

*achieved by later masters. Whereas in truth such primitive art does in the hands of great masters supply a medium for the expression of the highest emotional content. The gradual acquisition of the science of complete representation does not . . . imply necessarily any fuller attainment of the end of art; it only supplies a richer means of expression. But with each such enrichment, there follows increased restriction and a certain compensating loss of power of the earlier modes.***

It's difficult to imagine a less Greenbergian assertion than this disavowal of "that tyrannous obsession of the idea of progress in art." Fry's denial of the possibility of "fuller attainment of the end of art" simply through developments in its "means of expression" here hinges on what I contend is his dialectical view of art history, for enriching the means of expression in one respect often involves a "compensating loss of power" in other respects. There is thus no linear progression toward a goal in terms of which we can measure the success or failure of a given work of art. This is consistent with his remarks in "Art-History," where Fry writes "that the search for an objective standard of aesthetic values is hopeless and . . . that, could we attain it, the mere *knowledge* of that standard would be entirely useless to us," that "what matters is the intensity and significance of [the] effect [of the work] upon us." For all his early scientific training, and his ceaseless attempts to ground discussions of art in objective observation and logical reasoning, Fry is aware of the "fundamental difference of supreme importance" between scientific and aesthetic judgments. "Nature levies a very heavy tax on those who fail to acquire

* Compare with the following extract from Fry's 1911 lecture/essay "Post Impressionism": "And so art is conceived as a progressive triumph over the difficult feat of representing nature; a theory, which, if it were really believed, would put Meissonier above Raphael and Alma Tadema above Giotto. The fact is that changes in representative science are merely changes in the artist's organs of expression."

exact scientific truth of her processes," Fry writes in "Art-History." "But erroneous judgments in art do not bring on epidemics." In other words, the truth of scientific judgments can be verified by the results of their application, while "Art is purely a family matter among human beings."

That Fry is so little esteemed these days is at least partly due to an assumed correspondence between his formalism and Greenberg's which, as we have seen, doesn't withstand scrutiny. Such an association alone would make it difficult to get a fair hearing, yet in Fry's case, the obstacles have been compounded by an influential postcolonialist critique of his discussions of African art mounted by Marianna Torgovnick in *Gone Primitive* (1990). While space precludes a full rehearsal of the charges Torgovnick levels at Fry, any attempt to rehabilitate his reputation clearly must address the substance of her claims. In the chapter "The Politics of Roger Fry's *Vision and Design*," Torgovnick centers her critique on two texts collected in that volume, "The Art of the Bushmen" (1910) and "Negro Sculpture" (1920). Her thesis is that Fry sometimes "recognizes and attacks contemporary prejudices and the colonialism they support" and sometimes "speaks from within those prejudices and uses rhetoric typical of colonialism." Let us grant, for the moment, the truth of this assessment. Is it a valid thesis? That is, is it at all remarkable for people—even the most radical thinkers on certain fronts—to sometimes speak from within "contemporary prejudices," if by this Torgovnick means a prevalent but arbitrary viewpoint on a given matter in a given culture? Or perhaps a better question would be, does the fact that someone sometimes speaks within contemporary prejudices necessarily "undercut" those statements by the same person which "recognize and attack" such prejudices? Clearly Torgovnick concludes that it does, insisting that

the "colonialist" Fry eventually drags the "innovative" Fry "through the mud." "Fry's discussions of African pieces," we are told, "vacillate and waver, and remain fundamentally ambivalent about the value of things African."

Yet Torgovnick's chapter has all the appearance of a hasty acquaintance with its topic. It is one thing, for example, to mistakenly class Renoir as a post-impressionist, or misidentify the original publication of "Art of the Bushmen," but to label Fry a champion of *impressionism* evinces a degree of inattention that raises doubts about Torgovnick's readiness to comment on his writings. The vague grasp of Fry's life and work this mistake suggests is evident in her initial assessment of the impact of his texts:

Paraphrasing Woolf, we can say that in or about December 1910—and also through the agency of Roger Fry—primitive objects became, in England, high art. . . .

Though Fry was in many ways a dabbler in African and other non-Western art, with no ethnographic or special training, he was the premier art theorist in Britain, and his work on African art has weight and importance greater than the eighteen-page length of the essays would suggest. Vision and Design *was the volume that made primitive objects, in England, high art and made them the occasion for an emerging modernist aesthetics.*

What is curious here is that Torgovnick has already indicated an awareness of the outrage provoked by Fry's advocacy of African art. She duly quotes, for example, the epistolary splutter of his one-time colleague Henry Tonks—"I say, don't you think Fry might find something more interesting to write about than Bushmen, Bushmen!!"— yet she seemingly discounts the level of contemporary prejudice it represents. While it is probably true that, by 1910, Fry "was the premier art theorist in Britain," it is equally true that, apart from a stormy year as curator of paintings at the Metropolitan in New York in 1906, he had no institutional authority until his appointment to the Slade professorship in 1933. All he had was a reputation to lose, which, as a

writer and lecturer on art, was his livelihood. To say that "primitive objects became high art" simply through the publication of "Art of the Bushmen," and again ten years later with the publication of *Vision and Design*, ignores the fact that such advocacy nearly cost Fry this reputation. Yet he was compelled to risk it for the same reason that, as an authority on Old Masters, he earned it: his scrupulous adherence to what he believed was the truth. As Reed points out, Fry's impolitic insistence on truth had "ruffled more than a few feathers" as early as 1904, the year he was first passed over for the Slade, well before the more controversial phase of his career. Given that Fry was denied the Slade again in 1910, year of both "Art of the Bushmen" and his first post-impressionist exhibit, Torgovnick's paraphrase of Woolf's statement is singularly inapposite. The fact that, nearly 30 years later in his introduction to *Last Lectures*, Sir Kenneth Clark feels the need to apologize for Fry's continued exaltation of "Negro Art" and denigration of Greek antiquities, indicates that "primitive objects" had further to go than Torgovnick suspects.

All of this is to suggest that Torgovnick underestimates the cultural context in which Fry is writing, for both Britain and the United States were, and continued to be long after his death, openly white-supremacist cultures. In this respect, the extent to which Fry shares contemporary prejudices hardly matters, next to the fact that he feels compelled to declare certain African art superior to British art of any period. Take, for example, the following passage from "Negro Sculpture," a review of an exhibition at the Chelsea Book Club:

We have the habit of thinking that the power to create expressive plastic form is one of the greatest of human achievements, and the names of great sculptors are handed down from generation to generation, so that it seems unfair to be forced to admit that certain nameless savages have possessed this power not only in a higher degree than we at this moment, but than we as a nation have ever possessed it. And yet that is where I find myself. I have to admit that some of these

things are great sculpture—greater, I think, than anything we produced even in the Middle Ages. Certainly they have the special qualities of sculpture in a higher degree. They have indeed complete plastic freedom; that is to say, these African artists really conceive form in three dimensions.

Torgovnick contends this passage illustrates Fry's "reluctance to pronounce African sculpture great art," enhancing this impression by limiting her quotation to the first two sentences and dwelling on the phrase "nameless savages." Yet this interpretation fails to do justice to either Fry's purpose or tone. Given the dates of the texts, by the time of "Negro Sculpture," Fry had maintained the greatness of African art for at least ten years, and would continue to for the rest of his life, as the chapter "Negro Art" in *Last Lectures* amply illustrates. If there is "reluctance" expressed in this passage, it is in Fry's distaste for iconoclasm as such. In 1903, for example, despite admiring Whistler's art, he decried the artist's "refus[al] to persuade" and "vicious pleasure in being misunderstood" when debating aesthetic principles. Fry genuinely wants to convince through reason, but by 1920, he's already seen how resistant the public was to his advocacy of African art as well as modernism. In "Retrospect," after alluding to his criticism of Whistler, he confesses that, in 1910, he hadn't expected the level of antagonism such advocacy would arouse, assuming that, if he could demonstrate his statements were "capable of a logical explanation, as the result of a consistent sensibility," the "cultured public" would accept them. Instead he was accused of "anarchism"—the 1910 equivalent of being accused of "terrorism"—indicating how threatening the British establishment found his art historical views. But Fry's regard for truth compels him not only to maintain his beliefs, but also to continue to attempt to persuade those Henry Tonkses of his day of the reasonability of his position. His tactic is to take his readers by the elbow and guide them step-by-step through an argument whose conclu-

sion he knows they're likely to resist. He acknowledges the prejudice which makes his idea inherently implausible to perhaps the majority of his readers in 1920, and yet within three sentences moves from these protestations to the assertion of the "complete plastic freedom" of African sculpture. When we note too that Fry airs yet never denies the assumption that "to create expressive plastic form is one of the greatest human achievements," the full force of his statement becomes apparent.

Yet there's a more pressing problem with Torgovnick's account of Fry, a fundamental confusion generated by the "primitive" conceit of *Gone Primitive*. This is best illustrated by her discussion of "Art of the Bushmen," which she asserts "begins by raising the analogy between children's drawings and those of Bushmen," citing the following extract:

The primitive drawing of our own race is singularly like that of children. Its most striking peculiarity is the extent to which it is dominated by the concepts of language. . . . The symbols for concepts gradually take on more and more of the likeness to appearances, but the mode of approach remains even in comparatively advanced periods the same.

In her haste to indict Fry's text as "a virtual encyclopedia of colonialist stereotypes about the African," Torgovnick rushes past the phrase "of our own race," which unambiguously modifies "primitive drawing." In other words, this passage doesn't refer to "the African" at all. In fact, throughout *Vision and Design*, Fry never uses the word "primitive" in relation to what he generally calls "Negro art"; only once in "Art of the Bushmen," in a non-artistic sense, is the term associated with Africans: "It would be an exaggeration to suppose that Palaeolithic and Bushman drawings are entirely uninfluenced by the concepts which even the most primitive people must form." In a previously uncollected review of a 1917 exhibition of "Children's Draw-

ings," he even classes "the modern negro" among "primitive races,"
yet in that same essay he explains what "primitive" means in an art
historical sense:

> By primitive is usually meant that phase in the artistic sequence of a civilisation which precedes
> the phase of more or less complete power of representation. Thus for the Italians primitive is
> almost equivalent to any painting previous to Leonardo and Fra Bartolommeo. I should like for
> the time being to apply the word primitive not so much to a period in time as to a particular psy-
> chological attitude which occurs most frequently in those periods which we call primitive, but
> which is not universal even in these periods. Thus I do not count Cimabue or Giotto as primi-
> tives, nor Fra Angelico, Ucello, nor Piero della Francesca—but I should count almost all the me-
> diaeval miniaturists. . . . Now, the distinction I would draw between these two groups, which I
> will call Primitive and Formalist, is that the primitive artist is intensely moved by events and ob-
> jects. . . . The Formalist . . . is dominated by a passionate feeling about form.

To be sure, Fry's use of "primitive" isn't always consistent; often he
uses it in a purely historical sense, and he's previously labeled Cima-
bue and della Francesca "primitives" in 1911, though I imagine this
vacillation stems from the fact he considers such figures transitional
between primitive and later representational and formalist modes of
art. But Fry is clear enough in "Art of the Bushmen" about what he
means by the dominance of the conceptual over the representational
that characterizes the primitive mode: the eye, for example, drawn
full-face on a head in profile, an image based on the concept of the eye
rather than its actual appearance in such a position. Yet, as we saw
above, in the quotation from "Expression and Representation," prim-
itive art isn't a pejorative category for Fry, but rather capable of ex-
pressing "the highest emotional content." Be that as it may, the point
of both "Art of the Bushmen" and "Negro Sculpture" is that, as far as
Fry can tell, so much African art seems to have skipped "the artistic
sequence of a civilisation," bypassing the primitive entirely; the Bush-
men drawings demonstrate a visual acuity wholly at odds with the

concept-bound primitive mode, while the sculptures achieve the "complete plastic freedom" which he considers the most sophisticated mode of formalism. That Fry saw the degree to which formalist analysis of African art upset traditional hierarchies and conventional assumptions about art and life as confirmation of his dialectical view of art history is evident from his final assessment of "Negro Art" in *Last Lectures*. "More than any other art," Fry claims, "it will prevent our ever returning to that compact, nicely rounded-off theory which could be built by disregarding everything but the Greek tradition. No synthesis will be valid which cannot embrace at once certain masterpieces of the Greeks and such a work as this."

Beyond compromising much of her analysis, Torgovnick's misunderstanding of Fry's use of "primitive" is symptomatic of her overall lack of interest in ascertaining what he's actually talking about. Her unreliability as a guide to Fry's work is further abetted by a habit of omission. She takes issue, for example, with Fry's use of the word "Bushman," while eliding the fact that "Art of the Bushmen" is occasioned as a review of the 1909 Clarendon Press book *Bushman Paintings* by M. Helen Tongue and Dorothea Bleek. An extraordinary folio of color reproductions of Tongue's copies of South African cave drawings—of which the outlines illustrating "Art of the Bushmen" only give the barest hint—*Bushman Paintings* is inconvenient for Torgovnick's argument, insofar as opinions she wishes to ascribe to Fry are largely encapsulations of the survey of the ethnographic literature in the preface by Henry Balfour, curator of Oxford University's ethnographic collections. Fry's summary "about the near extinction of the Bushman," for example, is based entirely on Balfour's preface, though notably avoids its quasi-Darwinist conclusion that the Bushmen's decline results from "inexorable natural law." To dismiss Fry for being "a dabbler" "with no ethnographic training" overlooks the fact that

Balfour's ethnographically informed account utterly naturalizes the paternalist stereotype of strong and weak races by which colonialism justifies itself. While accusing Fry of "mak[ing] no attempt to distinguish between different parts and different peoples in Africa," moreover, Torgovnick herself shows no awareness that "Bushman" refers to a specific people inhabiting parts of South Africa and Namibia, or that, despite the anthropological trend toward less colonialist-imbued nomenclature like "Kalahari" or "San," "Bushman" is still a term of self-identification among some communities. Instead she introduces a discussion of a mask—depicting the god Woot of the Kuba people of the Democratic Republic of the Congo—whose relevance to Fry is neither established nor apparent. As there's no dearth of actual examples of African pieces Fry did discuss—*Last Lectures*, for example, reproduces no fewer than eight masks or heads—the randomness of her selection betrays a certain contempt for those cultural distinctions she accuses him of neglecting.

The vogue *Gone Primitive* enjoyed in early '90s critical theory has left Fry's reputation under a cloud for nearly a generation. But in view of its troubling inaccuracies and misunderstandings—of which I have addressed only the most urgent—Torgovnick's chapter should not be allowed to stand as a definitive account. Prior to Fry, the discourse of fine art in English was dominated by the moral, religious, and nationalist imperatives of the Victorian era from which he emerged. The genius of Fry's formalism was to point the way out of these strictures to a field of analysis that rendered them irrelevant, and nothing can efface the revolutionary character of this opening gesture in the establishment of art history. To paraphrase his Cambridge colleague Wittgenstein, it was an advance comparable only to that which made astronomy out of astrology, and chemistry out of alchemy. Rooted in his search for the objective basis of aesthetic ex-

periences, Fry's desire "to align art with science, and not . . . make it a form of mysticism" was a necessary precondition for people to accept assertions they found flabbergasting, even offensive, much as Freud was compelled to make a science of psychoanalysis to validate the nature of his investigations and conclusions. Yet, unlike later formalists, Fry was never seduced into a complete identification between art and science. The science of Fry's work was ultimately the rigorous application of logic—plus a keen historical sense of aesthetic developments—to a discourse previously ruled by sentiment and effusion. The result was a new discourse, Art History, and while some of Fry's work has inevitably dated, the balance retains tremendous vitality. Our culture is indebted to him.

2008

VACHEL LINDSAY WITH THE SUBMERGED

At a library book sale, I came across a copy of the 1925 Macmillan edition of the *Collected Poems* of Vachel Lindsay, with illustrations by the author, for a measly $3. Score! It'd been a few years since I'd read Lindsay, and, as I was absorbed into the riot of weird symbolist drawings within the book's pages, I was reminded of how ill-suited he is to anthology presentation, denuded of the context of his time and the context of himself. By itself, a poem like "The Congo" looks vilely racist but examined against the totality of his era and what we know of his personal and political views, it's clear even this is motivated by a far nobler sense of humanity than the outwardly more dignified postures of Pound or Eliot. That said, I can easily appreciate the frustration of W. E. B. Du Bois and other African American critics of the day who recognized Lindsay's genuine good will yet were frequently appalled at its expression.

I started reading Lindsay when I learned he'd written what is usually considered the first book of film criticism, *The Art of the Moving Picture* (1915, rev. ed. 1922). From there I'd gone on to his two road memoirs, *Adventures While Preaching the Gospel of Beauty* (1914) and

FACING: This drawing by Vachel Lindsay is from the front flyleaf of my copy of *The Congo*, opposite the following inscription:

To the future director: Fred Applegate – this picture of a flower from the moon, With the good wishes and great hopes of Nicholas Vachel Lindsay July 15, 1925. Los Angeles California

A Handy Guide for Beggars, Especially Those of the Poetic Fraternity (1916), followed by his Swedenborgian utopian novel *The Golden Book of Springfield* (1920). Many of the themes of these four books, which form an essential tapestry against which to view his poems, are condensed into the *two* (!) introductions, both by Lindsay, attached to the front of his 1925 *Collected Poems*, "Adventures While Preaching Hieroglyphic Sermons" and "Adventures While Singing These Songs."

There are so many gems in these intros, it's hard to know where to begin, though his remarks about his days as a tramp—during which he carried only drawings and his *Rhymes to Be Traded for Bread | Being New Verses by Nicholas Vachel Lindsay, Springfield, Illinois, June 1912 | Printed Expressly as a Substitute for Money.*—seem apropos to the present slate of concerns in America and American poetry:

The reason my beggar days started talk was that each time I broke loose, and went on the road, in the spring, after a winter of Art lecturing, it was definitely an act of protest against the United States commercial standard, a protest against the type of life set forth for all time in two books of Sinclair Lewis: Babbitt *and* Main Street. . . .

It was because it was a three-times-loudly-proclaimed act of defiance, not the time spent on the road, that made the stir. As a matter of fact I came back temporarily beaten each time, at the end of less than four months. But each time I was fortified to try it again. I am not yet through, either. I have spent a total of only two springs and one summer as a beggar, less than a year. Because it was an act of spiritual war, I have written many bulletins and reminiscences.

The poem called "General Booth Enters Heaven" was built in part upon certain adventures while singing these songs. When I was dead broke, and begging, in Atlanta, Georgia, and much confused as to my next move in this world, I slept for three nights in the Salvation Army quarters there. And when I passed through Newark, New Jersey, on another trip, I slept in the Salvation Army quarters there. I could tell some fearful stories of similar experiences. I will say briefly, that I know the Salvation Army from the inside. Certainly, at that time, the Army was struggling with what General Booth called the submerged tenth of the population. And I was with the submerged.

It is hard not to be in awe of this. Lindsay literally went "on the road" without a dime in his pocket, just poems. This is the behavior of a mystic or a madman, probably both, though, as the refusal of capital inherent in his 1912 pamphlet's title suggests, Lindsay was also a homespun anarchist thinker, as Ron Sakolsky explicates in the Charles H. Kerr edition of *The Golden Book of Springfield* (2000). It is small wonder more genteel institutions like the YMCA and the Anti-Saloon League actually kicked him out of their ranks. Harriet Monroe did what she could to keep him alive, making him famous in the first place in the pages of *Poetry* at its inception 100 years ago and inventing awards to give him over the years. And though he estimates he'd "recited to about one million people" by 1925—for he was way more famous ultimately as a performer than as a writer—the strain of trying to keep it together financially as a poet eventually broke him and he committed suicide impulsively one night (December 5, 1931) by drinking lye, a particularly slow and gruesome way to die. Like Williams said, the pure products of America do go crazy, and Lindsay was one of them.

2012

SURREALISM'S
ISLAND
MARTINIQUE

Since his death in 1966, André Breton has received more than his fair share of knocks. I've heard both critics and poets call him "fascist," though if pressed, they can only cite Breton's sometimes dogmatic leadership of the surrealist movement. Such loose talk is tiresome and ahistorical. A staunch communist, Breton was nonetheless the first to denounce the totalitarian Stalin when the rest of the French Left turned a blind eye. He never went for Mao like the *Tel Quel* crowd. As leader of a left-wing movement opposed to Hitler, he was on the Nazis' Parisian to-do list, and he only narrowly avoided arrest by Vichy authorities in Marseille, escaping to America aided by the efforts of Varian Fry (a sort of Schindler for lefty artists). Breton's even occasionally criticized for fleeing the Nazis—as if it contradicted his principles—though his accusers tend to lead safe, academic lives. As we see in *Martinique: Snake Charmer*, a chronicle of Breton's stopover between Marseille and NYC, exile's no picnic.

Breton had his flaws, of course, notably sexism and homophobia, yet even these were complicated, given the number of women and gays within the surrealist group. Most of his positions were politically progressive, particularly his anti-colonialism and anti-racism. Where much of the modernist avant-garde (Pound, Eliot, Marinetti, etc.) was avowedly racist, surrealism was the only movement that welcomed black artists as colleagues and innovators. In *Martinique*, in reference to the poet Aimé Césaire (who died only a few months before this writing, at 94), Breton writes: "It is a black man who handles the French language as no white man today is capable of handling it . . . who is the one guiding us today

into the unexplored." (Similarly, Breton would declare the Haitian Magloire Saint-Aude the most important surrealist poet of the postwar period.) Where even sympathetic artists like the cubists exoticized Africans, Breton identifies with Césaire, "unable to distinguish his will from my own." This might seem naive in today's political climate, yet the testimonials by the Martinican and Haitian writers who met Breton in the '40s—translated in Michael Richardson's 1996 book *Refusal of the Shadow*—suggest the feeling was mutual. Maybe it's not so naive, for surrealism stretches the limits of the possible.

Like many surrealist books, *Martinique* is a hybrid work, alternating between "lyrical language" and "the language of simple information," reflecting "intolerable malaise on the one hand and radiance on the other." That Breton could still pursue the poetic marvelous under such trying conditions—on arrival, he's thrown into a concentration camp by the pro-Vichy regime and, once freed, is constantly shadowed by police—is extraordinary. He was fascinated by Martinique's natural beauty, celebrating, for example, the effect of rainfall on the island in surrealist terms: "If the light is the least bit veiled, all the sky's water pierces its canopy, from a rigging of vertigo, water continually shakes itself, tuning its tall green-copper organ pipes." Not even the uncertainty of his fate could stop Breton's imagination.

This edition of *Martinique*—the first in English—is not without drawbacks, the most egregious being the poor reproductions of André Masson's drawings, seemingly scanned from the French edition. But the translation is admirable. In a society which falsely imagines itself "post-racial," *Martinique* is essential reading.

GORDON ONSLOW FORD
COSMOS
AND DEATH

As I begin to write, I notice it's February 15, 2009. A minor instance of objective chance, uncanny all the same, as it's six years to the day that I met Gordon Onslow Ford, at the painter's last exhibition. (I didn't intend to start this piece until tomorrow, but something made me turn to it today, prompting me to look up the date.) The show—*Gordon Onslow Ford at Ninety: Paintings from the Last Five Years*—was at the Braunstein/Quay Gallery in San Francisco, close to SFMOMA, and I wondered why he wasn't being given a retrospective there, given his age and importance. Perhaps they wouldn't have let him paint the walls grey, which he insisted on when showing his work. In any case, my then-girlfriend and I, along with Andrew Joron, went to the artist's reception in hopes of a glimpse of him, and we milled among his recent paintings, abstractions that can only be called "cosmic" for lack of a better word. Often on black backgrounds, they seemed to penetrate deep into the farthest regions of space, to places where stars are born. Even the one with the impossible olive-green background. He was definitely one of those painters who took a long time to develop, whose most recent works are generally their best. His youthful paintings are quite often interesting but he clearly broke through to some-

FACING: Gordon Onslow Ford, *Enter the Garden* (1962). Parles paint on canvas, 48 × 36 inches.

thing uniquely his own around 1959/1960, and, given his age, had had a good 40 years to take it further and further out. Suddenly there he was.

The times I've felt awe in the presence of an artist are comparatively few, but this was definitely one of them. The simple fact he'd created the paintings surrounding us was reason enough; the room's atmosphere was charged with synergies bouncing from wall to wall. But aside from this, and my appreciation of his work generally, the old man who just slipped into the room was a man who'd made history, yet still walked the earth. A "real surrealist," member of what you might call the "third wave" of the original Paris group, Onslow Ford was one of a trio, with Matta and Esteban Frances, whom Breton swept up in 1938 and featured in his major essay "Artistic Genesis and Perspective of Surrealism" (1941) as the movement's latest development. He was obviously most interested in Matta and least in Onslow Ford, but his appreciation was genuine enough to buy a few of Onslow Ford's paintings. I've seen one of these, *Country Feast* (1943), in person and it exuded an aura from Breton's selection and ownership, given that, to me, for all his flaws, Breton is among the greatest figures of the 20th century. *Country Feast* is painted in black, white, and grey, and, with characteristic intuition, Breton chose the painting that pointed the way to the future. For Onslow Ford really came into his own with black-and-white paintings, inspired by his education in Chinese calligraphy, though he was able to successfully import these lessons into his color work. The calligraphy no doubt led to his conviction that the basic elements of the visual world were circle, dot, and line, as he relates in *Painting in the Instant* (1964). From this streamlined vocabulary, the basis of all his subsequent work, he built up extraordinarily varied and complicated compositions which lack the severity such restriction might imply.

During the Second World War, Onslow Ford wound up in NYC with the exiled surrealists, and, as one of the few in their circle who spoke English, assumed a more important role as a spokesman for the group, lecturing and so forth. Along with Matta, he seems to have had a profound influence on what became known as abstract expressionism. As early as 1939, he'd experimented with pouring paint onto canvas, making him possibly the first to do so, though only two of these paintings survive, according to the catalogue, *Gordon Onslow Ford: The Formative Years*. While remaining friends with Breton, however, he gradually drifted away from surrealism and moved to Mexico, forming a close bond with Wolfgang Paalen and participating in Paalen's magazine *DYN*. Relocating to San Francisco, they formed the para-surrealist group Dynaton with Onslow Ford's wife Jacqueline Johnson, a writer, and Lee Mullican. In the '50s, Onslow Ford began to study Zen and later settled in Marin, where his substantial property is now, I believe, part of his Lucid Art Foundation. Among his other achievements, he had a hand in the development of acrylic paint, in response to his need for faster-drying black and white to accommodate his spontaneous techniques.

After speaking with various gallery-goers, Onslow Ford eventually wandered over to our small circle, giving us the chance to talk with him at length. He was affable, even dashing in a khaki-colored suit. He was delighted to learn I actually owned one of his works, a drawing unsigned but unmistakably his, which I'd scored very cheaply in the early, Wild West days of eBay. My girlfriend was wearing one of those Chinese T-shirts with distorted English reading: S H/ LIFECONSISTS/ NOTIN/ NOLDING/ GOODCARDS/ BUTINPLAUING/ WELL/ THOES YOU, and he enjoyed this as a popular manifestation of surrealism. He was still sympathetic to surrealism, although I felt like his writings on the subject had "gone soft"—as Philip Lamantia

expressed it once in conversation—or at least conflated surrealism with Zen. This doesn't reduce my admiration for Onslow Ford in the slightest, for a painter's ideas about painting don't always matter in the face of the results.

I don't recall many specific details of the conversation—I think Andrew did the talking for us—so much as my impressions of the man himself. His movements were slow but unhesitant, and his eyes had that lucidity of a mind serene but searching, actively engaged with his art and the world. I remember he told us he painted every day. He could retreat into vagueness if he didn't feel like addressing something, but this seemed deliberate, using his age to advantage, as it were. In terms of his appearance, I specifically recall his fingers, which had a smooth puffiness I've sometimes remarked in people in their 90s. His cheeks too shared this characteristic, as if extreme age eventually shed its wrinkles and took on a childlike appearance, even as he defied senility's second childhood. His age itself was its own source of awe. For I'm terrified of death, of the complete cessation of consciousness and existence, and contemplate my own to a greater or lesser extent every day of my life. I can't even imagine being 90, knowing the extreme unlikelihood of surviving another decade. Death is around the corner, waiting. I make this confession because I felt the paintings around us, though abstract, wrestled with the nearness of death. Their cosmic aspect seemed to contemplate the vast eternal universe from the perspective of finite consciousness, depicting its dissolution in a manner solemn yet serene. Dissolution was but one process in a mysterious but definite order. The paintings don't entirely foreclose on existence beyond this dissolution, for our perception is limited to the external aspect of extremely distant worlds, yet the paintings suggested a resignation, calming the terror of death if not utterly vanquishing it. Naturally this isn't art criticism, and I've no

idea whatever what his thoughts on such matters were, but such was the impression I had at the time.

Less than 10 months later, November 9, 2003, Onslow Ford died. Despite his age, his death was mildly shocking to me; it followed so soon on meeting him and he'd seemed so alive. But he'd really been at the threshold when we met.

Maybe a year or so later, I found myself with Andrew at Onslow Ford's compound in Marin, hidden, like the Batcave, beyond a tattered wooden gate. I recall various white buildings, studios, houses for various artists who lived on the property. There was a poetry reading we weren't too interested in beyond its being our chance to see Onslow Ford's place. Donald Guravich and Joanne Kyger showed up, always a smoking good time; otherwise I had no idea who the other attendees were. The reading was held in a small lecture hall on the property. Andrew and I spent most of our time poking around a huge bookshelf at the rear of the hall. I pulled down a bound album that, to my astonishment, contained a stack of realistic watercolors, many of them seascapes; near as I could guess, these paintings came from Onslow Ford's period in the Royal Navy, prior to his late '30s encounter with Matta. The album was an extraordinary thing to pluck off a shelf—holding Onslow Fords!—and touching, too, to see the unselfconscious love of painting at the root of his accomplishments. I put the album down pretty quick, however, for fear of damaging it.

After the reading, Andrew and I spoke to Fariba Bogzaran, cofounder and head of the Lucid Art Foundation. She was delighted that we'd met Onslow Ford, that we knew quite a bit about him, that we deeply admired his work. And, though it wasn't on the afternoon's agenda, she was more than happy to show us his studio. She brought us to one of the aforementioned white buildings and hauled open the door. There it was. The studio, Fariba told us, hadn't been touched

48 since his death, and the whole room was bathed in his aura, the personality exhibited in neat rows of brushes, tables crowded with well-organized jars of paint, the final, unfinished painting lying flat on a low table next to a chair. For most of his life, he'd painted standing over a canvas lying on the floor; the table and chair were a late concession to age. This canvas was white, covered in colored circles, many of which were paper cutouts used to plot the overall balance of the composition. It was only near the very end that he'd had to give up daily painting. If I recall correctly, he had a collapse of some sort and a fairly rapid decline. But he was lucid the entire time and apparently knew he was dying. Again, the prospect of death, the knowledge of its imminent approach, filled me with mental vertigo. I walked around the studio a bit, seeking out a small staircase with a painting at the top, then descending for a final walk through. Throughout were hung recent works, arranged by the artist himself, of a cosmic tendency even exceeding the 2003 gallery show. He'd never before hung his finished paintings in his studio like this, Fariba told us, and here too an uncanny feeling possessed me, as though he'd had an intimation of his approaching death, and chose to construct this mini-gallery in putting his affairs in order. Again these are my impressions and likely have nothing to do with Onslow Ford's experiences.

Is the studio as he left it still? I hope so. I would like to think that, in some form, Gordon Onslow Ford still *is*.

2009

POSTSCRIPT

"You like old people," a younger poet once said to me. I confess I was taken aback by her blunt appraisal, almost an accusation, or rather, I'd never thought of it that way. As an artist, you seek out the masters—your own masters, at any rate—and it follows these people tend to be older. The fact of their elderliness seems incidental to the matter at

hand and yet, I've probably gleaned whatever non-art-related wisdom I have from such encounters, much of which amounts to: give not a shit for trifles / for important stuff give all. And yet, I guess I do feel a certain amount of awe before old age. I wrote this piece a few years ago for a magazine that never came out, and it's hard not to feel a little ridiculous holding Onslow Ford up as an example of extreme longevity when I'm working for Lawrence Ferlinghetti and just completed an essay on Sylvia Fein, both of whom are 94 as I write. Nor can I omit Richard O. Moore, who's become a good friend of mine by now and is only a year their junior. In the face of these subsequent relationships, some of "Cosmos and Death" is a bit embarrassing—certainly it's uncomfortable to imagine friends in their 90s reading your impression of a 90-year-old's elderliness—but I've left the piece as is for fear of falsifying the essentials.

2013

SURREALISM AND THE ABSTRACT TRUTH

I: A Glimpse of Surrealism: New Worlds

A museum-quality show in terms of ambition and achievement, *Surrealism: New Worlds* (2011–2012) fleshed out a forgotten, if not *effaced*, chapter in American art history, even as it incidentally told the story of the gallery showing it. For the *éminence grise* of San Francisco's Weinstein Gallery is Gordon Onslow Ford (1912–2003), who, in addition to his role in the evolution of abstract art, was also one of the great collectors of modernism. Along with his friends Roberto Matta and Esteban Frances, the British-born Onslow Ford joined André Breton's Surrealist Movement in Paris in 1938, and would subsequently pursue an increasingly visionary, Zen-influenced abstraction in New York City, Mexico, and finally Northern California, where he lived from 1947 until his death. Onslow Ford's influence helped transform Weinstein—his exclusive dealer—into a serious place for historically connected surrealist art; through him, the gallery would forge links with other, then-living surrealists like Enrico Donati (1909–2008), and even now, after his death, it continues to gather his fellow travelers, as when it began representing the estate of Gerome Kamrowski in 2005, or the estate of Jimmy Ernst (Max's son) in 2010.

FACING: "Alfred Barr, Farley Farm House, East Sussex, England 1952" photograph by Lee Miller.

Befitting its plural title, *New Worlds* didn't present anything like a unified aesthetic, because surrealism alone among the modernist movements isn't an aesthetic but rather a critical assault on the conventions of reality. Thus abstraction mingled freely with figurative art, assemblages with bronzes, an automatic work like Óscar Domínguez's decalcomania *Three Figures* (1947) with a meticulous imitation readymade like Marcel Duchamp's *Eau et gaz à tous les étages* (1958). Drawn from a roughly 30-year time span, the 1930s to the '60s, the show listed some 22 artists—an unlisted Dorothea Tanning (then alive at 101,* though more active as a writer than a painter) brought the number up to 23—all of whom were connected to some degree to Breton's group. The theme, broadly speaking, was the encounter between the European-formulated surrealism and the "new world" of America.

Being a gallery, Weinstein naturally leaned most heavily on painters it represents; Onslow Ford, Donati, Kamrowski, and Leonor Fini were the pillars of the show, along with substantial contributions from Matta and Jimmy Ernst. What was remarkable, therefore, was how deftly the gallery filled out the show with works from big-name artists from the surrealist pantheon. A pair of Max Ernsts—*Convolvulus! Convolvulus!* (1941) and *Head of a Man* (1947)—gave as good an impression of his mercurial range as possible from merely two paintings, the former an Henri Rousseau–like jungle of hidden creatures emerging from weird plumes of color, the latter an austere though colorful neo-cubist mask. A single André Masson had to suffice for that artist's equally varied output, but the massive *Le Centaure porte-clé* (1947) (or "centaur key-ring") was a real stunner whose mutating im-

* Tanning (8/25/1910–1/31/2012) would die within 12 days of the original publication (1/19/2012) of my review of the show.

age suggested something of his graphic work. Large canvases by seldom-seen surrealists like Domínguez and Kurt Seligmann lent the show considerable depth.

The most crucial of the surrealist old masters represented, however, was Yves Tanguy, who staked out his own wall with three oils and one of his delicately rendered gouaches. All were what you'd call prime works of the artist, with significant pedigrees: one belonged to the early surrealist poet Paul Éluard, another to Hans Bellmer, and even the gouache has appeared in books and museums. But to identify Tanguy as more "crucial" here than, say, Masson or Max Ernst isn't to remark on the greater significance and number of the works in question; rather, the influence of Tanguy on painters like Onslow Ford, Donati, Matta, Kamrowski, and William Baziotes felt more pronounced, and in fact constituted the heart of the show. For while *New Worlds* showcased surrealism's variety over a 30-year span, the main thrust of the show inevitably became the development of *abstract surrealism*, particularly as affected by the arrival of Breton, Tanguy, and other members of the surrealist group in NYC in the early '40s, fleeing the Nazi occupation of Paris.

The encounter between the European surrealists and American artists like Kamrowski and Baziotes is the chapter of art history largely effaced through the application of the term "abstract expressionism" to NY artists of the late '40s and the '50s. The term was already in use, coined in 1919 in German by Oswald Herzog for his manifesto, "Der abstrakte Expressionismus," in the second issue of the Berlin avant-garde magazine *Der Sturm*. Though it was brought into English by MoMA's first director, Alfred H. Barr Jr., as early as 1929 to describe Kandinsky, and appeared on the cover of the catalogue to Barr's groundbreaking 1936 exhibition *Cubism and Abstract Art*, the term was anachronistically applied by American art critics

like Clement Greenberg as a way to avoid the label "abstract surrealism" (which also appears on the catalogue cover). With its communist and anarchist associations, "surrealism" carried too much revolutionary baggage for the postwar political climate in the U.S. The move also helped elide the stubborn political reality that abstract art was first achieved in Germany by a Russian artist, as if to suggest that historical "expressionism" hadn't really been "abstract" and only here in America had become so. Thus Greenberg in "'American-Type' Painting" (1955, 1958) elaborates an account of art as a series of laws, problems, solutions in order to write: "The early Kandinsky may have had a glimpse of this solution, but if he did it was hardly more than a glimpse. Pollock had had more than that."

Though no one believes in laws of painting anymore, the eclipse of abstract surrealism from American art history has proved curiously durable. But *New Worlds* illustrated the pivotal role of surrealism with a collaborative poured painting by Kamrowski, Baziotes, and Jackson Pollock, uncertainly dated "Winter 1940–1941." Given that Onslow Ford began pouring paint in 1939, and gave a series of lectures on surrealism in New York City attended by at least two if not all three of these young American artists beginning in January 1941, it's hard not to conclude that Pollock's initial inspiration for his drip paintings was Onslow Ford's account of surrealist automatism. This is the type of connection the label "abstract expressionism" obscures.

Yet this historical neglect has paved the way for Weinstein's success, as the gallery has become an effective advocate for abstract surrealism.

II: The Fall Guy: Alfred H. Barr Jr.

When I say "abstract surrealism" has largely been effaced from American art history, this is no mere rhetorical posture. No sooner does An-

dré Breton leave New York City for Paris in 1945 than U.S. art critics begin the erasure of abstract surrealism in favor of the manufacture of American abstract expressionism. The reasons for this, as I suggest above, are plain: surrealism is too compromised by revolutionary ideology and, as has since become apparent, the U.S. covert intelligence community had uses for abstract art. As art critic Philip Dodd comments in Frances Stonor Saunders's *The Cultural Cold War: The CIA and the World of Arts and Letters* (1999), "There may be a really perverse argument that says the CIA were the best art critics in America in the fifties because they saw work that actually should have been antipathetic to them—made by old lefties, coming out of European surrealism—and they saw the potential power in that kind of art and ran with it." As Dodd rightly suggests, there's a certain genius at work here, for this move was by no means obvious. Alienating the bourgeoisie had been a tenet of the modernist avant-garde from its very origins, and there were always contemporary conservatives willing to play the McCarthyite version of the shocked bourgeois, like Michigan Republican Congressman George Dondero, who railed against the Soviet influence he found lurking behind all abstract art. But as we've seen with Arthur Jerome Eddy, the ease with which conservative *receptivity* can defang the avant-garde is disconcerting, and with abstract art in particular, as Saunders writes, its very refusal to yield definitive imagery or imply a narrative makes itself ripe for co-optation:

Where Dondero saw in Abstract Expressionism evidence of a Communist conspiracy, America's cultural mandarins detected a contrary virtue: for them, it spoke to a specifically anti-Communist ideology, the ideology of freedom, of free enterprise. Non-figurative and politically silent, it was the very antithesis to socialist realism. It was precisely the kind of art the Soviets loved to hate. But it was more than this. It was, claimed its apologists, an explicitly American intervention in the modernist canon. As early as 1946, critics were applauding the new art as "independent, self-reliant, a true expression of the national will, spirit and character. It seems that, in aesthetic

character, US art is no longer a repository of European influences, that it is not a mere amalgamate of foreign 'isms,' assembled, compiled and assimilated with lesser or greater intelligence."

As Saunders documents meticulously throughout *The Cultural Cold War*, elements within the CIA—for it was by no means an organization-wide policy—wished to use American abstract painting, among other arts, to assert the cultural superiority of the United States, seeing this as a battle for hearts and minds that would be crucial to defeating Soviet-sponsored communism. This perception was symptomatic of the organization's expansion of intelligence activity beyond information gathering and analysis into psychological operations and propaganda. To fight this battle, the CIA set up various front groups, most notoriously the Congress for Cultural Freedom, which "at its peak . . . had offices in thirty-five countries, employed dozens of personnel, published over twenty prestige magazines, held art exhibitions, owned a news and features service, organized high-profile international conferences, and rewarded musicians and artists with prizes and public performances. Its mission was to nudge the intelligentsia of western Europe away from its lingering fascination with Marxism and Communism towards a view more accommodating of 'the American Way.'" But the CIA wasn't merely limited to its indirect subsidiaries, also making use of existing institutions like the Museum of Modern Art, which in this case was easy to do because the president of MoMA starting in 1939 was Standard Oil scion, future National Security Council member, and future Republican Vice President Nelson Rockefeller. Rockefeller's mother, Abby, was one of the principal founders of MoMA—he called it "Mommy's Museum," reports Saunders—and his involvement in intelligence predated the CIA's existence, beginning in 1940 as FDR's Coordinator of Inter-American Affairs. (He was never actually a CIA man because he had

his own spies, it seems.) He would also later enthusiastically endorse the "free enterprise" reading of abstract expressionism.

On the one hand, this is all old news. As Saunders points out, accusations against MoMA's promotion of abstract expressionism for the purposes of cold war propaganda date at least as far back as 1974, when Eva Cockcroft published her essay "Abstract Expressionism, Weapon of the Cold War" in *Artforum*. On the other hand, art history, particularly as it relates to surrealism and abstraction, still hasn't recovered from the distortions of this time. The CIA has essentially won the day, for the mission has been exposed but the false intelligence about the development of abstract expressionism hasn't been corrected. And at least one reason for the persistent misinformation about abstract surrealism is the contemporary critical reputation of Alfred Barr. As the first director of MoMA, from 1929 to 1943, then later director of museum collections from 1947 to 1968, Barr is tagged as "the authoritative tastemaker of his day" (Saunders) and even "the single most important man in shaping the Museum's artistic character and determining the success or failure of individual American artists and art movements" (Cockcroft). Both writers see Barr as having participated in an anticommunist plot to promote American abstract expressionism as a manifestation of the United States' postwar cultural supremacy.

Yet there's something squishy about the lines of evidence they marshal to support this conjecture. Cockcroft on her part infers Barr's "'credentials' as a cold warrior" from his December 14, 1952, *New York Times Magazine* article, "Is Modern Art Communistic?" "In his battle against the ignorant right-wing McCarthyists at home, Barr reflected the attitudes of enlightened cold warriors like CIA's [Thomas W.] Braden and MoMA's [director of international activities Porter A.] Mc-Cray," broadly corresponding to the "free enterprise" vision of abstract

art summarized by Saunders above. Yet there's little in Barr's article to support such a reading; his point is put plainly in the last paragraph: "Those who equate modern art with totalitarianism are ignorant of the facts.... Those who assert or imply that modern art is a subversive instrument of the Kremlin are guilty of fantastic falsehood." While arguing from the examples of Soviet Russia and Nazi Germany, Barr is careful not to equate communism with totalitarianism, even as he distinguishes between Leninism and Marxism, or details the early ferment of the Russian revolution, when the likes of Kandinsky and Chagall were given "important posts in universities and academies." You will search this article in vain for anything like the suggestion that free markets are a necessary precondition for modernist art, or indeed that a communist government is necessarily totalitarian.

I think Cockcroft's reading of Barr here is well-intentioned but misguided. She's breaking the first ground on the topic and the *New York Times Magazine* has framed the article in such a way as to give the impression that it poses the question in its title and answers definitively *no*. But anyone who's written for a newspaper will know Barr likely didn't title his own piece, and is it so hard to imagine him putting forward such an argument at the height of McCarthyism, when there were serious consequences to being branded "communist," in order to deflect the attacks of politicians like Dondero, whom he names by name, rather than for more nefarious motives? Nevertheless, if I expect Saunders to have a more substantial account of Barr's role in these matters, it's not simply because she's had the benefit of publishing 25 years after Cockcroft's original article. Rather, Saunders herself has created the expectation because the 500-page *Cultural Cold War* is so thorough in its tracings of the labyrinthine connections between the CIA and the organization's numerous operatives and front groups. It *has* to be thorough, otherwise it'd be ridiculous; who'd be-

lieve such far-fetched tales, without a mountain of evidence support-
ing them? The book is a detailed page-turner, a cold war bureaucratic
thriller, yet when it comes to Barr, all we get are two pages of vague
innuendo about his "fine Italian hand" and nothing in the way of sub-
stance. The weak treatment of Barr is a singular and puzzling failure
amid Saunders's otherwise impeccable scholarship.

There are at least two problems with the cold warrior reading of
Barr. To begin with, historically, Barr was frequently criticized for his
"seeming neglect" of American art and "the Museum's perceived neg-
lect not only of the abstract expressionists but also of American ab-
stract art in general." As Sybil Gordon Kantor writes in *Alfred H. Barr,
Jr., and the Intellectual Origins of the Museum of Modern Art* (2002),
"his interest in historical orthodoxy, the enfolding narrative that em-
braced innovation, precluded American art because it did not con-
tribute to the creation of the international abstract art movement."
Barr included Americans in his narrative of the development of ab-
stract art, but only when their work was in dialogue with the interna-
tional movement—hence the synchromists MacDonald-Wright and
Russell and the surrealists Calder and Man Ray—rather than expres-
sive of some specifically "American-type" quality. This paints a rather
different picture of Barr than the one suggested by Saunders and
Cockcroft. The second problem with the image of the determinedly
internationalist Barr as cold warrior is that he was, in fact, fired from
his position as director of MoMA in 1943, eventually replaced in 1949
by Rockefeller's handpicked man from the Office of Inter-American
Affairs, René d'Harnoncourt. Though myriad bureaucratic reasons
are cited, Barr's dismissal was the culmination of a series of outrages
committed against the conservative sensibilities of MoMA's board of
trustees. Kantor locates the beginning of the chain of events at the
Fantastic Art, Dada, Surrealism show, which opened on December 7,

 1936, and is snarked at in full color in the December 14, 1936, issue of *Life*. Méret Oppenheim's fur-lined teacup, *Object* (1936), caused especial consternation among trustee and journalist alike, but what may have also irked various board members was the active participation of André Breton's (internationalist) (communist) surrealist movement in the show, hot on the heels of the group's collaboration with Barr on *Cubism and Abstract Art*. Essentially, Barr made "Mommy's Museum" a cultural wing for the international Popular Front against fascism in that pivotal year of 1936,* and this can't have escaped Nelson Rockefeller's notice, though it'd be three years before he'd become president of the board of trustees. Nonetheless, Barr managed to endure until 1943, when he was fired in the wake of what we might call two surre-

* In *Inventing Abstraction, 1910–1925*, Leah Dickerman cites Barr's outrage after a 1933 visit to Nazi Germany as the genesis of his two 1936 shows: "Fuming about the censorious yellow-and-black labels already affixed alongside certain modern pictures in public collections in Nuremberg and Munich, flagging them as 'degenerate,' and the dismissal of museum personnel deemed unsuitable, instead of sunbathing he wrote a series of impassioned articles called 'Hitler and Nine Muses,' describing the impact of Nazi policies on the cultural sphere. In these texts, produced only a month after the National Socialists won election, Barr observed that their party was already 'able to dominate to an extraordinary degree almost every phase of the cultural life in Germany.' Culture, he made clear, was a first target for the Nazis. To his surprise, Barr failed to find a venue to publish his on-the-ground cultural reportage, with the exception of a small section on film and nationalism. Margaret Barr reports her own indignation: 'He has never been turned down. As it turns out neither the daily newspapers nor the periodicals—*The Nation, Harper's, Scribner's, North American Review, The New Republic*—are interested. Is it indifference or disbelief?' Barr's understanding of the cultural repercussions of European fascism, and his commitment to articulating the threat that it posed to modernist art and its producers, served as key motivations behind his paired 1936 shows. Preparations for *Cubism and Abstract Art* began soon after his return."

alist sins against trustee orthodoxy: exhibiting Joe Milone's baroquely decorated, protoassemblagist shoeshine stand in the lobby during the 1942 Christmas season and mounting a retrospective of primitive outsider artist Morris Hirshfield, known for his weird female nudes, in the summer of 1943. The actual firing is attributed to chairman of the board Stephen C. Clark, but I think we can take for granted Rockefeller's knowledge and sanction of the removal of the first and only director thus far in the history of Mommy's Museum.

Whenever you come across two diametrically opposed readings of a particular cultural figure, you should be given pause. In Barr's case, the fact that he has been accused both of fostering American abstract expressionism in the name of a jingoistic, anticommunist crusade and of neglecting American abstract expressionism due to a Eurocentric disdain for the cultural achievements of the United States suggests that neither conception of him is accurate. If Barr lends himself to attack from opposite ends of an ideological spectrum, this is primarily because he can't be easily appropriated by either side. Barr was trying to document the history of modernist art with as close an adherence to truth as humanly possible—successive visits to Nazi Germany in '33 and '35 had convinced him such recent history could already be erased—and this has left him with few friends because truth is ideologically messy. But the main problem with Barr's reception history, when all is said and done, is that he's never allowed to speak for himself. That is, Barr's most important work, the over-200-page catalogue to his groundbreaking 1936 exhibition *Cubism and Abstract Art*, has only rarely been reprinted, in 1966, 1974, and, most recently, 1986. Almost 30 years since its last appearance: I imagine you can whip through an art history Ph.D. on modernism without having to read it. But to me it's still the best book on its subject—the develop-

ment of abstract art from its origins to the then-present—and the fact that it's not in print, not considered as crucial a text of American modernism in its own way as *The Cantos*, is one of the sad lingering effects of the CIA's cold war art offensive.

III: *Inventing* Inventing Abstraction

For evidence of the pernicious effect of Barr's lack of critical standing, and the unavailability of *Cubism and Abstract Art*, on contemporary art history, we need only turn to MoMA itself and its massive 2013 retrospective, *Inventing Abstraction, 1910–1925*. Visiting the exhibit—indeed, visiting MoMA at all—you'd never know Alfred Barr existed, despite this show's obvious debt to his, its use of materials Barr acquired during his time as the museum director, and its wall-sized map of the "network" of artists and promoters of abstraction, this last an ineffectual travesty of Barr's famous chart outlining the development of abstract art through various avant-garde movements and tendencies over time which served as the original cover of his 1936 catalogue. Barr fares somewhat better in *Inventing Abstraction*'s catalogue, which devotes a pair of essays to his chart and the *Cubism and Abstract Art* show, respectively. Yet even so, his work is seriously misrepresented. In the latter essay, "Abstraction in 1936: Cubism and Abstract Art at the Museum of Modern Art," *Inventing Abstraction* curator Leah Dickerman writes that "by 1936, Barr seems to have thought that as a form of contemporary practice, abstraction was already in abeyance. On the chart, the period between 1925 and 1935 remains unpopulated by the names of movements." But the fact that this second sentence is perfectly accurate—the last new avant-garde movement named on the chart, "(Abstract) Surrealism," is listed at 1924, the year of Breton's first manifesto—in no way guarantees the truth of the first sentence. It is, in fact, false, as is clear from Barr's own preface:

The first purely abstract paintings were done as long as twenty years ago and many of the conclu-sions in the development of abstract art were reached before the [First World] War. Nevertheless there is today a quickening interest in the subject here, and in many countries in Europe, where ten years ago one heard on all sides that abstract art was dead. In a few years it will be time to hold an exhibition of abstract art of the 1930's to show the contemporary work done by groups in London, Barcelona, Prague, Warsaw, Milan, Paris, New York, and other centers of activity.

This description of the "quickening interest" in abstract art and the offhand list of seven-plus "centers of activity" in which "contemporary work" is being done, not to mention the preponderance of works in *Cubism and Abstract Art* dated 1934–36, many made specifically for it, are wholly at odds with Dickerman's assertion that Barr thought "abstraction was already in abeyance." And Dickerman has not simply overlooked this passage, for she quotes it selectively in a footnote ("Ten years ago [1926] one heard on all sides that abstract art was dead"), in effect making the sentence say the exact opposite of what it says; her statement is thus a conscious falsehood, rather than a mere mistake.

Why would Dickerman distort Barr's position so drastically? While it's tempting to imagine curators at MoMA still fighting the cold war like a platoon lost in the jungle, I think the answer's probably much simpler, for Barr's actual position counters not simply the organization of Dickerman's show but the conventional wisdom of contemporary art history. As Anna Moszynska puts it in her history of *Abstract Art* (1990): "Breton's literary concern with imagery meant that Surrealist art was seldom purely abstract." This idea has been repeated in one form or another so often that it is generally accepted as true, and Dickerman doesn't want to challenge it, which explains why there wasn't any surrealist art as such in *Inventing Abstraction,** despite the

* There are, to be sure, plenty of future surrealists and close associates of the group in the show, mostly grouped under Dada, including Arp, Duchamp, Man Ray,

fact that Barr's chart locates "(Abstract) Surrealism" at 1924, within the period of movements she otherwise finds so determinative. But only through some arbitrary criterion of purity—such as Greenberg's assertion that abstract painting's purity lay in a surrender to "the flat picture plane's denial of efforts to 'hole through' it for realistic perspectival space"—could you possibly defend the idea that "Surrealist art was seldom purely abstract," when the group included such painters as Masson, Tanguy, Arp, Ernst, Miró, Seligmann, Onslow Ford, Matta, Paalen, Gorky; really the list is endless and enumeration pointless. There is, of course, much surrealist painting of a non-abstract nature—the "dream scenarios" of such painters as Dalí, Brauner, Carrington, Varo, de Chirico—because, from the surrealist point of view, as Jean-Louis Bédouin writes in the group's official history, *Vingt ans de surréalisme, 1939–1959* (1961), the debate between partisans of figurative and abstract art is "a false dilemma":

Faced with the categorical choice to which the partisans of non-figuration would submit painters, and, through the painted work, the spirit of those who see this choice as ruling the whole conception of life, surrealism undertakes more than ever to preserve a total freedom of choice. Since surrealist painting began . . . one could say that all the "tendencies" of plastic expression coexisted in the interior of surrealism. . . . Surrealism does not impose any formal criterion on the artist. On the contrary, it demands that the artist become the creator of new forms, the explorer of the never-before-seen.[†]

Picabia, and Tzara. Apollinaire, who coined the word "surrealist," is also present, while Picasso, who had a long on-and-off relationship with Breton's group, is the show's very fountainhead.

 † "Face à l'option catégorique à laquelle les partisans de la non-figuration voudraient soumettre les peintres, et, à travers l'oeuvre peinte, l'esprit de ceux qui la regardent de telle sorte que cette option commande toute *la conception de la vie*, le surréalisme entend plus que jamais garder une totale liberté de choix. Depuis qu'il existe une peinture surréaliste . . . on peut dire que toutes les "tendances" de l'expression

Barr himself was well aware surrealism's prerogatives lay elsewhere than in purely formal criteria. "Abstract art, it should be clearly understood, was no more a part of the Surrealist program than it had been of Dada," he writes in *Cubism and Abstract Art*. "From a strictly Surrealist point of view an abstract design is merely a by-product." And yet, despite the lack of any a priori disposition toward abstraction, surrealism, according to Barr, would come to revitalize and even dominate the tradition of abstract art that had threatened to wane in the mid-1920s.

To demonstrate this, we need first to return to Dickerman's misreading of Barr's chart of the development of abstraction. Her assertion that Barr felt abstraction was "in abeyance" by 1936 is based on the lack of new movements on the chart after 1924. But the point of his chart is not simply to map a network of movements, but rather to illustrate the development over time of the two main currents of abstract art as of 1935: "NON-GEOMETRICAL ABSTRACT ART" and "GEOMETRICAL ABSTRACT ART." That is to say, abstract art is alive and well at the bottom of Barr's chart—i.e., the then-present—and the arrows linking various avant-garde groups culminate in one or the other of these two tendencies. Barr makes this reading of his chart clear in the section of *Cubism and Abstract Art* headed "Two main traditions of Abstract Art":

The first and more important current finds its sources in the art and theories of Cézanne and Seurat, passes through the widening stream of Cubism and finds its delta in the various geometrical and Constructivist movements which developed in Russia and Holland during the War and

plastique ont coexisté à l'interieur du surréalisme. . . . Le surréalisme n'impose à l'artiste aucune critère formelle. Il lui demande au contraire d'être le créateur de formes nouvelles, l'explorateur du jamais-vu."

66

have since spread throughout the World. This current may be described as intellectual, structural, architectonic, geometrical, rectilinear and classical in its austerity and dependence upon logic and calculation. The second—and, until recently, secondary—current has its principal source in the art and theories of Gauguin and his circle, flows through the Fauvisme of Matisse to the Abstract Expressionism of the pre-War paintings of Kandinsky. After running under ground for a few years it reappears vigorously among the masters of abstract art associated with Surrealism. This tradition, by contrast with the first, is intuitional and emotional rather than intellectual; organic or biomorphic rather than geometrical in its forms; curvilinear rather than rectilinear, decorative rather than structural, and romantic rather than classical in its exaltation of the mystical, the spontaneous and the irrational.

"The masters of abstract art associated with Surrealism" is not a phrase we hear very often in art history these days, and yet here is Barr saying it as the historical events are unfolding. What is striking, too, is how consistently he develops the above picture over the course of his catalogue, connecting surrealism to the pre–World War I abstract expressionism in Munich through the direct influence of Klee—who participated in the first group exhibition of surrealist painting along with Arp, Ernst, Miró, Masson, de Chirico, Man Ray, Pierre Roy, and Picasso in 1925—and through "analogy of form and method" between Kandinsky's abstract *Improvisations* and the "automatic method of the Surrealists." Barr will conclude *Cubism and Abstract Art* with a short discussion of "The younger generation" that is dominated by surrealists and ends on the following note:

At the risk of generalizing about the very recent past, it seems fairly clear that the geometric tradition in abstract art . . . is in decline. . . . The non-geometric biomorphic forms of Arp and Miró and [English sculptor Henry] Moore are definitely in the ascendant. The formal tradition of Gauguin, Fauvism and Expressionism will probably dominate for some time to come the tradition of Cézanne and Cubism.

This passage is remarkable and perhaps accounts for the fact that *Cubism and Abstract Art* has seldom been reprinted. For here Barr essen-

tially argues that surrealist abstraction is not only the present but also
the future of abstract art. And he was, of course, correct that non-geo-
metrical abstraction would "dominate for some time to come." The
abstract American painting that originally arose in the mid-'40s from
surrealism and later took on the label "abstract expressionism" is quite
evidently non-geometrical in character, so Barr's remarks are truly
prescient here, even though he couldn't have foreseen the actual cir-
cumstances of the Parisian surrealists' exile in New York City.
Reprinting Barr's book would thus restore too big a piece of what I've
suggested is a deliberately effaced chapter in American art history.

IV: The Villain: Clement Greenberg

If Saunders were looking for a villain for *The Cultural Cold War* in the
genre of painting on par with, say, Nicolas Nabokov's role in the genre
of music, I'm rather surprised she spent so little time on Clement
Greenberg. As she herself points out, Greenberg was "the art critic
who did most to put Abstract Expressionism on the map." This alone
would seem to warrant scrutiny on her part, given how thoroughly she
develops evidence for Cockcroft's original thesis concerning the cold
war role of American abstract expressionism. Saunders does note in
passing that Greenberg was a member of the more conservative fac-
tion of the American Committee for Cultural Freedom, a group that
served as the domestic branch of the CIA's aforementioned anti-
communist front group, the Congress for Cultural Freedom. He also
wrote for numerous magazines that she implicates as recipients of
CIA funding, including *Encounter, New Leader*, and *Partisan Review*.
In a relatively recent biography, *Art Czar: The Rise and Fall of Clement
Greenberg* (2006), Alice Goldfarb Marquis writes that Barbara Rose
(and others) believed Greenberg was some sort of CIA agent, though
Marquis does such a poor job of sourcing her quotations, you'll never

find out from her book when or where Rose might have made such a remark. Nonetheless, *Art Czar* indicates that suspicions about Greenberg's motives and activities as an art critic aren't new, making it all the more puzzling that Saunders merely recycles vague accusations against Barr instead of subjecting Greenberg's role in the rise of American abstract expressionism to a thorough investigation.

That Greenberg had a "lifelong disdain" for surrealism, as *Art Czar* puts it, is evident from his writings. If the movement needed to be purged from the history of the development of American abstract art, he was clearly the right man for the job. In truth, however, or at least for our purposes here, it matters little whether or not Greenberg was an actual CIA man; what is more to the point is that he did the cultural work the Agency needed done and, as a result, reaped the rewards in the form of State Department–sponsored travel and other lucrative gigs as a speaker on and international representative of modern American art. Even more importantly, his work, though much disputed, has been allowed to *stand*, in the sense that Greenberg's major collection of critical essays, *Art and Culture*, has never not been in print since its debut over 50 years ago. His four-volume *Collected Essays and Criticism* (1986–1993) similarly endures, while a seminal document of modernism like *Cubism and Abstract Art* languishes out of print. This is, on the one hand, symptomatic of the general academic tendency to revise away from primary source materials. On the other hand, it remains the single greatest stumbling block to forming an accurate picture of the direct lineage from abstract surrealism to American abstract expressionism.

A brief look at *Art and Culture* suffices to show the tactics by which Greenberg erases surrealism from the narrative of abstraction while establishing the currency of the term "abstract expressionism" as a label for post–Second World War American art. When not bashing surrealism, Greenberg skillfully omits it through a terminological sleight

of hand. Take, for example, his 1953 "Contribution to a Symposium"
in *Art News* called "Is the French Avant-Garde Over-Rated?" Green-
berg begins by more or less rewriting the question in the form of *Is
America the Greatest?*: "Do I mean that the new American abstract
painting is superior on the whole to the French? I do." This jingois-
tic assessment is no shock and its lack of specificity precludes chal-
lenge; Greenberg names four French painters he claims to like and
says they're not as good as the great Americans of 1953: "Gorky, Got-
tlieb, Hofmann, Kline, de Kooning, Motherwell, Newman, Pollock,
Rothko." Leaving aside the question of the extent to which Green-
berg's "Americans" are imported—Gorky, Hofmann, de Kooning, and
Rothko are all European-born—the trick Greenberg must perform is
to sever this group from surrealism, and this is no mean feat given
Gorky's and Motherwell's active collaboration with the group during
Breton's exile in NYC and even Rothko's and Pollock's more periph-
eral participation in the surrealist milieu. Greenberg's strategy is to
simply avoid the word "surrealism" altogether by performing varia-
tions on the word "cubist":

*Our new abstract painting seems to have anticipated the French version by two or three years,
but I doubt whether there has been any real acceptance of American influence on the part of
the French as yet (and I don't much care). The development of post-Cubist art (say rather, Late
Cubist) had brought American and French painting to the same point at about the same time, but
we had the advantage of having established Klee, Miró, and Mondrian as influences before Paris
did, and of having continued (thanks to Hans Hofmann and Milton Avery) to learn from Matisse
when he was being disregarded by the younger artists in Paris. Also, André Masson's presence
on this side of the Atlantic during the war was of inestimable benefit to us. Unfulfilled though he
is, and tragically so, he is still the most seminal of all painters, not excepting Miró, in the gen-
eration after Picasso's. He, more than anyone else, anticipated the new abstract painting, and
I don't believe he has received enough credit for it.*

This passage is so ludicrous, it's difficult to know where to begin, but
we might start by asking what this "post-Cubist art" he refers to is.

"Post-Cubist" isn't a term with any particular art historical significa-
tion, the way "post-impressionist" designates the reaction against im-
pressionism led by such artists as Cézanne, Van Gogh, Gauguin, et al.
If we remove Mondrian from this equation, "post-Cubist" sounds an
awful lot like "surrealist," given that Miró and Masson were surreal-
ists, and, as mentioned above, showed work in the first exhibition of
surrealist painting in 1925, along with Klee and Picasso. In his 1941
essay "Artistic Genesis and Perspective of Surrealism," moreover, Bre-
ton affirms that Klee's automatism was a crucial influence on the
movement as far back as the first *Manifesto* (1924), in which both Klee
and Masson are mentioned by name. Restoring Mondrian to this
equation only further erodes Greenberg's credibility, for while it's true
Mondrian wasn't a surrealist, his influence certainly made itself felt
in Paris long before New York through the former members of De Stijl
(1917–31)—such as Van Doesburg and Arp—who helped form the Ab-
straction-Création group (1931–35). Among the current or future sur-
realists in this venture are Calder, Gorky, Seligmann, and Paalen, and,
of course, Arp himself. Saying Masson "more than anyone else antic-
ipated the new abstract painting" would be an open admission that
surrealism was at the root of the New American Painting in any uni-
verse excerpt Greenberg's, in which the movement has been replaced
with a concept of his own invention, "Late Cubism," whose parame-
ters are so nebulous he can include Hofmann, de Kooning, Gorky,
Miró, and even Pollock within it.

At the same time that Greenberg seemingly champions "Late
Cubism," however, he is laying the groundwork for the appropriation
of the term "abstract expressionism" as a way to characterize post-
war American painting. In a footnote to "'American-Type' Painting,"
Greenberg blames *New Yorker* art critic Robert M. Coates for saddling
us with the term in 1946, "at least in order to apply it to American

painting." Yet Greenberg had already begun to appropriate the phrase as early as the same 1953 "Contribution" he reprints in *Art and Culture*:

Despite their seeming convergence, there are crucial differences between the French and the American versions of so-called Abstract Expressionism. . . .

The American version of Abstract Expressionism is usually characterized, in failure as well as in success, by a fresher, more open, more immediate surface.

Greenberg's "so-called" qualification finds him using "Abstract Expressionism" as though grudgingly, because it seems to have won the day. But two years later, in "'American-Type' Painting," Greenberg redefines "abstract expressionism" for his own purposes, through a series of well-placed maneuvers:

In some ways Hans Hofmann is the most remarkable phenomenon of "abstract expressionism," as well as the exponent of it with the clearest title so far to the appellation "master." Active and known as a teacher here and in pre-Hitler Germany, Hofmann did not begin showing consistently until 1944, when in his early sixties, which was only a short time after his art had turned openly abstract. . . . Hofmann . . . assimilated the Fauve Matisse before he did Cubism.

The years 1947 and 1948 constituted a turning point for "abstract expressionism." . . . But it was only in 1950 that "abstract expressionism" jelled as a general manifestation.

Actually, not one of the original "abstract expressionists"—least of all Kline—has felt more than a cursory interest in Oriental art.

Let us begin at the end of this tale. By calling Franz Kline "one of the original 'abstract expressionists,'" Greenberg definitively wrests the term away from Herzog, Barr, and Kandinsky, given that Kline was only a year old when Kandinsky painted his first abstract canvases in 1911. Locating the "turning point for 'abstract expressionism'" at 1947–48 further severs it from Kandinsky, so that Greenberg may award Hofmann the title "master." But if Hofmann was "active and

known as a teacher . . . in pre-Hitler Germany," surely he was aware of the stir caused by Kandinsky's New Artists' Federation, at the Modern Gallery, Munich, 1909, which Arthur Jerome Eddy identified five years later as the beginning of German modernism in his book *Cubists and Post-Impressionism*. And Eddy knows what he's talking about; his massive bibliography of books and articles on modern art from 1908 to 1914 indicates he read French as well as German, and he's the type of guy who can name 19 *Russian fauves*, among whom Kandinsky figures. Yet as of 1919, when Eddy publishes the revised edition of *Cubists and Post-Impressionism* and Herzog coins "abstract expressionism" in his *Der Sturm* manifesto, Hofmann is still nowhere in sight. If he "assimilated the Fauve Matisse before he did Cubism," mightn't we imagine that he did so through Kandinsky, who was well-known after the notorious 1909 show and who, after the Soviet government changed its position on avant-garde art, taught at Bauhaus (1921–33) until it was shut down by Hitler? Greenberg neatly avoids this question through the adverbial display of "openly abstract," as if Hofmann's own abstraction had been deeply hidden, yet present even before he'd heard of Kandinsky. This replacement of Kandinsky by Hofmann as the master of abstract expressionism was a necessary prerequisite to Greenberg's appropriation of the term for American art, for it would not do, at the outset of the cold war, to have an aristocratic Leftist mystic Russian fauve working in Germany as the ultimate origin of "the new abstract painting" with which America hopes to conquer the art world. Kandinsky must go, so Greenberg elsewhere tars him with the ultimate insult on the abstract brush, *"illustration,"* essentially the same rationale used to exclude surrealism from the history of abstract art.

When you subject it to even the lightest historical scrutiny, *Art and Culture* crumbles on the basis of its factual inaccuracies alone, irre-

spective of any formalist analysis Greenberg might hazard. But the
narrative Greenberg helped construct—erasing surrealism from the
development of abstract art and transferring the term "abstract ex-
pressionism" from Kandinsky and his followers in the 1910s to the
abstract American painting emerging out of surrealism in the 1940s
—has proven a formidable structure, not so easy to dismantle, as the
recent *Inventing Abstraction* suggests. *Art and Culture* might thus be
bad art criticism, but it's first-rate propaganda.

Nonetheless, cracks have begun to appear in this edifice. I have
mentioned the work of the Weinstein Gallery, whose curatorial pre-
rogative has sprung directly from Gordon Onslow Ford and flowered
in major retrospectives for such abstract surrealist painters as Jimmy
Ernst, Gerome Kamrowski, and Enrico Donati. But even the muse-
ums are getting in on the action. At the same time MoMA was staging
Inventing Abstraction, the Morgan Library was hosting the splendid
Drawing Surrealism, curated by Leslie Jones and originating at the
L.A. County Museum of Art. Like Weinstein's *Surrealism: New Worlds*,
Drawing Surrealism wasn't specifically about abstract surrealism; it's
probably best described as works on paper from the movement's in-
ception through the late '40s, showcasing the bewildering variety of
techniques the group employed or invented during its heyday. Yet the
show nonetheless asserted the relationship between this work and
American abstract expressionism through a couple walls of "Late Sur-
realism," where usual suspects like Matta, Onslow Ford, Baziotes, and
Kamrowski rubbed shoulders with the likes of Pollock, Rothko,
Pousette-Dart, Louise Bourgeois, and John Graham. To see two major
shows operating on such fundamentally opposed historical premises
some 20 blocks apart in Manhattan was striking, to say the least, and
sadly MoMA was on the wrong side of history.

V: A Bunch of Pigs

The surrealist Lee Miller took a great photograph of Alfred Barr during a visit to her and Roland Penrose's Farley Farm in East Sussex, England, in 1952. Looking dapper in a tweed coat with pocket square and black fedora, Barr is by no means dressed for farm labor, but Miller has him posed with a metal bucket by a trough, not so much slopping the two pigs present as gently tilting the bucket for their inspection of its contents. With anthropomorphic expressions the photo surrealistically encourages, the pigs sniff at the contents in smug curiosity rather than hunger, while Barr stands there expressionless, patient and dignified, as if there were no humiliation to waiting on a bunch of pigs. It's hard not to see this as an allegory for Barr's relationship to the board of trustees at MoMA. The reference to Barr's "fine Italian hand" that Saunders seizes upon in *The Cultural Cold War* to establish his complicity in the museum's anticommunist activities I think refers more to the behind-the-scenes dealings and gentle persuasions he'd continually had to perform as director of MoMA; I'm sure he'd had to suffer many a moneyed fool in order to make the museum great. As a reward for this labor he was dismissed, yet even then, in the face of offers from other museums, he stuck around at a reduced salary, ostensibly to tie up loose ends and finish certain research projects. It seems he couldn't bring himself to part from the institution he'd built. But neither could the museum do without him, and within four years of his dismissal, he was back, with less executive authority, under the new title "director of collections." People like Picasso or Breton—people whose participation was vital to the museum's success in staging world-class shows of modernist art—they didn't do business with MoMA, they did business with Barr, because only Barr had the necessary tact to move between the realm of the largely communist and anarchist artists of European modernism and an institution

founded and funded by American capitalists, in an effort to benefit the public at large.

That's a tough tightrope to walk, and his loss of MoMA's directorship suggests Barr ultimately fell too far on the artists' side for the trustees' comfort. And he's still paying the price, inasmuch as the passage of time hasn't restored his reputation or brought his writing back into print. Unless *Cubism and Abstract Art* is made available again, critics will feel safe misrepresenting Barr for their own purposes. In her essay on Barr's catalogue, Leah Dickerman writes that "mounting *Cubism and Abstract Art* at that moment had everything to do with what was going on in Europe. A single poignant sentence in the catalogue introduction sets the project in relation to the rise of fascism: 'This essay and exhibition might well be dedicated to those painters of squares and circles (and the architects influenced by them) who have suffered at the hands of philistines with political power.'" Robert Rosenblum, in his Reaganite introduction to the 1986 reprint of *Cubism and Abstract Art*, has a similar, albeit less charitable take on this passage, calling it "poignantly strained" even as he notes its basis in "the grim new facts of contemporary life in Germany and the U.S.S.R." Such assertions of what is, in fact, the very real connection between Barr's 1936 show and the rise of totalitarianism in Europe again mislead through selectivity, for what both commentators omit to mention is Barr's own footnote to his dedication:

As this volume goes to press the United States Customs has refused to permit the Museum of Modern Art to enter as works of art nineteen pieces of more or less abstract sculpture under a ruling which requires that sculpture must represent an animal or human form. Some of the nineteen pieces are illustrated by figs. 47, 49, 96, 97, 104, 105, 155, 202, 209, 210, 216, 221, 222, 223. They are all considered dutiable as plaster, bronze, stone, wood, etc., and have been entered under bond. The hand-painted canvases in the exhibition were, however, admitted free, no matter how abstract.

The "philistines with political power" that Barr refers to in his dedication clearly aren't limited to Europe, as this footnote suggests; through the United States Customs, the administration of Franklin Delano Roosevelt appears to have actively interfered with MoMA's assembling of *Cubism and Abstract Art* by taxing various sculptures according to their materials. In keeping with his penchant for understatement, Barr protests this decision not by denouncing it but merely by reporting it in such a way as to allow the reader to identify the pieces and draw his or her own conclusions. Looking at the sculptures Customs refused to acknowledge as human or animal puts that organization in rather a bad light, for examples like figures 96 and 97— Raymond Duchamp-Villon's *The Lovers* (1913) and *Horse* (1914), respectively—while not photorealistic, are quite evidently related to their titles. Whatever Dickerman's and Rosenblum's motives for ignoring this footnote in order to make the dedication seem solely directed at European events, their silence is a disservice to Barr. Certainly unsubstantiated claims against Barr as a cultural cold warrior ring false against documented challenges to the propriety of the U.S. government's decisions, such as we see here.

The truth is that Alfred Barr is a hero. Our whole notion of a museum for modern or contemporary art, a museum that includes film, architecture, design, and photography alongside painting and sculpture, comes from him. On top of this, the catalogue to *Cubism and Abstract Art* remains the most valuable book on its subject, at once a primary and a secondary source on the quintessential formal development in the visual arts during modernism. Our knowledge of abstract art is truly indebted to his occasional personal acts of boldness, whether it was tiptoeing around Moscow to see Rodchenko's officially "repressed" paintings in 1928 or smuggling Malevich paintings out of

Nazi Germany wrapped in his umbrella in 1935. Yet Barr has been continually disparaged, insinuated against, and lied about in the years since his death, and today Lee Miller's allegorical photograph has an even wider application than it did in 1952. A bunch of pigs, indeed.

2012, 2014

A FOOTNOTE ON JIMMY ERNST

I once had the chance to review a great show of surrealist art, *Surrealism: New Worlds*, that was up at the Weinstein Gallery in San Francisco from December 2011 to February 2012. My account focused primarily on the development of "abstract surrealism" and how that phrase was displaced by the historically suspect "abstract expressionism" as a way for jingoistic American art critics to divorce the work of Jackson Pollock, et al., from its direct and undeniable origins in surrealism. As is frequently the case when up against a word count, I had much to discuss that I couldn't fit into the piece, chief of which was the work of Jimmy Ernst (1920–1984). Jimmy Ernst was the son of Max Ernst, as thankless a task as being Ravi Coltrane in music and exacerbated all the more by surviving his famous father by less than a decade (Max died in '76). The shadow Max Ernst cast was too long to escape in so short a time, and I suspect the more or less successful effacement of "abstract surrealism" from American art history further contributed to Jimmy's relative obscurity. This is doubly unfair considering Max abandoned Jimmy and his mother when Jimmy was two and, while he was somewhat influenced by his father, he was largely self-taught as an artist. You can pick up such facts from the younger Ernst's gripping memoir of his early years, *A Not-So-Still Life* (1984), which remains available in the 1992 Pushcart Press edition.

One reason perhaps I didn't get to Jimmy Ernst in the article was the vintage of the works chosen for the show. As *Surrealism: New Worlds* broadly emphasized the encounter between surrealism and

the "new world" of America, the Jimmy Ernsts were mostly from the late 1940s, in order to represent—along with William Baziotes and Gerome Kamrowski—the reverberation of surrealism into the period of abstract expressionism so-called. Having had the opportunity to see a major retrospective of Ernst at the Weinstein in 2010, shortly after the gallery began representing his estate, I think it's safe to say that these late '40s paintings come well before the full flowering of his genius, which begins sometime around 1960. His paintings, in other words, weren't the most crucial ones there, though the large canvases were by no means unimpressive; one in particular, *Science Fiction* (1948), must be among his most significant early works, prefiguring the blue-and-red color scheme he would increasingly exploit in his period of later mastery. Having first admired *Science Fiction* during the 2010 retrospective, I felt like I was seeing an old friend, and I hoped to somehow in passing urge some public institution like SFMOMA to purchase it so it wouldn't fall into private hands. HA! I frequently have such outlandish agendas as a journalist that I'm forced to set aside as the word count starts counting and this was no exception. In the end, it was all I could do to simply mention Jimmy Ernst in a desperate bid to make a handful of readers out there aware of his existence. Sometimes that's all you have room for, but Ernst deserves more.

2012

SYLVIA FEIN AND THE DEATH OF THE WHITE KNIGHT

It strikes me now that I still might never have heard of Sylvia Fein had I not fallen in love at the beginning of 2012. For I miss everything—having to work an odd schedule to stay alive and maintaining fixed habits as a writer in service to the writing—but my friends had just returned amazed from the massive L.A. County Museum of Art show, *In Wonderland: The Surrealist Adventures of Women Artists in Mexico and the United States,* and my offhand remark to my new girl-friend that we should check it out was taken seriously enough that I couldn't back out of what became our first road trip, in April of that year. Left to my own devices, I would never have experienced one of the great museum shows of my life. I was by no means unversed in the subject matter of *In Wonderland,* yet each wall disclosed some-thing new, whether it was an unfamiliar work by a familiar artist, like Leonora Carrington's red leather mask or Kay Sage's backward canvas, or astonishing works from artists who were just names to me, like Alice Rahon or Jacqueline Lamba, or works by artists utterly unknown to me, like Gertrude Abercrombie or Gerrie Gutmann. Into this last category fell Sylvia Fein, who, with Yayoi Kusama, was one of only two living artists in the entire show. Born in 1919, Fein had been a mem-

FACING: Sylvia Fein, *The Lady with the White Knight* (1942–43). Egg tempera on Ma-sonite.

ber of a group of "magic realist" artists in the Madison, Milwaukee, and Chicago region in the early 1940s along with the abovementioned Abercrombie and four men, Marshall Glasier, Dudley Huppler, Karl Priebe, and John Wilde. Influenced by surrealism, the group would take that movement's uncanny, figurative dreamscapes as its point of departure, in contrast to the contemporaneous use of surrealism made by the American abstract expressionists.

In Wonderland included several large paintings by Fein; the catalogue reproduces *The Lady with the White Knight* (1942–43), *The Tea Party* (1943), *Girl of Ajijic* (1944), *Lady with Her Baby* (1947), and *The Lady Magician* (1954), but I'm sure I saw one or two others, like *Mama's Music Class* (1947–49). This last is not a painting you'd forget, a large, horizontal group-photo-style portrait of 12 women in mostly white Victorian-era dress in front of a far-receding landscape of sculptured lawns and an enormous yellow sky. The effect of this sky is considerably heightened in person due to the materials she uses, for Fein has spent almost her entire career as an artist working in egg tempera on Masonite. As Robert Cozzolino writes in *With Friends: Six Magic Realists* (2005), the only work devoted to this Midwestern group, Fein "studied and experimented with ground pigment and emulsions like an alchemist in a secret workshop," and in this we might crudely characterize her as a homegrown Remedios Varo. Like Varo, whose technical training at the Real Academia de Bellas Artes de San Fernando in Madrid emphasized "the traditional formulas for canvas preparation, pigment mixing, glazing, and varnishing that constitute the standard repertoire of the old masters," Fein steeped herself in the arcana of her materials at the University of Wisconsin–Madison under the tutelage of muralist and art historian James S. Watrous; the tempera for *The Tea Party*, for example, was made from a 15th-century recipe that called for wood ashes, fish glue, and whale wax, among other ingredients. Though Varo painted in oil, her method, as I un-

derstand it, was akin to tempera in its application of many thin layers of paint and varnish on Masonite,* building up impossible, translucent depths akin to the aforesaid sky of *Mama's Music Class*. There are other curious parallels; like Varo, Fein in her earliest mature work frequently depicts a version of herself as the protagonist of a scene. While they are less fantastic, more mythic, her scenes nonetheless share with Varo's a Renaissance delight in the minutiae of things, replacing the latter's elaborate pulleys, gears, and retorts with an array of seeds, bugs, bottles, and cups. In *Mama's Music Class*, the impulse is manifested both in the foreground in the women's discreet jewelry and contrasting lacework and in the background in the distant fountains, statues, and sculptured shrubberies. According to Fein herself, I'm by no means the first to note a resemblance; when Varo first became known in Mexico City in the mid-'50s, Fein immediately received some reproductions in the mail from one of her friends there, recognizing the fortuitous sympathies between their work. Fein herself was in another part of Mexico at the time, one of several trips, and she credits her initial stay there in the mid-'40s as the catalyzing influence on her art, so this country forms another link between their art, even though she spent the greater part of her life in Northern California after World War II.

A few weeks later, my girlfriend Suzanne and I found ourselves driving out to Alhambra Valley, an unincorporated hamlet by Martinez,

* I'm not a painter and I'm not going to lie; I owe the initial suggestion that Varo's actual technique is like painting in egg tempera to her wikipedia page: en.wikipedia .org/wiki/Remedios_Varo. There's no citation for this assertion. But Janet Kaplan's description of Varo's application of layers of oil and varnish in *Unexpected Journeys: The Art and Life of Remedios Varo* (see, for example, page 125) sounds very like Fein's own conversation regarding her buildup of layers of tempera in order to achieve depth, so the suggestion seems to me worth pursuing.

CA, only 22 miles from where I live. We'd been invited by Sylvia Fein and her husband, Bill Scheuber, for lunch, to meet *In Wonderland* co-curator Ilene Fort, along with various other friends and associates. I'd invented a bit of business for the occasion, hoping to use an image of Sylvia's on the cover of Lisa Jarnot's selected poems, *Joie de Vivre*, which I was editing for City Lights. Visiting a surrealist painter, I've sometimes found, entails crossing a visible boundary—I think of the white wooden gate separating Onslow Ford's compound from the surrounding environs—and it was clear from the suspiciously nonofficial-looking signage demarcating streets and promoting bicycle awareness exactly when we passed out of Martinez and into Sylvia's world. Bill had made his fortune after the war as an innovator in medical insurance, so the couple had the wherewithal to design and build an amazing, natural-light-filled house—vast and open, a painter's dream—on a hill overlooking several acres of land planted with fruit trees, vines, vegetables, and flowers of all description. I mention this in part because the house and especially the garden and crops seem such extensions of Fein's personality, her alchemical interest in the process of growth and transformation, as well as clues, perhaps, to her abandonment of painting for roughly 30 years between 1973 and 2003. For she was not unsuccessful as an artist, being represented by the Feingarten Galleries, which could show her work in New York City as well as San Francisco, Los Angeles, Chicago, and Carmel. By the mid-'50s, when monumental abstraction was in, Fein was working nearly in miniature, painting tiny landscapes and seascapes in egg tempera. Nothing could have been less fashionable, but her paintings still sold, yet the cycles of inspiration that had been motivating her work since the '40s had simply suspended themselves and she wasn't inclined to force the issue. But too the tremendous creative force that resides in her was no doubt diverted into other channels, including her extensive agricultural pursuits, as well as her two books, *Heidi's*

Horse (1976), an analysis of her daughter's drawings of horses between the ages of two and 16, and *First Drawings: Genesis of Visual Thinking* (1993), a related account exploring the development of visual logic in children, primitive cultures, and other artists. She would "resume[] painting with extraordinary energy and imagination" during the preparations for the *With Friends* exhibition, which prompted a return to the previously suspended cycles of inspiration; they haven't abandoned her since. Sometimes she seems to view her art as something special, higher, but other times she simply speaks of it as of a piece with the rest of her life, and taking care of her garden seems to be of more urgent concern to her than worrying about the fate of her art or her fame as an artist.

Standing at the front door, somewhat abashed to be the focus of the gathering, Sylvia herself was a shy, elfin presence, short-statured and red-haired, with a vigor altogether belying her age. Her miniature greyhound named Leonardo da Vinci circled protectively, a hyperactive, not terribly obedient familiar in place of Varo's ubiquitous cats. After settling us in the living room among the various guests, she was off after various drinks and hors d'oeuvres, and Ilene Fort had to forcibly corral her back among us. Sylvia, it was clear, was uncomfortable talking about herself, and if she were a comparatively unknown artist, this probably stemmed as much from her personal reticence as from her abandonment of a successful early career. She was most interested in discussing painting as process and inspiration rather than in terms of works she had made, yet she was at her best in the brief tour of the house prior to lunch, in front of particular paintings hanging on the walls. An older picture might start to elicit some information from her about the period when it was made, and I'd occasionally float as innocuous a question as I could, for fear of making her clam up altogether.

But the best paintings were her most recent; there were in partic-

86 ular a series of what can only be called cosmic abstractions, orbs seemingly floating in an atmosphere of which they too are made, whose backgrounds have an indescribable depth stemming from her mastery of the egg tempera technique—the sky of *Mama's Music Class* become both total and interstellar, if not interdimensional with their various yellow, red, or blue universes. She indicated she achieved something of a trance state in her rapid application of the fast-drying emulsion and was often herself surprised with the results, and this conception of the artist as medium, combined with her occasional tendency to throw an eyeball, or a floating diaphanous hand, into these otherwise abstract universes, makes me want to dispense with the "magic realism" label and call her a surrealist painter outright. And by this I mean her art reflects surrealism's denial of the validity of framing modernist, avant-garde painting in terms of abstraction versus representation. Like many surrealist artists, Fein refuses this division both in the spectrum along which she paints—for her landscapes and seascapes are of a piece with her abstract imaginative worlds—and even within a given work, which might mix abstract and representational elements.

Lunch itself was a good time; we got to meet Sylvia's husband Bill, whom we'd seen as a young man in her painting *The Lady with the White Knight*, one of several dramatic depictions of her wartime anxiety over his fate in the U.S. Army, which had sent him to Guam to train as a cryptographer. Dressed in a short, chain-mail tunic, otherwise naked, Bill stands on the left of the painting, staring off resolute, heroic, with various supplies (food, weaponry) dangling from his right hand, while his left touches the back of his wife, who looks away to

FACING: Sylvia Fein, *For W.K.S.: I Think I Shall Never See a Tree as Lovely as Thee* (2013). Egg tempera on Masonite.

the right as though struggling with a variety of emotions. They'd gotten hitched right before he shipped out in 1942, and it was wonderful to see them here still together after the palpable anguish Fein had embodied in her paintings some 70 years before. Bill was a charming and affable host and I was surprised to hear from Sylvia, when she took me aside briefly to speak about the book cover, that he was dying. He had cancer and Alzheimer's, though the latter he concealed well at lunch. (Suzanne told me later he did ask her with mild concern if they'd met before and was reassured to learn they hadn't, so he seemed quite aware of his fading memory.) The glimpse of Sylvia's undisguised grief formed an ominous cloud on the horizon of an otherwise amazing afternoon.

Suzanne and I left immediately after lunch; I had to get back to San Francisco to go to work. My last memory of that visit is seeing Sylvia piloting some sort of cart as she gave her guests a tour of the property, Leonardo da Vinci tearing off after them.

I visited Sylvia a couple more times over the summer in connection with the proposed cover. I knew the painting I wanted to use as soon as I saw it—*Good-bye* (2011), a yellow sky with a number of floating, beribboned hands and a sort of solar eye in the upper-right corner—but I snapped a few others to try just in case. During one of these visits, Bill was well enough to have lunch with us and he was in fine form, telling "war stories" about his platoon of cryptographers on Guam, like calling cadences in obscure languages as they marched, much to the consternation of their sergeant. It sounded like the premise for a military-themed sitcom, cryptographers on Guam and the regular-army sarge in charge of them. My other object during these visits and various email exchanges was to persuade Sylvia to record an interview about her art and life, which she was extremely reluctant to do. She

seems to have a congenital aversion to talking about herself, and I even resorted to such speeches as, "You want people to care about your art when you're gone, you want your paintings to survive and be shown, not stay tucked away in some museum's storage, it's not too early to start working on your reputation," all of the art-world sort of reasoning she clearly couldn't give a fig about. If I began making any progress, I think it had more to do with the fact that I was a poet myself rather than a straight-up art critic; she liked poetry—especially Housman!—and was suspicious of art criticism.

In October 2012, Sylvia traveled to Mexico City for the opening of *In Wonderland* at the Museo de Arte Moderno. It was a big to-do with government officials, national press, the whole works. Her inclusion at the opening, she tells me, was an afterthought; really, this was a historical show, Kusama famously doesn't travel, and Fein's own survival to so advanced an age was an accident of history that hadn't been planned for. Nonetheless, her unexpected presence caused a bit of a sensation among reporters and museumgoers, and she sat for numerous interviews and signed innumerable catalogues. All this I would learn a few months later; I didn't hear from her on her return, and I should've known better than to wait for her to call, even though that's how we left it. She was too reticent for that, but at the same time, I didn't want to apply undue pressure. I figured she was busy with Bill and I was also running around, writing a few different pieces. It was probably February by the time I called her to check in about the galleys for Lisa Jarnot's selected and I didn't get to see her again until April, when I brought her copies of the finished product. Bill was essentially bedridden at this point, though Sylvia seemed a little less stressed than she had a few months earlier; she had help from her neighbors and from hospice workers, whereas before she seemed to be shouldering the entire burden herself. But now she had a little time to think

and could fill me in on the Mexico trip, and she even had a plan: she wanted to record an interview about her time in Mexico in the '40s. She showed me tantalizing glimpses from a thick scrapbook of those charming miniature '40s snapshots and other ephemera from her original stay there, and her recent return had obviously fired her imagination in terms of the importance of the place in the development of her art. This, she insisted, was the real information about her as an artist and a person that hadn't been recorded.

We fixed the date, two weeks into the future, and toasted with a glass of a red vinho verde I'd brought. Unbeknownst to me, she loved vinho verde and had never come across the red, whereas I'd only just found it myself in San Francisco at a tiny grocery near Suzanne's apartment. Sylvia's delight in this coincidence seemed to portend great things. Meanwhile, I was most impressed with the paintings surrounding me. *The Lady with the White Knight* had been hung in the kitchen, as though a talisman; having protected Bill during the war, perhaps it could ward off death in the present circumstance. There were also new paintings, in particular her most recent, not yet varnished, a deep black cosmos in which hovered a pair of blue eyes, streaming tears. It was heartbreaking, yet the fact that she was able to paint, and paint so powerfully, was an encouraging sign.

The day before our scheduled interview I called Sylvia to confirm. She was surprised; hadn't I received her email? I hadn't. Inexplicably, this email, datestamped May 6, wouldn't arrive in my inbox until May 26, well after this conversation.

"Bill died. My white knight has gone to heaven."

I know I said the things you say when you hear someone's loved one has died but really, what could I say? The length of their union is so far beyond my ken there's nothing I could offer. I've been to see her once since then, but we've put the Mexico interview on hold for the

moment. It's too much right now. But she's still able to paint, the most recent picture I've seen being a dark, semi-abstract willow tree on a black background in memory of Bill, as powerful a portrait of dejection as I've ever stood before. Yet too, the change in tone from the grief-driven works painted before his death makes me think she'll endure even this.* I'm hoping we'll get back to the Mexico interview one day, but in the meantime I've written this.

2013

* Fortunately, I was right. A few months after I finished this piece, I received word that Sylvia was mounting a retrospective, *Surreal Nature*, focusing on the past ten years of work, at the Krowswork Gallery in Oakland. I wrote a piece on her and the show that wound up on the cover of the *San Francisco Bay Guardian*: www.sfbg.com/2014/01/14/secret-life-sylvia-fein. The opening, January 18, 2014, was packed with people; I was truly astonished at the degree of interest the story helped generate. If you can be said to be starting a new chapter in your life at age 94, I believe Sylvia is doing just that.

PHILIP LAMANTIA AND ANDRÉ BRETON

To him the meaning of an episode was not inside like a kernel but outside, enveloping the tale which brought it out only as a glow brings out a haze, in the likeness of one of those misty halos that sometimes are made visible by the spectral illumination of moonshine.

—Joseph Conrad, "Heart of Darkness"

That the standard biography of André Breton by Mark Polizzotti, which has all the *appearance* of being exhaustive, nonetheless excludes Philip Lamantia is a disservice not only to both poets but to the reader as well. For surely the reader would be interested to learn that, during his Second World War exile in the United States, Breton admitted but one American poet into the ranks of surrealism—let us not count Charles Duits, who wrote in French and receives ample coverage—that this poet was only 15 at the time, that he went on to become one of the major poets of a generation that includes Creeley and Duncan, O'Hara and Ashbery, and that he was still alive and living in San Francisco at the time of the bio's original publication. Two years later, City Lights would issue Lamantia's *Bed of Sphinxes: New & Selected Poems 1943–1993* (1997), containing the poet's own account in "Poem for André Breton":

When we met for the last time by chance, you were with Yves Tanguy whose blue eyes
were the myth for all time, in the autumn of 1944

FACING: Philip Lamantia and Garrett Caples, ca. 2000. Photograph by Jeff Clark.

Daylight tubes stretched to masonry on Fifth and Fifty-Seventh in the logos of
onomatopoeic languages of autochthonic peoples
Never have I beheld the Everglades less dimly than today dreaming the Ode to André
Breton, you who surpassed all in the tasty knowables of Charles Fourier
Only the great calumet pipe for both of you We are hidden by stars and tars of this time
No one had glimpsed you great poet of my time But the look of your eyes in the horizon of
northern fires turning verbal at Strawberry California
the Sierra Nevada seen from Mount Diablo on the rare clear day is enough of a gift to hold
up over the rivers of noise
Metallic salt flies free
that "the state of grace" is never fallen
that the psychonic entities are oak leaves burnished with mysteries of marvelous love
whose powers wake you with the glyph of geometric odors flaring in the siroccos
about to return to Africa
Mousterian flint stones caress the airs of Timbuctu as I turn a corner of volcanic sunsets
from the latest eruption of Mount Saint Helens

Being a poem, "Poem for André Breton" compresses the events that triggered it almost entirely out of sight in favor of evoking Breton's aura. Its intensity speaks for itself, and I have no doubt the poem provides more valuable testimony about what Breton was like "in the flesh" than a literal description could. Yet the particulars of their encounter are worth telling, so I feel compelled to record at least some of what I've heard—or misheard—about the meeting of André Breton and Philip Lamantia.

In an interview with David Meltzer in *San Francisco Beat* (2001), Lamantia gives the following details:

I was turned on to Surrealism through a great Dalí retrospective at the San Francisco Museum of Art (now SFMOMA), followed by an equally marvelous exhibition of Miró. Within weeks I had read everything available on Surrealism that I could get from the public library. There wasn't much: David Gascoyne, the premier British Surrealist poet—whose Short Survey of Surrealism *was superb—Julien Levy's* Surrealism, *Georges Lemaître's* From Cubism to Surrealism in French

Literature (he was teaching at Stanford), and, finally, the discovery of the luxurious New York Surrealist review, VVV—two issues edited by Breton and friends—which I found in the tiny but ample no-loan library at the museum. In almost no time I had a dozen poems ready for publication and sent some to View: A Magazine of the Arts, *which was edited, in New York, by the only important American poet who was plausibly Surrealist, Charles Henri Ford. In spring 1943 my poems were featured on one of* View's *large-format pages. On the cover was a photograph by Man Ray.*

. . . It was just after this that I discovered VVV's *whereabouts and sent other poems there to André Breton. He wrote, accepting three poems and requesting a letter from me "clarifying" my relation to Surrealism. Acceptance by the man I fervently believed the most important poet and mind of the century led to my decision to quit school and take off for New York. I arrived in April 1944 in Manhattan.*

Between the interview and the poem, we're left with a roughly eight-month window of 1944, during which Lamantia and Breton met exactly three times. The first meeting occurred in the offices of *View*, located on the top floor at 1 East 53rd Street, swank digs, in other words, complete with a small antechamber gallery where Lamantia met a young Jackson Mac Low. Unlike *VVV*, *View* was well-heeled and could offer Lamantia a job, most of which consisted of wading through and rejecting piles of unsolicited MSS; Ford claimed Lamantia as a discovery, and, apparently, with the exception of incarcerated murderer turned Christian Scientist Joe Massey, Philip was the only poet to emerge from those very same piles and be published in *View*. The magazine had taken the further step of announcing in its December 1943 issue that View Editions would bring out "*First Poems* by Philip Lamantia with a cover by Max Ernst." He was being "launched in literature," as the phrase went, which, for his parents, put a reasonable face on the otherwise mad proposition of letting their now 16-year-old, expelled from high school poet of a son run off and join the surrealists. That Breton lent his imprimatur to the book project is evident

both from the fact that he'd already accepted some of the poems for *VVV* and from the choice of Ernst as artist (though by the time of Lamantia's actual arrival, Ernst and Breton had fallen out). Announced for the same series of View Editions, moreover, was a bilingual selection of Breton's own verse, *Young Cherry Trees Secured Against Hares*, with a cover by Marcel Duchamp. This volume in fact occasioned the first meeting between Breton and Lamantia, who was working in the office when Breton arrived to sign the contract with Ford. Breton was visibly pleased to meet Philip at last, though they could only communicate through Ford, as Breton spoke no English and Lamantia no French. The meeting was brief—clearly Breton was making his rounds—but it served to establish personal contact between the poets, leading to their second, most substantial encounter.

Through surrealist channels it was arranged that Breton and Lamantia would dine together, in private, save for the presence of art and music critic Léon Kochnitzky—a mutual friend as well as a colleague of Breton's at the Office of War Information—to act as interpreter. The significance of this meeting can be gauged by the fact that Breton is usually portrayed as over-aloof from the art milieu during his stay in New York. The introduction to an anthology of *View*, for example, cites Édouard Roditi, translator of *Young Cherry Trees*: "Surrealism proper, Roditi reminds us, was a closed society. 'One must be invited to join, and we never sought admission.'" Maybe you needed the right key. Suffice it to say, an audience alone with Breton was rare, generally reserved for old friends, important fellow exiles, or, inevitably, new surrealists. For his part, Breton wanted to further sound Lamantia's purchase on surrealism as well as answer any questions the younger poet may have had about it. As for Lamantia, he thought Breton was "the most important poet and mind of the century"; enough said. In 1944, Breton was 48 years old. Photographs of him

at the time reveal the combined effects of exile, poverty, and war short-ages; he has shed much of the heft he exhibits in late '30s photos, and his hair has taken on a tempestuous wave the like of which cannot be seen in photos dating from any other period of his life. It is this lean Breton we must imagine rushing into the now-forgotten restaurant, some minutes late, with a flourish of courtly apologies. He seats him-self and focuses his considerable powers of attention on the young poet opposite him. At least two documents from the period record La-mantia's appearance: the standard surrealist mugshot, age 15, pub-lished in *VVV* alongside his letter of "clarification," under the title "Surrealism in 1943"; and, even closer in date, two shots of him, age 16, walking beside Maya Deren in her film *At Land* (1944). The very Rimbaldian image; I suspect Breton was pleased.

Think of the two or three best conversations of your life and imag-ine the difficulty of distilling into written form an account that con-veyed the tenor of their nuances with any degree of accuracy. Laman-tia never published a description of his dinner with André Breton and, being at an even further remove 70 years later, I can't hope to repro-duce the substance of their dialogue. Yet I confess I couldn't help pressing Philip on the subject once I knew him well enough to do so. Invariably such inquires occurred seated around the "the great calu-met pipe" of line 4 of "Poem for André Breton"; "calumet" derives from the Greek word *kalamos*, and with this reed as its pen, my mem-ory doubtlessly contains certain distortions. Details bleed into each other. But as I recall he told me they talked about the war, of course, and much about poetry. Being surrealists they dwelt on the relation-ship of poetry to desire, for the author of *Nadja* felt a deep sympathy with the fevered eroticism of the "BIANCA" section of "Touch of the Marvelous," one of three poems by Lamantia published in *VVV*. What I remember more clearly are Lamantia's observations on Breton him-

 self. Like many commentators, Philip remarked Breton's huge gesticulating hands and his immense leonine head, both animated by a magnetic personality that bridged their linguistic divide. Indeed this raises what, for me, is the most intriguing detail of the encounter, for while Léon Kochnitzky did translate back and forth between the two poets, Lamantia nonetheless formed the distinct impression that Breton understood English quite well, judging by the immediacy of the older poet's reactions. I mention this because Breton is often faulted for not learning English during his time in NY, as if this failure were indicative of some typically French sense of superiority. Yet the breadth of his reading alone—from Scrutator's 1910 *Occult Review* article on "Automatic Drawing" that Breton cites in "The Automatic Message" to the plays of J. M. Synge in *The Anthology of Black Humor* to the poems of Lamantia in *VVV*—indicates a more than functional level of English comprehension. Breton was no linguistic chauvinist and, if he refused to speak English, I imagine it's because he couldn't express himself as André Breton in another tongue. It's quite possible to have extensive passive knowledge of a language yet be unable to generate the least statement of intellectual import in it. As Breton endured a painful exile to preserve his freedom of expression, what right have we in retrospect to demand he sacrifice it? If he wanted to talk to you, in any case, he found a way, and I can't imagine this is the last time the initiator of a movement as international in character as surrealism resorted to some such expedient in order to communicate with an artist in whom he had an interest.

Of the third and final meeting between these poets, we have the testimony of "Poem for André Breton," in which Lamantia provides the location (5th & 57th) and the approximate date, "autumn of 1944." From August 20 to October 20 of that year Breton was on the Gaspé Peninsula in Quebec, composing *Arcanum 17*, so in all likelihood the

encounter Lamantia recalls occurred in November. He could see them coming from a block away, talking with animation, so complete their absorption in each other they might have been walking through an uninhabited forest, with no expectation of encountering another intelligence. Yet as they drew near Breton suddenly stopped short, exclaiming, to the mild astonishment of Tanguy, *C'est le jeune poète américain!* as he thrust out a massive hand for Lamantia to clasp. Chance encounters delighted Breton, and the remainder of this one was spent in a quasi-silence of Chaplinesque courtesy, a brief island of calm on the perpetually streaming sidewalk of Manhattan pedestrians. Breton, Lamantia said, had the air of a magician, unveiling mysteries. He introduced Philip to Tanguy, who displayed the vague glimmer of one who had been informed of and then had promptly forgotten about the existence of the young poet. Though Tanguy spent most of his time in Woodbury, CT, his art is reproduced in the same issue of *VVV* as "Surrealism in 1943," itself facing an image by his friend Enrico Donati, so one presumes at least a faint awareness on his part. It's no doubt a tribute to the depth of their penetration that his eyes impressed themselves so firmly in Lamantia's memory, if you consider the flame-like appearance of Tanguy's hair at the time. Perhaps these flames were absorbed by Breton's own aspect, as Lamantia sees "the look of [his] eyes in the horizon of northern fires turning verbal at Strawberry California" in line 5 of "Poem for André Breton." Being the focus of Breton's magnetic enthusiasm was intense. I'm almost positive Philip said something to the effect that it felt like the sun beaming down on you. If so, this would square not only with descriptions of Breton left by other writers but also with Lamantia's own imagery. The word "imagery" is misleading here, for while it is true line 5 characterizes "the look" of Breton's eyes in terms of another apparently visual phenomenon—I say "apparently" because the poet spec-

ifies the image is "turning verbal"—the resulting *analogy* cannot itself be characterized in visual terms, for the resemblance it posits is not physical but metaphysical. Another way to put it might be to say that the surrealist image is by definition analogical—Reverdy's "bringing together of two more or less distant [yet, he immediately adds, *pertinent*] realities"—but not necessarily visual, in contradistinction to the idea promulgated by language poets and deep imagists that surrealism is primarily oriented toward visual imagery.

The three meetings between André Breton and Philip Lamantia were, of course, of inestimably greater significance to the life of the younger poet. He was but 16 when they met, while Breton was an international figure of several decades' standing, connected with many of the greatest artists of the time. Indeed, held against the background of Lamantia's biography and previous work, "Poem for André Breton" reflects a sense of this proportion, insofar as the majority of the poem refers specifically to Lamantia's own experience. That is, he reads Breton into various landscapes of talismanic importance to his own poetics, such as "Mount Diablo"—site of the creation of the world in Pomo Indian legend—which figures in *Meadowlark West* (1986). In the tenth and final line of "Poem for André Breton," the dedicatee seems to disappear entirely, yet I can't help but feel Breton is submerged in the image of "volcanic sunsets," erupting in slow moments to transform the world below. Given Lamantia's considerable achievements subsequent to their brief personal contact, the indication that he sees Breton even as he reviews his own intellectual interests is the most profound homage he could pay to the founder and chief theoretician of the surrealist movement. In a sense, "Poem for André Breton" embodies the very reason why even in periods of dissidence Lamantia has always been the most authentic voice of surrealism in American poetry since his appearance in *VVV*. For he has shown the

uncanny ability to assimilate prior surrealist innovation and from there generate anew. I use the word "uncanny" here advisedly, for you must have a certain faculty for analogical reasoning in order to grasp those surrealist principles that can't be fully articulated and that fundamentally resist systemization. Surrealism, it can't be said enough, is not a style, and those who absorb it as such are quickly left holding so many awkward antiques. I remember Philip reflecting once on his good fortune to have been exposed to both Dalí and Miró during his initial period of discovery, for it impressed on him an immediate awareness that surrealism isn't a matter of aesthetics. While Breton's influence on Lamantia is substantial, for example, it hasn't chiefly manifested itself on the stylistic level, though the final two lines of "Plumage of Recognition" (also in *VVV*) seem to me his most Bretonian ("I am at a house built by Gaudi / 'May I come in?' "). More often, the agonistic violence of Lamantia's poetry, as well as his persistent concern with religious and mystical experience, recalls for me the work of Georges Bataille. And while Breton probably wouldn't have condoned an overtly Catholic book like *Ekstasis* (1959), it would be a mistake, I think, to assume a categorical difference between these poems and their near-contemporaries in *Narcotica* (1959) and *Destroyed Works* (1962). Surrealism will not be bound by dogma—not even on Breton's authority—and if you can't enlarge its domain in any appreciable fashion, of what use are you to surrealism?

Though admittedly of far less personal importance for André Breton, the story of his encounter with Philip Lamantia seems to me of sufficient biographical significance to warrant inclusion in any definitive account of Breton's life. The objection that Ford, not Breton, "discovered" Lamantia is without force, insofar as the sequence in which they published him was dictated largely by Philip's circumstances. It was only after submitting work to *View*, a magazine widely available

on newsstands, that he located the much more occulted *VVV*. In his now-lost reply to Lamantia's initial letter, Breton regretted not having been able to debut the young poet in *VVV*, which, while undoubtedly indicative of his rivalry with his sometime collaborator Ford, also suggests the extent to which he considered Philip the genuine article. Breton's ultimate presentation of Lamantia in *VVV* is restrained but unmistakable; in addition to the Donati image en face, the title "Surrealism in 1943" appearing above the letter of clarification plainly claims Lamantia for surrealism by permitting him to speak for surrealism. As the letter's nominal addressee, Breton in effect endorses it, not so much in the position of arbitrator of surrealism as in his equally characteristic posture of *listener*. This aspect of Breton has, I think, been underappreciated by subsequent commentators. Ford, it is true, had the literary acumen to recognize the accomplishment of Lamantia's *First Poems*, though the volume of that title would never appear due to a break between them. (Reorganized under the title *Erotic Poems*, it would be issued in Berkeley by Bern Porter in 1946, after Lamantia returned to San Francisco.) Nonetheless, the fact that he took Lamantia seriously enough to solicit a statement of his views on surrealism says a lot about Breton. The tendency among adults, of course, is to treat the prodigy as a child, an inarticulate savant, not a source for consultation, and I can well imagine this contributes to the consternation and rancor which smolder behind statements about Breton by those adult poets he didn't consult on the same subject. Breton was truly alive to the revolutionary possibility of Rimbaud, and not without cause; the first English-language surrealist poet, David Gascoyne, published his first book at 16 and wrote his *Short Survey of Surrealism*, the first book on the subject in English, at 19. But as Breton also writes in "Letter to a Young Girl Living in America" (1952), in order "to appreciate" Rimbaud, "one must have left one's whole child-

hood behind," and it's no accident that, in the arrangement of Lamantia's poems, Breton gives pride of place to "The Islands of Africa," dedicated "To the memory of Arthur Rimbaud, the rebel and the seeker." Lamantia's poetry had placed him precociously beyond childhood, and it was on such terms that Breton chose to engage with him.

I began this piece in February 2004 without quite realizing that month marked the 60th anniversary of Philip Lamantia's appearance in *VVV*. Only after quoting his account in the Meltzer interview did it occur to me to track the sequence of events from October 8, 1943—the date of Lamantia's letter of clarification—through his April 1944 arrival in Manhattan. As the piece took shape, the U.S. government—with the craven participation of a French government desperate to appease it—began facilitating a coup d'état in Haiti against President Jean-Bertrand Aristide, a populist chosen by over 90 percent of his country's electorate, quite unlike the 2nd Bush administration which sought his departure. The rebels were composed of bloodthirsty gangs from the previous coup plus thugs from the Duvalier era, supplied with American weapons funneled in through the adjoining Dominican Republic. On February 29, in one of the more brazen moves of its brazen career, the Bush administration had Aristide and his family kidnapped at gunpoint and held prisoner for two weeks in the Central African Republic, a country whose human rights record is so bad we don't even have (official) relations with it. Aristide subsequently went into exile in South Africa. As Kim Ives and Ansel Herz later reported in *The Nation*, the Bush administration, and the Obama administration after it, spent "tens of millions of taxpayer dollars" unsuccessfully trying to frame Aristide for a crime—any crime—while preventing him from returning to Haiti for seven years. Though Aristide finally returned in March 2011, and still enjoys wide support

among the people, Haiti remains occupied by UN forces and devastated by the 2010 earthquake.

As these events unfolded I couldn't help but relate them to André Breton, particularly the Breton of exile and *Arcanum 17*, who made such brief but decisive contact with Lamantia. About a year after their final encounter, Breton, en route to the uncertainty of post-liberation Paris, stopped off in Port-au-Prince to give a series of lectures at the invitation of Pierre Mabille, a lifelong friend and fellow surrealist who was then France's cultural attaché to Haiti. In his introduction to the anthology *Refusal of the Shadow: Surrealism and the Caribbean* (1996), Michael Richardson summarizes the events that ensued:

Breton's talks had a dramatic effect . . . and were partially responsible for the fall of the government, with far-reaching consequences. The government's fall led to the election as president of Dumarsais Estimé, a popular, progressively inclined and relatively honest politician. Estimé was a black, the first non-mulatto president since the [1915–1934] US occupation [of Haiti] and also the first not to be a pawn of US interests (the United States retained control of the Haitian treasury until 1947). His attempt to assert the independence of Haiti, breaking dependence on the United States and the power of the mulatto élite, failed, and he was overthrown in a coup d'état in 1948 which restored mulatto power.

In "André Breton and Port-au-Prince," reprinted in the same anthology, René Depestre offers an eyewitness account of Breton's role in these events. On December 20, 1945, to a packed theater audience composed of intellectuals, university students, and assembled dignitaries—including U.S.-sponsored dictator Élie Lescot—Breton gave a lecture on surrealism in which he praised the "lyrical element" of Haitian culture and the "inalienable enthusiasm for liberty" of its people. The audience was electrified. Depestre and his fellow editors printed the lecture in a special year-end issue of their student newspaper, *La Ruche* ("the beehive"). Never was a publication more aptly named, for as soon as Lescot confiscated the issue and jailed the edi-

tors, the students staged a strike that led to a general strike that brought down the dictatorship. In the interim between the fall of Lescot in January and the election of Estimé in August of 1946, Breton and Mabille were expelled from Haiti by the military junta which then ruled and which would return to overthrow Estimé in 1948. After a brief period of mulatto rule, François Duvalier would stage a U.S.-backed coup in 1956.

"What Breton said was hardly incendiary," Richardson remarks, yet clearly it was. While Breton himself would later point out that "the social forces that caused [the revolution] were all in place and would doubtless have become manifest if he had not visited the island," the fact that he sparked the Haitian Revolution of 1946 bespeaks the same incendiary quality Lamantia credits with kindling his own endeavors in "Poem for André Breton." *Refusal of the Shadow* provides further testimony on this aspect of Breton from Paul Laraque—a Haitian poet who heard Breton's lecture and met with him privately—in "André Breton and Haiti":

With leonine head, a mane of sun, Breton stepped forward, a god begotten by lightning. To see him was to grasp the beauty of the angel of revolt. The shadows became sources of light. The storm of life was shot through with bolts of light whose flashing blades, burst from the scabbard of night, tore through the veil of time and restored the lost paradise of innocence to love. Putting all mysticism aside, one then felt that mankind's supreme ambition is two-fold: to banish hell from the earth and to integrate heaven into it.

Some people reproach Breton with having been too intransigent; others with not having been intransigent enough. What is certain is that he was, in all senses of the word, incorruptible; even whilst being very broadminded, he never to my knowledge compromised his principles.

For us the surrealist coming to consciousness corresponded to the revelation of Breton's personality, spiritually by the mediation of his works but above all, in a way that cannot be gauged, by an entirely physical attraction. My own debt to Breton lay, above all, in his having brought me lucidity.

I find these remarks extraordinary, all the more because I can't imagine a black poet saying this about any other white poet of the period. Certainly none of Breton's Anglo-American contemporaries could elicit a like response. Kenneth Rexroth—who, on Lamantia's return to San Francisco, became his poetic mentor for the next few years—made this point loud and clear in "Why Is American Poetry Culturally Deprived?" (1963):

> *Now, it so happens that if any international community recruited English and American poets in the interbellum period, it was fascism—Pound, Yeats, Eliot are on record. This is not because American poets are exceptionally vicious men, although some of them are and have been. It is simply because fascism is so much more easily assimilated by simple and emotionally unstable minds—you don't have to read so many books.*

If this remark sounds caustic, we would do well to recall that for the entire period of Anglo-American high modernism—roughly corresponding to the first half of the 20th century—"America," as the U.S. styles itself, was officially an apartheid state. Hatred of the other was our cultural norm; discrimination against blacks and Asians was codified in various laws, and this by no means exhausted the varieties of American bigotry. Both Pound and Eliot, for instance, were candidly anti-Semitic; Eliot couldn't even stand Irishmen (neither, it seems, could Yeats). There's certainly no candidate for the type of respect Laraque pays Breton among these cosmic bumblers. Yet Rexroth's account of the reactionary tendencies in American poetry has gone largely unheeded by the contemporary avant-garde. I hear talk of rehabilitating Pound's poetics in the name of a vague liberalism about as often as I hear Breton characterized as "fascist" for some real or imagined intransigence. Both sentiments—I can't really call them "ideas"—reveal a fundamental obtuseness in the prevailing discourse

around poetry, for the conclusions they draw are precisely the opposite of those history supports.

Irrespective of their professional degree of anti-romanticism, and whether it be stamped "neo-classical" or "avant-garde," most poets I've encountered subscribe to some version of Shelley's "poet as unacknowledged legislator," usually though by no means always rooted in a deeply exaggerated sense of their own importance. They romanticize themselves; indeed, who doesn't? The secret dream of these poets is that their words alone might move other people to action, not through argument so much as force of conviction. The potential pitfall of this desire was evident to Rexroth. Poets tend to enjoy reading, so when Rexroth points out a deficiency in this department, he refers not to quantity but kind. The very pleasure poets seek in the act of reading renders many of them incapable of pursuing any topic to its necessary depth, because doing so would likely compromise their enjoyment. They might have to read some pretty boring shit in order to get the information they need to take an informed position. Their own emphasis on aesthetics, poetics, the formal aspect of writing leaves them vulnerable to oversimplification and elegance where substance must prevail and prone to purely theoretical articulation where particularity and application are all that matter. For all its theoretical politics, the present Eurocentric avant-garde displays little curiosity about the actual mechanisms of American imperialism that dictate our day-to-day life in the form of the ubiquitous crap we make other peoples make for us for next to nothing. Such realities are too ugly and complicated for theory, and theory's shown itself unable to cope after 9/11. When the twin towers collapsed, a lot of elegant ideas went with them.

Without conscious intent or explicit appeal, his words ignited a

smoldering revolution, and I sometimes wonder if this incendiary aspect of André Breton hasn't contributed to the warmth with which he's denounced, even today, by poets and intellectuals who groan under the weight of their political impotence. Breton provokes a seemingly personal rage in people who weren't even born during his lifetime and have barely read a line he wrote. They're content with secondhand assessments of him by *Tel Quel* writers whose work appeared in English translation long before most of his major books. They hold him responsible for Crevel's suicide or Artaud's madness and they resent his fleeing the occupation of Paris instead of remaining to face certain death as the charismatic leader of a semi-organized, self-declaredly anti-Nazi movement. Breton opposed authoritarian regimes throughout his life, condemning Stalinism in the '30s, for example, when everyone else on the left worshipped it. He wasn't satisfied with ideological alibis. "Yes," he wrote in "Prolegomena to a Third Manifesto of Surrealism or Else" (1942), "I can be captivated by a system, but never to the extent of not wanting to see the *fallible point* of what a *man like myself* tells me is the truth." This statement reveals a crucial difference in principle between surrealism and Anglo-American avant-garde aesthetics even as it suggests why surrealism was the one genuinely multicultural movement within modernism. Breton's rigorous interrogation of the self, in other words, set the tone for extraordinary dialogues with the other, marked not by co-optation but by genuine exchange. Thus there were black surrealists, Asian surrealists, Arabs, Jews, Serbs, Slavs; in his post–WW2 collection of essays *La Clé des champs* (1953), Breton would proclaim Haitian writer Clément Magloire-Saint-Aude the supreme surrealist poet of his time. Contrast this with, say, the Académie française, whose first black member—surrealist fellow traveler and former president of Senegal, Léopold Sédar Senghor—was elected in 1983. In a period of rampant

xenophobia punctuated by two world wars, Breton was a beacon of resistance in the name of the true marvelous of humanity. Yet France couldn't even get it up to preserve his apartment, intact for over 30 years after his death and, judging from photographs, as authentic a corridor to the marvelous as Simon Rodia's towers or the grottoes of Facteur Cheval. It's a sign of the small esteem in which he's held in the culture to which he gave so much.

2004, 2012

MYSTERIES OF THE SIX GALLERY

PHILIP LAMANTIA, JOHN HOFFMAN

1

At the October 7, 1955, "Six Poets at Six Gallery" event in San Francisco at which Allen Ginsberg debuted "Howl," the first reader of the evening, excluding introductory remarks by emcee Kenneth Rexroth, was Philip Lamantia. Among the performances that night—which also included readings by Michael McClure, Philip Whalen, and Gary Snyder—Lamantia's was singular in that he read none of his own work. Instead he read the poems of his best friend, John Hoffman (1928–1952), who had died of unknown causes in Mexico three years earlier. While Lamantia's desire to pay homage to the life and work of his friend is understandable, and the self-effacement of his gesture characteristic, the fact that he didn't read even one of his own poems is curious, and in later years, when pressed for a reason, he tended to be evasive. A few years before his death, however, he disclosed his motives to John Suiter, in an extensive interview Suiter would draw on for his book *Poets on the Peaks: Gary Snyder, Philip Whalen & Jack Kerouac in the North Cascades* (2002).

In Mexico, several months before the Six Gallery reading, during a near-death experience induced by a scorpion bite, Lamantia had

undergone what he sometimes considered a mystical "conversion" to Catholicism, in which he had spontaneously "cried out for the Virgin Mother to save his life." Of Sicilian American heritage, the poet was unsurprisingly already a baptized Catholic, though he said his family wasn't particularly religious, he'd only fleetingly attended Catholic school, and he'd considered himself an atheist since his teens. Embracing Catholicism for Lamantia therefore implied a change in his life, which in turn necessitated a change in his poetry, for while generally not anecdotal or literally autobiographical, his poems almost without exception were products of fervent beliefs. Issues that remain abstractions for most people had a vital immediacy to him, yet too, his beliefs could alter radically over time, with consequent revaluations of his prior poetry. Lamantia thought nothing of condemning a whole body of his own work on the basis of its perceived philosophical, moral, or spiritual failings. Thus we find him in *Poets on the Peaks*:

"*I was going through a crisis of conversion and I couldn't write and I didn't want to read my old poems even though Rexroth said, 'Oh you should get out—All the poems that you wrote before, you can't go on thinking that they were all mortal sins!'*" recalls Philip today. "*But indeed, I was sort of thinking that way—I wanted to withdraw.*"

Lamantia's desire to suppress his own writing was in many ways more typical than his desire to publish it, which accounts for his somewhat slender body of published work. Though a nationally known poet for over 60 years, beginning with his debut in *View* magazine at age 15, he only published six full collections in his lifetime—*Erotic Poems* (1946), *Ekstasis* (1959), *Destroyed Works* (1962), *The Blood of the Air* (1970), *Becoming Visible* (1981), and *Meadowlark West* (1986)—in addition to five selected editions and the notorious hybrid poetry/

prose pamphlet *Narcotica* (1959).* Though he endured periods of depression in which he didn't write, Lamantia still wrote much more than he ever published, and had even burnt a great deal of unpublished work sometime around 1960, an event alluded to by the title of his third book. Almost a decade of activity, from 1946 to 1955, was apparently destroyed at this time, apart from a few poems scattered in periodicals. With the poet's death on March 7, 2005—exactly seven months shy of the 50th anniversary of the Six Gallery reading—the question of what his poetry was like at the time seemed destined to remain unanswered.

Instead, however, began a process of elucidation. Found among his papers by his wife Nancy Joyce Peters was a typescript labeled: "TAU / Philip Lamantia / Bern Porter 1955." Taking its title from the Greek letter τ, an ancient Christian symbol for the cross, *Tau* is a collection of 17 poems, many untitled, only four of which were ever published: "Terror Conduction," "Intersection," and "The Game" (retitled "Man Is in Pain") all appear, with minor variations, in Lamantia's second book, *Ekstasis*, while "The Owl" was printed in his *Selected Poems*, though for chronological reasons, the poem was placed in the "Ekstasis" section of his later selected *Bed of Sphinxes*. The appearance of Bern Porter—publisher of *Erotic Poems*—on the title page, along with acknowledg-

* By "five selected editions" I mean his three "selecteds"—*Selected Poems 1943–1966* (City Lights, 1967), *Penguin Modern Poets 13: Charles Bukowski, Philip Lamantia, Harold Norse* (Penguin, 1969), and *Bed of Sphinxes: New and Selected Poems 1943–1993* (City Lights, 1997)—as well as the two editions of *Touch of the Marvelous* (Oyez, 1966; Four Seasons, 1974), which more properly speaking are the collected poems of his first surrealist period (1943–46). Lamantia was also in the habit of introducing previously uncollected poems in these editions, such as "Blue Locus" in *Selected Poems*, "Egypt" in *Bed of Sphinxes*, or "To Henry Miller . . ." in the second *Touch of the Marvelous*.

ments, copyright notice, and a page of instructions regarding the book's design, suggests *Tau* had reached an advanced stage of preparation by the time it was withdrawn, an impression confirmed by a listing of the then-forthcoming title in the back of *Graffiti*, a book of poems by Lamantia's first wife, Goldian "Gogo" Nesbit, published by Porter in 1955. The typescript of *Tau* also contains at least two subsequent layers of undated handwritten revisions. While he left a surprisingly considerable body of uncollected and unpublished poems among his papers, *Tau* is the only example of a discrete, book-length manuscript selected and arranged by Lamantia himself, yet remaining unpublished. The year 1955, of course, suggests these are the very poems he *didn't* read at the Six Gallery reading, a supposition confirmed in a letter to Lamantia from Goldian Nesbit, written during the summer of that year. The letter is clearly a response to one from Lamantia in Mexico detailing the circumstances of his conversion to Catholicism and the relation of this event to his poetry. In it, we find Nesbit imploring him not to destroy "this beautiful manuscript," and it is no doubt to her intercession that we owe the survival of these particular poems.

In the absence of more precise information about the book's composition in the form of draft material, *Tau* would seem to contain Lamantia's selection of those poems written after 1946 and before his conversion in 1955,* a time that includes the period of his closest as-

* Having had the opportunity to work on Lamantia's *Collected Poems* for the University of California in the years since first publishing these remarks in 2008, I should note that the composition history of Lamantia's books after *Erotic Poems* and before his 1967 City Lights *Selected Poems* is murky at best and obviously complicated by the aforementioned holocaust made of his unpublished work in 1960. My best guess is that *Tau* was largely composed between 1953—the year of his Koran-inspired vision referred to by Allen Ginsberg in "Howl" (see footnote on page 123)—and 1955, the year of his conversion to Catholicism. As he writes in a textual note to that vol-

sociation with Rexroth. The importance of this period for Lamantia cannot be overstated, for hitherto his education in poetry as such was scant. If I recall his stories correctly, Lamantia started writing poetry in middle school under the tutelage of a flaming-haired Irishman named Griffin, whose English classes consisted purely in the reading and discussion of poetry and whose standing policy was that anyone who wrote a poem didn't have to do that evening's homework. The young Lamantia immediately launched himself into a *Rubáiyát*-like epic whose daily installments he would read to the class. Sadly nothing remains of this juvenilia, though it was evidently accomplished enough to impress the adults in his life with a real sense of his precocious talent. For the next couple of years his main poetic touchstone appears to have been Poe, until his fateful encounter with surrealism in 1942 through museum exhibitions of Dalí and Miró. Attracted by its commitment to social revolution at least as much as its creative manifestations, Lamantia began to write and publish his earliest mature poems in 1943 at age 15. In a very real sense, this early work draws as much on radio shows like *The Shadow*, comics like *Mandrake the Magician*, and the golden age of American cinema as on literature for inspiration, for his rapid passage from middle school poet to avant-garde surrealist precluded any formative period of wide reading and imitation in the art of poetry. This is not to suggest that he wasn't already a voracious reader, but rather that his previous reading had been devoted to other matters.†

ume, Lamantia composed *Ekstasis* from poems written during the 10-year period between 1948 and 1958, and the inclusion of the poems from *Tau* alongside indications from the "Destroyed Works" typescript like section 23's "FROM A BOOK OF MY TRAVELS" suggests he may have drawn other poems in *Ekstasis* from previously completed, no longer extant MSS.

 † Prior to his 1942 discovery of surrealism, for example, the young Lamantia had already visited the esoteric library of Manly P. Hall in L.A.—the first sign of a lifelong

It wasn't until his return from his youthful adventures among the war-exiled surrealists in New York City (1944–45) that Lamantia gained his first serious exposure to poetry as a form of art with its own history and traditions, partly by attending the lectures of Josephine Miles at the University of California–Berkeley but most decisively through his friendship with Rexroth. Rexroth's encyclopedic knowledge of poetry in a vast array of cultures, his prodigious recall, and his extensive library were an invaluable education for Lamantia in the art he would practice—periods of depression and destroyed work notwithstanding—for the rest of his life. After the European surrealists left New York and the movement failed to flourish in America, Lamantia was open to Rexroth's ideas about poetry, combined, as they were, with an interest in anarchist politics: a reaction, in other words, that wasn't reactionary. After their close friendship ended, however, particularly after he re-embraced surrealism in the mid-1960s, Lamantia regarded this period with much ambivalence, feeling Rexroth had led him away from his original source of creativity. Indeed, in what remains one of the most substantial accounts of his life, an entry in *Dictionary of Literary Biography*, vol. 16: *The Beats* (1982) written, with the poet's participation, by Nancy Joyce Peters, Rexroth is only obliquely indicated by a reference to Lamantia's late '40s involvement with "the San Francisco libertarian-anarchist circle, which was composed of former conscientious objectors, Russian and Italian anarchists, and left-

fascination with mysticism, alchemy, and the occult—while afterward he read literally everything written in English on surrealism at the time, most notably David Gascoyne's *A Short Survey of Surrealism* (1935), Julien Levy's *Surrealism* (1936), and Georges Lemaître's *From Cubism to Surrealism in French Literature* (1941). Worth noting in this regard too is the existence of a pair of the poet's childhood scrapbooks containing Sunday newspaper comics like *Ripley's Believe It or Not* and scenes from exotic locales, suggesting his interest in the marvelous predated his interest in poetry as such.

wing intellectuals, academics, and literati." Yet, near the end of his life, during his second Catholic period, or perhaps his first surrealist-Catholic phase, Lamantia looked back with gratitude and affection on his former mentor, warmly recalling his association with Rexroth in an interview for David Meltzer's *San Francisco Beat* (1999). As for Rexroth, he seems to have had only good things to say about his former protégé, going so far—in, for example, *American Poetry in the Twentieth Century* (1971)—as to claim that "a great deal of what has happened since in poetry was anticipated in the poetry Lamantia wrote before he was twenty-one."

In terms of his own poetry, *Tau* clearly develops out of what Lamantia sometimes called the "naturalistic" section of the two-part *Erotic Poems*, printed before, though written after, the visionary automatic surrealist poems of the second section. By *Tau*, naturalism has been dispensed with, leaving behind only an apparent austerity in comparison with the flow of images in his earlier work. Yet scattered throughout are a surprising number of neologisms reflecting his interest in *Finnegans Wake* (1939) and indicating his avant-garde proclivities are by no means extinguished. Reflecting too his deeper acquaintance with poetry's past, the poems of *Tau* are more self-conscious, representing Lamantia's first serious experiments with poetic form. Yet by this stage in his poetic development he is already incapable of mere student imitation. He continually gestures toward formal structures, only to break them with a violence quite unlike what is usually called "fragmentation" in poetry. When Lamantia inhabits a form, it melts from within, as in "The Owl," whose pattern of chorus-like repetitions at the end of a verse barely establishes itself before it becomes transformed, a theme-and-variation approach indicative of his interest in jazz at the time. Here we might note the manuscript of *Tau* contains a number of performance cues penciled in Lamantia's hand,

marking passages for silence, solos, etc., occasionally accompanied by musical notations, suggesting the poems may have been performed live during one of the jazz poetry readings he gave along with Howard Hart, Jack Kerouac, and musician David Amram.* The fact that these readings occurred in 1957, two years after the Six Gallery event, hardly precludes this possibility, given Lamantia's mercurial temperament. Some of *Tau* is in *Ekstasis*, so it's likely his sense of these poems' incompatibility with his Catholicism had abated with time.†

In retrospect it's difficult to see the discontinuity Lamantia once felt so strongly existed between *Tau* and *Ekstasis*, for the spiritual self-interrogation of the one seemingly flowers in the rapturous faith of the other. This is not to pretend I have any clear sense of the implications of the symbolism of "tau" as used within the volume.‡ The poems are deeply mysterious, doubtlessly drawing on his esoteric re-

* This is seemingly confirmed by an early draft of the prior publication acknowledgments of *Ekstasis*, which says "Many of these poems were publicly read at poetry and jazz spectacles for 1957–58 at the Brata Gallery, Circle in the Square (New York City) and the Labaudt Gallery and the Cellar (San Francisco)." The fact that this sentence was cut may suggest that more of *Tau* was contemplated for *Ekstasis* at one time.

† In conversation, Lamantia did once credit his friendship with Kerouac, a lifelong Catholic whose faith accommodated an enthusiastic interest in and practice of various tenets of Buddhism, with helping him relax his quite possibly self-destructive level of rigor in the immediate aftermath of his first conversion, during which he regarded his earlier poetic output as "mortal sins."

‡ Lamantia's interest in the tau cross continued beyond this period. As Nancy Joyce Peters points out, "Philip throughout his life preferred this cross because he felt it symbolized the true, mystical, esoteric religion he embraced, not the conventional accepted version of Christianity." We might also note that, while Lamantia was drawn to the Trappist order during his initial Catholic phase immediately following *Tau*, his primary interest in his later surrealist-Catholic phase was in Saint Francis and the Franciscan order, whose standard is the tau.

searches at the time, and resist immediate interpretation. While I don't wish to downplay the importance of his content—for if ever there was a poet who desired extra-literary communication with his readers, that poet was Philip—I also think Lamantia's poetry, like Yeats's, always comes through as poetry even when its references remain stridently opaque. In any case, the formal preoccupations of *Tau* would increase through *Ekstasis, Narcotica,* and *Destroyed Works,* and my sense is he viewed none of this work as surrealist. Yet it is hard to withhold the designation from the Artaud-influenced texts of the latter two volumes, or indeed from certain poems of *Tau,* which opens with an invocation of the concept of "Mad Love" so celebrated in Breton's book of that name. (Another *Tau* poem, "Shot Into The Sun," also appears to refer to Artaud: "Antonin spied The Bird / In pieces on a beak of crow.") Yet in his introduction to *Erotic Poems,* Rexroth puts his finger on the consistent quality of Lamantia's poetry that persists beyond his particular beliefs at any given time:

Your poetry . . . has a great drive and excitement that only comes with the conviction that what one has to say is of great importance and people had ought to listen. Although some of it uses the language, or at least the symbolic patterns of the unconscious, it is not that deadliest of all dull "made up" things: "unconscious writing." The force that associates the ideas is a conscious Eros and a vision of a world that is founded and ruled by Eros as ultimate power. It is for this reason that I do not see the vast difference which you do between the two sections of the book.

Writing from a perspective hostile to surrealism, Rexroth clearly has his own agenda here, not least of which is to put himself, rather than André Breton, at the root of Lamantia's development as a poet.* But

* Later, in *An Autobiographical Novel,* Rexroth will write George Leite, the editor of the important Bay Area little magazine *Circle* who introduced him to Lamantia, out of the picture, pretending to have met the then-teenaged poet through a high school English teacher.

however you feel about this remark, it contains an essential truth, for while his life and work can't be subsumed under any one category, love (or "Eros," as Rexroth would have it) is as fundamental a touchstone for Lamantia as you could specify, be it erotic love, love for humanity, or divine love. Lamantia always strove to do what he thought was the right thing to do, which, on October 7, 1955, at the Six Gallery, meant reading the poems of John Hoffman instead of his own.

2

My only sin is promiscuity —John Hoffman

But who was John Hoffman? The legend of this poet and his poems, heightened by his early mysterious death and the poems' long unavailability, was established by three related circumstances: the posthumous reading of the poems at the Six Gallery by Philip Lamantia; the lines in Allen Ginsberg's "Howl" alluding to the poet; and the depiction of the Six Gallery reading by Jack Kerouac in *The Dharma Bums* (1958).

The two lines concerning Hoffman in "Howl" (1956) are:

who got busted in their pubic beards returning through Laredo with a belt of marijuana
 for New York

and

who disappeared into the volcanoes of Mexico leaving behind nothing but the shadow of
 dungarees and the lava and ash of poetry scattered in fireplace Chicago

According to the annotated *Howl: Original Draft Facsimile* (1986), the first of these lines is based on an anecdote about Hoffman, though the note doesn't elaborate and the story never came up in the several conversations I had with Lamantia about his friend. The second line alludes, "poetically" rather than factually, to Hoffman's death at age 24 in Mexico, though the phrase "fireplace Chicago" refers to an ac-

count of the 1871 Chicago fire and has no biographical connection to Hoffman himself.

During his very last reading—an occasion devoted to Hoffman's life and work, held at City Lights Bookstore on September 20, 2001—Lamantia also cited Hoffman as the inspiration for the famous phrase from line 3 of "Howl," "angelheaded hipsters." This is neither confirmed nor contradicted by the annotated *Howl*, which only glosses that line's "starry dynamo" and "machinery of night." In the previous line, said hipsters are "dragging themselves through the negro streets at dawn looking for an angry fix," and while the annotations indicate this is based on Herbert Huncke's adventures in Harlem, the line is equally applicable to Hoffman and Lamantia's own youthful indiscretions. As the annotated *Howl* notes, the poem's allusion to Lamantia —"who bared their brains to Heaven under the El and saw Mohammedan angels staggering on tenement roofs illuminated"—occurs nearby in line 5, lending his assertion some (admittedly circumstantial) weight.

Kerouac's mildly fictionalized account of the Six Gallery reading in *The Dharma Bums*—with Lamantia as "Francis DaPavia" and Hoffman as "Altman"—perhaps did the most to elevate Hoffman to literary legend:

Delicate Francis DaPavia read, from delicate onionskin yellow pages, or pink, which he kept flipping carefully with long white fingers, the poems of his dead chum Altman who'd eaten too much peyote in Chihuahua (or died of polio, one) but read none of his own poems—a charming elegy in itself to the memory of the dead young poet, enough to draw tears from the Cervantes of Chapter Seven, and read them in a delicate Englishy voice that had me crying with inside laughter though I later got to know Francis and liked him. *

* A brief mention in Kerouac's *Visions of Cody* of a "John Parkman," who "committed suicide on Peyotl," also refers to Hoffman.

To these extracts we might add Carl Solomon's biographical note on the poet, also from the annotated *Howl*:

*John Hoffman, 1930?–1950 or 1951. Hometown: Menlo Park, California. Friend of Gerd Stern, poet, born circa 1930. Also friend of Philip Lamantia, Chris Maclaine, both California poets. Blond, handsome, bespectacled, long hair. Spaced out quality that amused many people. Girl friend blonde girl named Karen. Went to Mexico in 1950. Experimented with peyote. Died of mononucleosis while in Mexico. Poems highly regarded by avant-garde connoisseurs.**

Such accounts, with their colorful inconsistencies, have formed the basis of Hoffman's legend.

But, legend aside, what, in fact, is known about the life of John Hoffman? According to the dedication page of a bound typescript version of *Journey to the End*—prepared by Lamantia in 1956 for a proposed Bern Porter publication announced, along with *Tau*, in the end-matter of Gogo Nesbit's *Graffiti*—Hoffman's mother was one "Styleta Veuve (Mrs. William Peter Veuve)," indicating her remarriage after the death of his father. Of his father I know nothing, though I believe he was already dead by the time Hoffman and Lamantia met. As Solomon's sketch indicates, Hoffman was from Menlo Park, consistent with Lamantia's own notes and his recollection that the poet's family was fairly well-off.† If I recall correctly, Lamantia said Hoffman's re-

* A more anecdotal version of this sketch of Hoffman titled "A Generation Ago" appears in Solomon's *Emergency Messages: An Autobiographical Miscellany* (1989).

† Here we might note the existence, among the few effects of Hoffman's possessed by his ex-girlfriend after his death, a handwritten bill of sale dated October 3, 1841, "for the purchase of a Black boy named Daniel aged about twenty two years . . . a Slave for life . . ." The purchaser is identified as "Doct[or] HS Hoffman" and the location "St. Louis." This rather startling document suggests the family's prosperity was longstanding. We can only speculate why Hoffman carried such a document, but I imagine it must have had to do with his ambivalent feelings about his family.

lations with his mother were strained and with his stepfather nonexistent.* Whether Hoffman has any surviving relatives today is unknown.

As he notes in an introduction to *Journey to the End* written in 1954, Lamantia met Hoffman in 1947. This meeting took place after a poetry reading Philip had given. Someone had told Hoffman he could get marijuana from Philip, which might have occasioned his approach, though it appeared he knew Lamantia's work already. "When we first met he was living in a cheap hotel near here," Philip recalled at City Lights during his last reading. "And there were only two books in his room: a bound copy of the poems of Saint John of the Cross— a rare book even then—and a copy of my first book, *Erotic Poems*." Hoffman fell into conversation with Philip, along with a third poet, Gerd Stern, on whom Kerouac based the character "Jack Steen" in *The Subterraneans* (1958). Afterward, at a nearby bar, the group apparently clicked so well each poet assumed the other two already knew each other, and only in comparing notes after Hoffman's death did they realize the mistake.† At the time, the trio cordially repaired to someone's "pad," possibly Hoffman's two-book hotel room, and Philip got everyone high. Much time would pass before Lamantia learned, with

* In this regard, unless I'm mistaken, the preservation of Hoffman's poetry was largely or even entirely the work of the poet's friends rather than his family.

† Gerd Stern's oral history, *From Beat Scene Poet to Psychedelic Multimedia Artist in San Francisco and Beyond, 1948–1978* (2001), confirms the poets met at a North Beach bar, called 12 Adler Place (a.k.a. Spec's), across the street from the building which, in 1953, would become City Lights Bookstore. Lamantia's 1954 introduction places the meeting in 1947, which given Stern's admitted vagueness as to dates in his oral history, may be more accurate, though the 1959 introduction by Lamantia also says 1948. I have privileged Lamantia's 1954 text as it was written closest to the event.

amazement, that his new friend had never "turned on" before, and I include these details primarily for the sidelight they throw on Hoffman's character. That is, both the lingering vagueness as to who knew whom and his utter nonchalance in stepping into the unknown were characteristic of Hoffman as Philip described him, that "spaced out quality that amused many people." Thin, bespectacled, with a small beard, Hoffman was, according to Lamantia, the very archetype of the cool hipster, whose persona served as the basis for the degraded stereotype of the "beatnik" in American culture.

By the same token, however, according to Lamantia—who described their relationship as "the deepest friendship I've ever had with another male in my life"—Hoffman's air of inattention or abstraction was more than simply "spaced out." "John was a very religious person," Philip said. "He was very silent but he had presence." These personal attributes no doubt laid the groundwork for the intensity of their bond, for even in nonreligious periods, Lamantia had a deeply spiritual sensibility; the fervor of his commitment to surrealism at various points in his life more or less mirrors his ecstatic devotion to god during his periods of Christian mysticism. As alluded to in the fifth line of "Howl," Lamantia had previously had a vision in 1953 while reading the Koran and, he told me, for a time seriously contemplated embracing Islam.* In other words, his interest in visionary spiritual phenom-

* Despite Ginsberg's inclusion of New York's elevated train ("the El"), letters from Goldian Nesbit reveal that this vision took place on Post Street in San Francisco. Lamantia contributed the following account of this 1953 mystical experience—the first of several that would culminate in his 1955 conversion to Catholicism—to the annotated *Howl*:

> 1953, Spring, aged 25, reading the Koran on a couch, one night, I was suddenly physically laid out by a powerful force beyond my volition, which rendered me almost comatose: suddenly, consciousness was contracted to a single point at

ena was pronounced well before his dramatic 1955 conversion to the Catholic Church, and, notably, while the complexity and intensity of his spiritual life led him at times to repudiate the Church itself, he never repudiated his belief in the reality and significance of his mystical experiences.

In Hoffman, Lamantia found a fellow poet with whom he could discuss religious and spiritual matters with complete seriousness and candor, something he said he seldom found in the poetry scene, which tended to approach the concept of organized religion with a degree of cynicism. Of Hoffman's own religious interests I know nothing beyond his mention of "Zen" in a recently discovered poem, and the evidence of the poems themselves, whose keynote might be said to be a search for the metaphysical significance of ordinary experience. Hoffman's capacity for silence probably contributed to the poets' friendship, for, as anyone who ever met Philip in the upper hemisphere of his manic-depressive cycle can attest, he could, and would, talk for hours without pause. This is not by any means to suggest their relationship was one-sided; suffice it to say, being his best friend as well as sharing an attic apartment in the late '40s, the generally reticent Hoffman would speak to Philip at greater length and more inti-

the top of my head through which I was "siphoned" beyond the room, space and time into *another* state of awareness that seemed utterly beyond any other state before or since experienced. I floated toward an endless-looking universe of misty, lighted color forms: green, red, blue and silver, which circulated before me accompanied by such bliss that the one dominant thought was: This is it; I never want to return to anywhere but this *place*—i.e., I wanted to remain in this Ineffable Blissful Realm and explore it forever—since I felt a radiance beyond even further within it and so, suddenly the outline of a benign bearded Face appeared to whom I addressed my desire to remain in this marvel—and who calmly replied: "You can return, after you complete your work."

mately than to most others. As Lamantia told it, the time he spent living with Hoffman was one of the most enjoyable periods of his life.

The touchstone of Philip's anecdotes from this time was the *marginal*, a concept which he and Hoffman evolved to characterize their precarious existence outside societal norms and which occurs both in Lamantia's 1954 introduction to *Journey to the End* as well as in Hoffman's poem "The Marginal Conducts." Poet-intellectuals who only infrequently held jobs, Hoffman and Lamantia chose to inhabit the margins of a postwar American culture whose self-congratulatory patriotism and naive faith in technology they flatly rejected. Among the marginal conducts was experimentation with drugs as an aid to visionary experience—a deliberate derangement of the senses—some 20 years ahead of San Francisco's psychedelic era. I don't recall specifically whether they ate peyote together, though this seems probable as Philip began experimenting with it circa 1950, and, he said, you could still order peyote buttons through the mail from various botanical concerns. Subsequently, Lamantia would participate in the peyote-based religious rites of the Washoe Tribe, while Hoffman indeed experimented with peyote in Mexico, though the assertion that he died of an overdose Philip dismissed as impossible.* I do, however, recall a handful of Lamantia's anecdotes concerning their adventures: of paying a returning GI $10 for a combat medic's kit containing 50 tablets each of morphine and cocaine; of visiting another writer's home ver-

* Kerouac's insistence on the peyote overdose may in fact stem from his own indifference to the effects of this hallucinogen. Curiously, in reference to John Parkman in *Visions of Cody*, Kerouac calls it "Peyotl, the new sleeping pill," though I don't believe it's known for its soporific effects. But Lamantia once told me he gave some peyote to Kerouac, who took it and promptly fell asleep. On waking, he had no extravagant dreams to report, let alone the sort of waking visions Philip, among others, experienced.

bosely stoned and accidentally offending Anaïs Nin, whom their host (perhaps George Leite) had concealed behind a curtain; of encountering a Burroughsian psychiatrist who would give artists or writers a one-time dose of pure pharmaceutical cocaine on the condition they describe the experience afterward. (According to Philip, they walked across San Francisco and back twice that night, talking ecstatically the entire time.) Such stories would have a fantastic, improbable air, were they not among the lesser incidents of Lamantia's extraordinary life.

Like several poets and writers of their milieu, and despite their lack of regular income, Lamantia and Hoffman maintained a bicoastal existence between San Francisco and New York, though the two extant letters from Hoffman in Lamantia's archive indicate their travels weren't necessarily in sync. The two poets reunited in New York in 1949 or 1950, however, where Hoffman turned Lamantia on to heroin, as alluded to in the latter's "Poem for John Hoffman the Poet." Both became addicted, and Kerouac allegedly "condensed" them into the generalized portrait of New York junkies in *The Subterraneans*.* In the winter of that year, both poets returned to San Francisco, where Hoffman met his girlfriend, Karen Forrest, at a poetry reading at Knute Stiles and Bill Swan's North Beach apartment. Hoffman would soon move into Karen's studio at the Hanging Gardens apartments at 1232 Washington Street. As Karen herself writes, however, this household was short-lived:

John & I soon moved out of the small one-room place I had at the Hanging Gardens into larger quarters there. One of the features of the new pad—which had a small living room, shower, bedroom, & large kitchen where most of our living & entertaining took place—was a rear door that led off the kitchen onto a staircase that wound down & around until it led to a door that opened onto the cross street of Taylor. No one would ever have associated the nondescript door on Taylor with the Hanging Gardens' apartments around the corner.

* At least, according to Philip, this is what Kerouac *told* him in conversation.

John was working at the Mechanics Library & I was working for Standard Oil. Philip was a frequent visitor. We were all using "magic powder" that we got from "Cowboy," our dealer in the Fillmore. (A few years later, a somewhat controversial play, "The Connection," opened off Broadway. Its lead character was based on "Cowboy.") Near the end of February 1950, we received a long-distance call from Stockton. A musician friend, "Wigmo," who had a gig there called to tell us to get out of town ASAP. He'd been busted for smack in SF & the cops wouldn't release him to go to his Stockton gig unless he gave them some names. He gave them ours along with a few others who bought dope from Cowboy. I thought it was decent of him to notify all of us that the police were about to descend upon us. Indeed, when Philip arrived that day, he commented on the two men watching the entrance to the Hanging Gardens from across the street. Spooked, John & I packed what we could carry, phoned Cecil Westerberg, who had a car, to pick us up on Taylor Street & we went out the back way. Cecil took us to the Greyhound bus depot in Oakland— in case the cops were on the lookout for us at the SF bus station. We hopped on the first bus to L.A. & left town.

We stayed in Topanga Canyon for awhile with some New Yorkers we knew from the Village who had a cabin there. We hung out with them for a couple of weeks.

The exact chronology of their flight is uncertain, however. According to three surviving love letters mailed by John to Karen at the Washington Street address, Hoffman was staying in Topanga himself without her in January 1951. The reason for the couple's temporary separation isn't recorded, and it's not clear to me whether Karen's account reproduced above simply lists the wrong month and year; perhaps she had returned to San Francisco to settle some affairs before they continued their travels. In any case, the third of these letters, postmarked January 13, 1951, is worth quoting in full, for though not so intended, it's the closest thing we have to a self-portrait of the poet, as well as the most sustained specimen of his familiar voice:

Friday

My Darling,

I will stay down here until the end of January. If you will wait for me until then I will wait for you. However its possible I may leave any time between now & then. Just received and read your

long & interesting letter. Please don't get busted. I'm being as much of a master here as is possible. Can play Las Mañanitas & Nossa Senhora de Goiania on the guitar and reading Kafka's diary which is very funny. F.S. Fitzgerald was "The Last Tycoon" (good) and "The Great Gatsby" (stinks).

Horse seems pretty remote already & I want it to be even more so when I get back to Frisco. My teeth are in good shape. We have some gage here but I wanted to be cool with you on the phone. Marty and I drank some mace last nite and we're still stoned. Interesting stuff but the charge is great.

It rained very hard last nite & yesterday and there is some water in the creek now. The car breaks down occasionally. We have been stopped by the bulls twice for minor traffic violations. L.A. is a terrible town from what I have seen of it; but we don't leave the Canyon much.

Thanks for sending me Stern's card. Have you heard anything from Mason? The Sterns? If you see Sandy tell him he's full of horseshit about his tea plantation. We combed the area like hair for 8 hours and didn't find a seed.

We see the Eubanks occasionally & Penny once & our connection but no one else. We hear all the radio programs & war news. Fuck it. I miss and love you very much baby & look forward to seeing you & balling with you when I get back. Wanted to tell you so & hope the phone call didn't break you. Love. Write. John.

P.S. Have become a good driver esp. on the hairpin curves of Topanga esp. when high.

Some of the references are opaque to me but there is much to glean here, including the hitherto undocumented fact that Hoffman could play guitar. Even more significant in terms of his subsequent biography is the fact that he managed to kick heroin (i.e., "Horse"), for he would have found it difficult to score during their various travels. For rather than returning to San Francisco from Topanga, Hoffman and Karen ultimately hitchhiked to New Orleans and rented a room in the French Quarter, where, she writes, "John got a job as a street vendor & I worked as morning barmaid at a saloon on the waterfront. After a few weeks, we got on the road again, cutting over to Florida where we caught a ride with a truck driver taking beans from Florida to Boston who dropped us off just outside New York City." Unfortunately, the couple caught more than a ride, contracting a severe case of mononu-

cleosis, which no doubt accounts for Carl Solomon's theory of the cause of Hoffman's death. Though they recuperated at their friends Bob and Chris Storm's apartment on the Lower East Side, the stress of travel and illness had taken its toll and "the romance started to seep out of our relationship. We sort of went our separate ways after that. Good friends, yes, always, but love was no longer 'burning, burning.' John went up to Martha's Vineyard & I left for Mexico with Chris & Bob who had a house on Lake Chapala in Mexico."

Karen's account here broadly tallies with Gerd Stern's recollections in his oral history of the period, in which he says he unexpectedly encountered Hoffman one day at the San Remo bar in Greenwich Village. After various misadventures up the East Coast in the summer of '51, the pair returned to New York, broke, only to embark as merchant seamen on a Norwegian ship, the M.S. *Bowhill*, bound for Rio;* the ship also stopped at Montevideo, birthplace of protosurrealist French poet Lautréamont (Isidore Ducasse, 1846–1870), whose *Mal-*

* Stern's oral history records the following amusing episode from their stint as merchant seaman:

Finally, we got to Rio [de Janeiro, Brazil], and John had to clean the cabins. . . . He had devised this method of cleaning the cabins by taking a pail of soapy water and throwing it on the floor, and he would lay on the officer's bunk and read with the door locked until the motion of the sea had drained all the water, then run the mop a little over the deck and leave a couple of soapy streaks. The officers expected him to scrub the cabin deck on his hands and knees every day.

So we get into port and we get leave off the ship, and John thinks he's a smart guy, and he goes through each of the cabins and throws a bucket of water on the floor and then closes up the cabins. Of course, the ship was laying at the dock, and it wasn't moving [laughter] so the officers all found water on the floors in their cabins. Then they understood what had been happening. It didn't go over too well.

doror (1868) they both were reading. On concluding this voyage, Hoffman went on alone to Mexico to his peyote experiments, meeting up with Karen at Chris Storm's house in Ajijic. As Karen explains:

Chris & Bob had split up. Bob had gone back to SF & Chris didn't want to live alone; there was plenty of room so John moved in, too. In the interim, I'd become involved with a young Guadalajara lad, Jose Ana Casillas Ochoa, with whom I was about to travel to Mexico City. So John took off again to see if he could find some peyote. A couple of weeks later, he came back to Ajijic with a box of peyote buttons he'd bought off a farmer somewhere up north. I was packed & leaving for Mexico City the last time I saw John. He was sitting cross-legged on the living room floor in Ajijic, slicing up peyote buttons to masticate. He was leaving for Puerto Vallarta the following day, already had his plane ticket & was looking forward to the trip.

*Months later in Mexico City, I received a letter from Betty Keck that began, "I guess you heard John died on the beach in Puerto Vallarta." I hadn't heard. Betty's letter was the first notice I had of his death. Later, I learned that John had been found lying unconscious on the beach, rushed to a PV doctor who diagnosed polio, or TB, or some such thing, & sent John off to Guadalajara in an iron lung. Yale Harrison, a friend from NYC who happened to be in PV at the time, accompanied him on the flight to Guadalajara. I don't know whose decision it was to have John cremated. It could have been a money-saving decision by his mother: a cadaver is expensive to transport. Or, the Mexican authorities might have thought that, since nobody knew for certain what had killed him, cremation was the safest way of dealing with any possible disease he might have been carrying.**

All of these details support Lamantia's 1959 account of his friend's death, written as the introduction to a much announced but never

* The diagnosis of polio, also suggested by Kerouac in *The Dharma Bums*, is mentioned by William S. Burroughs in his 1953 novel *Junky* (1977), in a passage that clearly refers to Hoffman's 1952 death:

> We sat up all night talking and listening to Cash's records. Cash had told me about several cats from 'Frisco who had kicked junk habits with peyote. "It seems like they didn't want junk when they started using peyote." One of these junkies came down to Mexico and started taking peyote with the Indians. He was using it all the time in large quantities: up to twelve buttons in one dose. He died of a condition that was diagnosed as polio. I understand, however, that the symptoms of peyote poisoning and polio are identical.

published edition of Hoffman's poems by Auerhahn under the title *Farewell Final Albatross*. Here he writes that Hoffman was "stricken down by paralysis, in Puerto Vallarta, Mexico, 1952," dying "in a hospital in Guadalajara," a belief Philip retained in his later years. He also refers to "a certificate in Spanish" that said the body had been cremated. This was, he recalled during his final reading devoted to his friend, "unheard of in Mexico unless it was possible you had a disease." Hoffman's death thus uncannily mirrors that of Lautréamont, who died of an unknown fever at age 24 and was hastily buried for fear of contagion.

3

John Hoffman's literary legacy consists of the roughly 35 texts in verse and prose posthumously assembled by his friends, principally Lamantia, under the title *Journey to the End*. According to Lamantia, more poems existed at one time, but the whereabouts of this earlier work was unknown; Hoffman either "lost" them or left them "with an unnamed friend in New York City." Very little has surfaced since Lamantia first assembled the poems for a proposed 1956 Bern Porter edition of *Journey to the End*: one early poem, a prose fragment, and a notebook entry. But the poems we have are striking, to say the least; composed between 1949 and 1952, their composition predates everything they're associated with—"Howl," the Six Gallery, *New American Poetry*, etc.—and their biggest contemporary influence is probably Lamantia himself. Here I might note something Michael McClure said to Andrew Joron and me when we were working on Lamantia's *Collected Poems*: "We *all* looked to Philip," McClure insisted, pointing out that, going into the Six Gallery reading—aside from Rexroth, the evening's emcee—Lamantia was by far the most famous and experienced poet on the stage, the only one with a book, not to mention extensive magazine and journal publication, from *View* in the early '40s to the *New*

Directions annual in the early '50s. Even as a friend and partisan of Philip, I was taken aback by this perspective on early '50s San Francisco poetry, but it makes sense. In 1963, having eclipsed Lamantia's fame by many magnitudes, Ginsberg would defend *Destroyed Works* against an attack by Richard Howard in the pages of *Poetry* by invoking this period of Philip's wider influence:

His interest in techniques of surreal composition notoriously antedates mine and surpasses my practice in a quality of untouched-ness, nervous scatting, street moment purity—his imagination zapping in all directions of vision at once in a cafeteria—prosodic hesitancies and speedballs—the impatience, petulance, unhesitant declaration, machinegunning at mirrors nakedly —that make his line his mantric own.

Since I'm cited as stylistic authority I authoritatively declare Lamantia an American original, sooth-sayer even as Poe, genius in the language of Whitman, native companion and teacher to myself. "And for years I have been absorbed in contemplation of the golden roseate auricular gong-tongue emanating from his black and curly skull. Why not." Says Philip Whalen, and many poets his admirers Michael McClure and Robert Creeley others have spoken—

Not content to implicate himself, McClure, and Whalen, Ginsberg also reaches for Creeley, knowing Creeley's name will ultimately carry the most weight with 1963 readers of *Poetry*. And naturally Ginsberg invokes the surrealism Lamantia is best known for, the rapid flow of automatic irrational imagery in his early work that certainly influenced the "the best minds" litany of part one of "Howl" and re-emerges with vengeance in *Destroyed Works*. Yet Hoffman's poetry is influenced more by the poet he knew between '47 and '52, the Lamantia of the "naturalistic" section of *Erotic Poems* en route to becoming the meditative, esoteric Lamantia of *Tau*. None of this is to reduce Hoffman's poems to Lamantia's influence but rather simply to suggest that this influence was more pervasive at the time than is generally understood today.

"The Marginal Conducts" demonstrates a number of typical features of Hoffman's poetry:

1

The hanged man tilted
With the tides of grain,
The field birds picked
At his straw-filtered eyes,
Seven barren bare oak boughs remained,
One hangs and his voice is whisper,
Whisper: the hostile, rattling corn.

2

Weary of the sea
The fool stands in the sunken field
Playing with infinity:
The fool does not possess what's given him
His ship has rolled beneath a wave
And opened with the wind.
His body tilted to the sea
The fool juggles infinity two by two.

3

Love is a heart
Ahang on three staves
And the swords of the field unwound:
The hanged man turns,
Caresses the blackened birds,
Bids us to be silent in his turning.

This impersonal, third-person presentation of discrete scenes, the last seeming to revise the first, yet with little in the way of overt commentary, is one of the more characteristic modes of Hoffman's poetry. With its images of the hanged man and the fool, the poem seems to allude to the tarot, or to at least suggest an occult significance to its images, yet only discreetly, as these are laid out with relative austerity. "Birds," "field," "grain," "sea," "wave," "wind," "love," "heart": Hoffman's poetry tends toward such elemental words and scenes. Yet too,

in the midst of such apparent simplicity, he will slip in the entirely nonstandard "unwound," which grammatically must be a negative of the present-tense form of "wound" rather than the past-tense form of "wind." (The pull of the past-tense reading remains strong, however, because everything else in the poem seems to be "hanging" or "turning" in some fashion; this is deft.) The cumulative result of these tendencies is a spare, meditative poetry in which the idiomatic and Whitmanic characteristics of Beat writing are altogether absent. More like Stephen Crane perhaps, and not unlike Lamantia at times in *Tau*, Hoffman is a laconic allegorist whose poems are at once luminous and opaque.

Despite their auspicious debut at the Six Gallery, Hoffman's poems had a long road to publication. As Lamantia notes in his first introduction, Hoffman published no poetry during his lifetime; the proposed 1956 Bern Porter edition of *Journey to the End* would have been the first publication of Hoffman's work in any form and, as there are indications the book remained in progress after Lamantia withdrew *Tau*, the reasons behind its eventual cancellation aren't fully clear.* In 1959, Lamantia wrote a new introduction to Hoffman's poems in which he claims "*Farewell Final Albatross* is the title John Hoffman gave this book," and the book was announced as such by Auerhahn. When I knew Philip, he never referred to this second attempt and the book was quite definitely called *Journey to the End*, so I suspect the title change was purely due to the fact that *Journey* had been announced as a Bern Porter publication. But this second attempt probably accounts for the first magazine publications of Hoffman's work that same year; "Socrates or Confucius," "The Workers," and "i am a witness to the

* Letters between Philip and Goldian Nesbit suggest they were dissatisfied with Porter's handling of Nesbit's *Graffiti*, which might have prompted Lamantia to withdraw *Journey to the End*.

threshing of the grain" all appeared in issue 5 of the *Galley Sail Review* (Winter 1959–1960), while "Floridas" was included in issue 5 of Wallace Berman's *Semina*. Apart from these two publications, the latter of which certainly was never generally available, the bulk of Hoffman's surviving poems remained unpublished for the next 40 years. In 2000, however, under my desktop imprint of Kolourmeim Press, Philip prepared a chapbook limited edition of the poems—24 copies, symbolic of Hoffman's age—from the very same colored onionskin pages described in *The Dharma Bums*; this was preparatory to a planned City Lights edition that he grew too ill to carry out near the end of his life. Only in 2008, three years after Lamantia's death, 53 years after the Six Gallery reading, did Hoffman's poems finally appear in a generally available edition, as part of Number 59 in the City Lights Pocket Poets Series, *Tau* by Philip Lamantia and *Journey to the End* by John Hoffman.

4

I'd thought that was the end of the story but it wasn't quite, or rather, as soon as City Lights published the edition of Lamantia's and Hoffman's poems—that short window between the time the books return from the printer and the official pub date—I received an email from a woman who turned out to be Karen Forrest. No one had known her last name or what had become of her,* but since the book had already

* Carl Solomon, for example, doesn't record her surname, Lamantia hadn't remembered it, and the difficulty of the passage of time was compounded by the fact that even in the '50s, Karen notes, she had used "a variety of names including Kirk, Forrest, & Brodie. After awhile, I married a Spaniard, Juan Manuel Calvo Lespier, & became 'de Calvo.' But John had been dead for well over a year, maybe two by the time I became la Sra. de Calvo." I've elected to go with "Forrest" simply because it's on the envelopes of the letters from Hoffman in Topanga.

gone on sale at City Lights Bookstore and she again lived in San Francisco, she'd caught wind of it. I immediately sent her a copy and, though my introductory account of Hoffman contained numerous errors that I've tried to correct here, she was delighted. She didn't want to tape an interview herself; her relationship with Hoffman had been a lifetime ago, she mistrusted her memory, and she was married to someone now who had no connection to her "beat" youth, though he knew of it distantly. She wasn't about to put herself out there, in other words, and took pains to minimize her importance to Hoffman's biography. But she was thrilled that her old friend's poems had finally come out, from City Lights no less, for she'd always been convinced of their greatness and looked back fondly on him and their time together. (According to Karen, she carried the last known photograph of Hoffman in her wallet for years, until her purse was stolen one day at knifepoint in Mexico City.) In any case, she was happy enough to meet with Nancy Joyce Peters and me, to answer various questions about both Hoffman and Lamantia, and she always made herself available in subsequent years if I had a query about the time she knew those poets. She also let me copy the three letters from John in Topanga and the few other documents relating to him that she still possessed.

But if she wasn't sweating the factual errors in my account, I certainly was, and I looked forward to the day when I could collect and revise this essay. When the opportunity arose to assemble *Retrievals*, the first concrete step I took was to email Karen. I'd last spoken with her about a year and a half prior, while working on Lamantia's *Collected*, and thought her email address might have changed, so after a couple of weeks without a reply, I called her house and left a message on the answering machine. I let another couple of weeks go by and tried again; this time her husband answered. He apologized for not

getting back to me, but Karen was terminally ill with cancer and past the stage of being able to talk to anyone. He was polite but I could tell he didn't want to talk, so I simply expressed condolences and let him go. I felt crushed. I didn't know her very well at all, but I liked her quite a bit, and I definitely knew I'd failed to fully sort out the chronology of Hoffman's final two years. But she'd given me more information than I'd realized, once I went over our correspondence. About her own life, I don't know a great deal and I don't feel at liberty to divulge everything she told me. Let's just say she'd been a liberated young woman during a decidedly unliberated time and she'd suffered for it, though she seemed to have landed on her feet and found happiness later in life. As far as I know, as I write this she's still alive, but she will almost certainly be dead by the time these words are published. But I'd like to give Karen the last word, from one of her first emails to me:

John was born a few months before I was in 1928. He'd be 80 now if he'd lived. Young lust brought us together & kept us together only for an intense, albeit brief, period. John died; I lived. It's been a hell of a ride (Wheee!) for me since then & has pretty much obliterated any memory I have of the time John & I spent together. The only reason I seem to be of any importance in his life is because he didn't live long enough to acquire more experiences, more loves, more adventures before wiping out.

What matters is what he wrote. That his life & death have mystery should, I think, make the few poems he left even more attractive to those who read his words.

2008, 2012

APPARITIONS

THE MYTHICAL WORLD OF

MARIE WILSON

paintings + drawings

March 4 – April 15

CITY LIGHTS BOOKS INC.

261 COLUMBUS AVE. SF 362-8193 OPEN 10:00 AM to MIDNIGHT

APPARITIONS
OF MARIE
WILSON AT
CITY LIGHTS

As 2013 is the 60th anniversary of City Lights Books, I've been reflecting lately on its lost history. When I started working there, for example, I came across a catalogue from sometime in the early '60s, advertising City Lights publications to the rest of the trade, and I was immediately struck by the appearance, not just of the press's own titles but of the full lists of various Bay Area small presses—Oyez, Auerhahn, and White Rabbit, if I remember correctly—which often enough were only available in the bookstore's then-downstairs poetry section. In a way, City Lights was Small Press Distribution (SPD) *avant la lettre*, distributing small poetry presses not because it made money but because it was a cool thing to do.

Considering the history of the place and having spent time here, I get the distinct impression of Lawrence Ferlinghetti making it up as he goes along, using City Lights' success for the greater good of poetry, and I think this ethos endures even in today's necessarily more professionalized era, where SPD is its own organization in Berkeley with a packed warehouse of small press titles of all genres, and the poetry section at City Lights has moved upstairs because the downstairs is better bookselling real estate. The upstairs didn't belong to

FACING: Marie Wilson, poster for *Apparitions* at City Lights Books, March 1984. Photograph by Garrett Caples.

City Lights back then, at any rate, as the store only gradually took over the entire building, but the biggest change in the basement has been the shelving, which now goes to the ceiling to maximize the retail space. Back in the day the shelves only went halfway up, and you could see the inspirational phrases painted on the walls and wryly retained by Lawrence from the basement's pre–City Lights incarnation as a "holy roller" church, of which only "I AM THE DOOR" remains visible, because, of course, painted on a door. But since there was wallspace, Lawrence would sometimes permit artists to hang work, and I would give a great deal for a comprehensive list of all the shows staged in the makeshift gallery at City Lights' basement. (Given that some of these exhibitions took place under the auspices of various employees over the years, I doubt Lawrence himself knows.)

One of the better-known City Lights shows was *Apparitions: Paintings and Drawings by Marie Wilson*, which took place in March 1984. Memory of this show has endured in collective consciousness in part because of two printed items of evidence, a small poster and a twice-folded broadside depicting several images along with a short biography and testimonials by surrealist poets Nanos Valaoritis, Thom Burns, and Philip Lamantia. Yet Marie Wilson herself remains obscure today, and researching her images on the web is continually thwarted by the existence of the namesake actress/pinup girl, best remembered as the title character of the radio, TV, and film versions of *My Friend Irma* (1947–54). Somehow even LACMA's awesomely comprehensive and revelatory exhibition *In Wonderland: The Surrealist Adventures of Women Artists in Mexico and the United States* (2012) managed to overlook Marie Wilson, despite the California-born artist's active participation in the Paris surrealist group in the 1950s.

Born in Cedarville, California, in 1922, Wilson received a B.A. from Mills College and an M.A. from UC Berkeley but afterward fell

under the influence of Jean Varda of the Wolfgang Paalen/Gordon Onslow Ford para-surrealist group Dynaton. She was introduced into surrealist circles in Paris by Paalen in 1952. After a 1954 stint as Picasso's studio assistant, she worked in Paalen's studio, and, in 1955, André Breton included several of her works in an official surrealist exhibition at the gallery L'Étoile Scellée. In 1957 he published a full-page photo of one of her paintings in the second issue of his most significant postwar periodical, *Le surréalisme, même.* During this period she met the Greek surrealist poet Valaoritis, with whom she collaborated on *Terre de Diamant* (1958), a book of 16 lithographs accompanied by his poems in French. They would marry in 1960 and spend the ensuing 50-odd years in Greece, Paris, and the Bay Area.

I'd first learned of Wilson from Lamantia, whose 1970 volume *The Blood of the Air* has a frontispiece drawing by her. He also gave me a copy of the *Apparitions* pamphlet, and I later came across a double issue of Paul Mariah and Rich Tagett's *Manroot* (6/7, April 1972), for which she drew the front and back covers and section dividers for extended features of work by Valaoritis and Éluard, in addition to contributing her own portfolio of "9 Psychograms." Apart from the abovementioned works, however, reproductions of Wilson's art remain difficult to find, limited to a handful of illustrations for poetry books and a few catalogues in French and Greek. You can see examples of her work on the web, but I've yet to have the good fortune to see any original of hers in person. Based on what I've seen, I tend to favor her drawings over her paintings, though in truth they are fundamentally similar. As I understand, the symmetrical structures that dominate her work are the result of a spontaneous compositional process, one that starts in the center and works its way out by continually mirroring every mark on the opposite side of the central axis. I don't know if paint mutes the dynamic effect evident in black ink, but the draw-

ings seem to have an extra quivering dimension to them due to both the inexactness of a symmetry spontaneously executed by hand and the nervous energy of her line itself. But I would more than welcome the chance to be proven wrong by spending time with her paintings in person.

In recent years, Wilson and Valaoritis have permanently relocated to Athens, and now in her early 90s, she is too physically infirm to paint or draw. They are not especially easy to get ahold of, though fortunately my friend Peter Maravelis, the noir expert who moonlights as the events coordinator at City Lights, usually visits Greece once or twice a year on family business and is good friends with the couple. In 2011, when the press was about to publish Will Alexander's *Compression & Purity* as volume 5 in the Spotlight Poetry Series and needed suitable cover art, I knew only a "real surrealist" would do, and was able to dispatch a note with Peter asking Wilson for the use of one of her drawings. Weeks later he returned in triumph with a pair of catalogues, and we ended up using an enlarged detail of *The Creator* (1964), the intricacies of which seemed to magically resonate with the title of Will's book. In 2012, the surrealist press Rêve-à-Deux published Will's long poem for Lamantia, *The Brimstone Boat*, in an oversized edition featuring a color reproduction of an oil painting by Marie Wilson on the cover along with two interior drawings, plus a note on the artist by publisher Richard Waara. I've enjoyed seeing her work sitting on the poetry shelves at City Lights when I come in every week. It seems right at home.

2013

BARBARA GUEST IN THE SHADOW OF SURREALISM

HOTEL COMFORT

Minutes each hour took ostrich leaps on the roof of the Hotel Comfort in Strasbourg.
These Surrealist moments cherished each roof a long time.
In the thickened weather of Surrealism the cathedral
is across the street.

Wise lettuces exaggerate their claim near the windows of the Hotel Comfort.
And you have sent your letter of explanation for the pleasure obtained
in the wooden jar. Speech-maker, you have sent notes of pleasure
in the glass jars.

Tasting of weather and cinnamon.

"Hotel Comfort" is the last poem Barbara Guest (1920–2006) wrote and among its conspicuous features is its inclusion of the words "Surrealist" and "Surrealism." At her last two or three readings, she'd begun to identify herself as a surrealist, prompted in part by two poems she'd written about de Chirico which open her final book, *The Red Gaze* (2005). *The Red Gaze* was in fact originally subtitled *Surrealism and Other Poems*, though she nixed this in the end, not wishing, she said, to be *over*shadowed by surrealism.

It was a characteristically "Barbara" statement, one riffing off the title of her essay "The Shadow of Surrealism," which had recently

been collected in *Forces of Imagination* (2003). More an explication of her aesthetics than criticism per se, *Forces of Imagination* itself ends with a quotation from André Breton: "To imagine is to see." The fact that she deliberately and unfashionably allowed Breton the last word indicates the extent of surrealism's influence on her work. The last of a handful of poems postdating *The Red Gaze*, "Hotel Comfort" shows surrealism was on her mind up to the end of her artistic life.

Does all of this make her a surrealist? I find this question extremely difficult to answer, despite—or because of—knowing her for the last ten years of her life, very well for the last seven. Barbara herself was as otherworldly as her poetry. She seemed like a person from a different era, which I suppose she was, given the 52 years that separated us in age. She was stamped, I think, with a sense of glamour born of the expatriate-infused Hollywood she inhabited in the early 1940s. The experiences she drew on were commensurately glamorous. She might tell you about staying in a château in Zurich or attending an embassy party in Fez. "Have you been to Fez?" she would ask, unconscious of how improbable such an adventure is to most of us. To me, she was *la grande dame par excellence*, queenly, her presence commanding deference, yet too courtly and ladylike to come across as a diva. This probably sounds like sexist terminology but it's hard to convey the exact mixture in her personality between an old-fashioned conception of gender roles and an insistence on the equality of art, where gender determined nothing, especially mastery. Her conversation was very like her poems, consisting of oblique observations and unpredictable leaps, isolated from each other by periods of silence. She could be extremely difficult to follow. There was a time when I used to sit with her every week or two while her daughter ran errands. I always

FACING: Barbara Guest, ca. 2000. Photograph by Garrett Caples.

brought a bottle of wine to drink and Barbara took a kind of wistful pleasure in watching me drink it, having given up alcohol at her age. Occasionally I had no idea what she was talking about and the wine smoothed this over, but she grew easier to understand with repeated exposure. Her manner wasn't affectation—she seemed to think in a truly associative way—yet I felt nervous inhibition may have contributed to it long ago.

Throughout our many conversations about surrealism, I never once heard Barbara mention its revolutionary political aims. She was drawn to surrealism as art, and she had a passionate conviction that art is one of the highest human activities; surrealism notwithstanding, I agree, and to me she was a poet, artist, and avant-gardist in the highest sense of these words. When we met, she was around 76 years old; quite naturally one didn't expect her to, say, march against the war in 2003 when she was 83, though she was definitely appalled by post–9/11 America. Yet her political views were confused, leaning right even, but rooted in fear rather than genuine conservatism. Some poets broke with her over this.

She was, moreover, frank and consistent in her disdain for identity politics, never adopting them for convenience, even when, late in life, she became an icon among avant-garde women poets. While she rather enjoyed the praise, she nonetheless maintained a distance from many admirers when acquiescence would have been the prudent course. She wanted to be known as a poet, unqualified on the basis of gender or anything else save greatness. By the end of her life she'd achieved this, but it was a long, solitary road, which may account for her lack of solidarity with women poets as such; she'd gone it alone. A woman in a male-dominated world, she felt oppressed by the social order; her poetry wasn't taken seriously, and this was a deep source of pain to her. She felt continually slighted, from Ron Padgett and David

Shapiro's omission of her from *An Anthology of New York Poets*, to David Lehman's cursory treatment of her in *The Last Avant-Garde*.

The opening essay of *Forces of Imagination*, "Radical Poetics and Conservative Poetry," defines imagination as an extra-literary force which "disrupts [a] formulaic view of life," certainly a surrealist goal, if only a preliminary one. This definition is consistent with Breton's assertion: "To imagine is to see." The intensity of Barbara's imagination, moreover, is so clearly disruptive on a cognitive level, and her work altogether lacks the NY School sense of the quotidian. Yet she gives the key—or at least *a* key—to reading her work in "The Shadow of Surrealism":

I confess that often when looking at art I do not ask what it means, or how was the paint applied, the color chosen, but what has led the artist into this particular situation, what permits this particular piece of work, and how is it solved. When I look at certain paintings they begin to enter my unconscious. I then ask how the metamorphosis took place, and if the process I witness can be used in my own work.

This is good advice; to get anywhere with Barbara's poetry, you can't ask what it means. You must simply follow, and the syntax isn't always immediately apparent. You have to find it, or wait for it to emerge, particularly in her long minimalist poems sparsely scattered over the page, like *Quill, Solitary* APPARITION. Much imagery floats through the poems; the connections are so oblique as to be unfathomable. The poems add up in terms of form rather than content. They are strongly felt, emotional, suggesting a surrealist articulation of the irrational. Her formalism might seem at odds with surrealism, but it wasn't to her. "Imagination," she writes in *Forces*, "has its orderly zones." Sometimes it "hide[s] in boxes." Or "jars," as "Hotel Comfort" would have it.

Relative to much of her late work, "Hotel Comfort" is formally accessible, written in sentences, with unfashionable periods no less. The titular hotel really exists in Strasbourg; I believe she stayed there many

years ago. The name itself charms her, much like another building that lent its name to her book *Moscow Mansions*, but her poetic encounter with the hotel takes place on the imaginative level rather than in immediate experience. The poem has even less to do with the hotel than with the view "on" (perhaps also *of* or *from*) "the roof." The beginning, "Minutes each hour took ostrich leaps on the roof," is opaque. Seeking meaning here only yields silly questions. Are the "minutes" taking "ostrich leaps," and how could they be said to do this? Do they do so once an hour, or at random throughout each hour? What exactly are "ostrich leaps"? Such leaps must be imaginative, "Surrealist moments," if you will, and the phrase also has a formal function, to be echoed by the next line's "cherished each." This echo is part of a general pattern of long *e*'s throughout the first stanza, from "each" to "leaps" to "Surrealist" to "each" to "Surrealism" to "cathedral" to "street." There is, moreover, an aural game running through the poem in her repetitions. "Hotel Comfort," "each," "roof," "weather," "Surrealist," "pleasure," "jar"—these words or slight variants all appear twice within the eight-line poem, sometimes line-by-line, sometimes at wider intervals, creating a subtle musical elegance.

This is unquestionably poetry, but is it surrealism? Surrealism can't be accounted for through considerations of form. Yet the curious difficulty of locating a perspective from which this poem could be spoken quickly turns us from interpretation of meaning to interpretation of form. For the subject of this sentence could in fact be a suppressed "I" who "took ostrich leaps," raising the possibility of a different syntax entirely. Such elisions were certainly within her late poetic repertoire, a reduction to essentials without the austerity that phrase often implies. Here in "Hotel Comfort," we can't really be sure who or what the subject is, and this radical uncertainty is a sinking foundation on which to build further meaning-based interpretations. The poem's re-

sistance to interpretation, to rationalization in terms of content, suggests that, though it isn't a formalism, surrealism can be achieved through formal manipulations. Yet it still depends on the quality of the imagination animating them. In Barbara's case, the strong sensual appeal of her imagination separates her formalism from the process-oriented formalism of language poetry. Both are anti-quotidian, but where the poetics of language poetry exalt the formula by which a poem is generated, Barbara's formalism, again, "disrupts the formulaic"; she takes our everyday language and hands us back something as alien to quotidian experience as a fragment of meteor. This is a function of imagination, not formula.

The last two years of Barbara's life were horrific. She landed in a nursing home after a stroke from which she never completely recovered. It's unclear to me whether she grew senile or whether the nursing home itself drove her insane. There was no privacy; too many people were screaming, too many TVs roaring at the deaf, a woman in the next bed masturbating. Barbara couldn't remember where she was so she sometimes thought the attendants were attacking her when they were just doing the things their jobs entailed. I went to see her as much as I could, every day at first for months until the circumstances of earning a living made this impossible. In her lucid moments, she was terribly upset about not being able to write. I pointed out to her she'd done a lot and could afford to take a break. This seemed to satisfy her at the time, but nothing really stuck with her anymore, and she was just as upset the next time I saw her. It was painful to witness and is painful to recall. I've never been one to hurry my elders off the mortal stage, but I admit I felt relief when she died because it seemed like her life had become ceaseless torment. I wish I could say she derived some comfort from her achievements, but I don't think she did. A nursing home is not the Hotel Comfort.

Still, I'd like to think she had a real sense of her accomplishments, if not when she died then at least when she wrote "Hotel Comfort." The temptation to read a poet's last poem against the death to follow is perhaps irresistible, and I can't help taking the final lines of "Hotel Comfort" as an affirmation of her life's work. She is the "Speechmaker" apostrophizing herself; the "notes of pleasure"—textual and musical—are her poems, the "glass jars" her multiplicity of forms. The closing fragment places the imaginative (the taste of weather) on the same plane as the literal (the taste of cinnamon), denying their opposition; "To imagine is to see." It could be considered the final articulation of her aesthetic. Such biographical interpretation goes against the entire thrust of this essay, being a rationalization in terms of content. Yet I think it's a good one. She achieved her vision.

CIRCLES
RICHARD
TAGETT AND
RICHARD O.
MOORE

The proximity is damming . . . damning. —Richard Tagett

Who the hell am I to say who I am? —Richard Moore

In 2011, at age 75, Richard Tagett published his first generally available book, a selected poems called *Demodulating Angel*, to very little fanfare. Few poets I've asked know who he is, and this is partly his own doing, for Tagett holds a calling card he refuses to play. And by this I don't mean the 11 issues of the groundbreaking gay literary journal, *Manroot*, he co-edited with Paul Mariah between 1969 and 1978, as impressive as that alone is. I speak rather of something that, at this point in poetic history, confers instant and undeniable "street cred": the fact that, in 1961, after reading Donald Allen's *New American Poetry* (1960), he moved from New York to San Francisco to meet and discuss poetry with Jack Spicer.

Not that he's kept this fact hidden; in *Manroot* 10, "The Jack Spicer Issue," Tagett's "Mono/graphic Letter—Jack Spicer & Proximities" reveals he "made that decision standing in a Broadway bar, watching & listening to Ella Fitzgerald do her doo-beep-eeow." But back then, such testimony was in support of a marginal figure in American poetry—Black Sparrow hadn't even published *The Collected Books* (1975) yet—whereas today Spicer's position has never been more central, judging

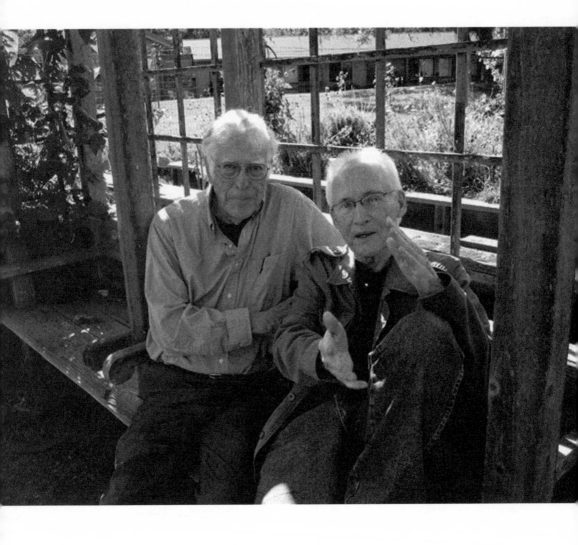

by his brisk-selling, American Book Award–winning collected poems, *My Vocabulary Did This to Me* (2008). Indeed, Spicer's work enjoys the luxury of being both central and hip, and the fact that Tagett not only perceived its significance when few others did but literally upended his life to trace its source would surely inspire interest in his own poetry, if only people knew.

"I don't want to be portrayed as some Spicer acolyte," Tagett snarls, when I propose writing about him, and throughout the process, he's been a half-willing participant at best. I can't say I blame him. Like most poets, he'd prefer to be considered on his own terms, rather than in relation to another. "I know I'm a poet," he adds in a later email. "I need no validation, only listeners." At the same time, however, a little of the former helps generate the latter, and lesser poets have built greater reputations on far flimsier foundations. Witness, for example, Jack Micheline's famous napkin, on which Kerouac scrawled his drunken endorsement.

Unlike that dubious blurb, however, Tagett's connection with Spicer is indisputably substantial. After passing a two-poem "audition"—the first of which, "Of What Is Real," opens *Demodulating Angel*—Tagett would spend the next two years as a core participant in Spicer's Sunday poetry group, then including Robin Blaser, George Stanley, and Stan Persky, eventually dropping out due to a severe, protracted case of mono. While he would subsequently join Robert Duncan's Society for Individual Rights in 1964, Tagett remained friends with Spicer, witnessing his final public appearance at the Berkeley Poetry Conference in 1965, shortly before his death. And while he would associate with Duncan off and on for fourteen years, Tagett's far

FACING: Richard O. Moore and Richard Tagett, 2011. Photograph by Brian Lucas.

briefer friendship with Spicer remained the decisive poetic encounter of his youth.

For a poet who's resolutely refused to dine out on his Spicer connection, the preceding paragraphs will probably feel akin to character assassination. But at the same time, I feel obliged to rehearse such information because it's so compelling, and surely the fact that he decided to meet Spicer while watching Ella Fitzgerald in a bar in NY elevates Tagett to a level of cool the average M.F.A. student can only dream of. And let's face it, how else do you direct attention to a 75-year-old who's just published his first book? Poets, I've found to my surprise, are not immune to the cultural bias toward youth; younger poets I meet tend to be extremely conscious of their immediate peer group, and perhaps the immediately preceding generation, measuring their accomplishments against each other, and they can be remarkably incurious about anyone older who's not already a bona fide star. As a critic, you need to give people reasons to turn to someone like Tagett, and, as I've suggested, there are plenty. To assert his membership in Spicer's circle is simply to vouch for his historical significance as a poet in order to direct readers to his work.

Tagett's resistance to such salesmanship is, of course, a mark of his integrity, but it raises a more fundamental question about the efficacy of considering membership in such a circle in relation to a poet's work. That is, does the fact of a poet's participation in a given scene shed much light in terms of the poetry itself? So general an inquiry obviously doesn't permit a singular answer, yet the question has forced itself on me lately, particularly in relation to another poet whose first book was even longer in coming: Richard O. Moore.

In 2010, at the age of 90, Moore published his debut volume, a selected poems called *Writing the Silences*, with University of California

Press. The core of California's marketing for this title can be gleaned from a sentence on the book's back cover: "Moore belonged to the San Francisco Renaissance literary circle of Kenneth Rexroth in the 1940s and 1950s, a precursor of the Beat poetry movement." This sentence was more than enough to pique my interest, but, like most marketing copy, it distorts as much as it reveals, conflating two overlapping but distinct groupings around Rexroth: the Friday night salons that continued well into the '60s, and the Wednesday night meetings of the San Francisco Libertarian Circle, which were conducted over a roughly three-year period between 1947 and 1949. The Fridays could conceivably be described as "literary," though they were also heavy on politics and philosophy, but the Wednesdays were specifically an anarchist discussion group, whose attendees were by no means limited to literary types and eventually numbered over 100. (For a time the meetings occurred in Moore's own apartment, because he was working as a dancer and living in the dance company's studio, but they soon outgrew this venue.)

Moore participated in both groups at different times. Having enrolled at Berkeley in 1939, he soon met Rexroth through fellow student and poet Thomas Parkinson and began attending the Fridays. Expelled from Berkeley for academic delinquency—though he suspects his involvement in antiwar demonstrations on campus may have been a factor—Moore moved to San Francisco, but would head north to the rustic Sonoma County town of Duncans Mills with his then-partner Eleanor McKinney in 1945. They would return, however, in the late '40s, to help found the country's first listener-supported radio station, KPFA, with Lewis Hill. Though he downplays his role, insisting he merely fell into the project by proximity to McKinney, Moore is nonetheless a significant figure in the history of alternative media. As he is fond of saying, public broadcasting "was my version of going

straight," though "going straight" for Moore wasn't incompatible with joining Rexroth's anarchist group.

Though he appeared in a few Bay Area little mags like *The Ark, Contour,* and *Circle* during this period, Moore never pursued publication with any assiduousness and soon left off altogether as his involvement with KPFA grew. But he always sought to incorporate poetry in the station's programming, interviewing poets, broadcasting them reading, and even securing Rexroth a weekly show devoted to books. While he would quit KPFA in 1952 over what he describes as a "political" disagreement, Moore would return to broadcasting two years later as an early member of the country's sixth public television station, KQED. He would spend the rest of his professional life working in public television in one capacity or another, and is probably best known for the *cinéma vérité* documentaries he directed in the '60s and '70s, including the famous *USA: Poetry* (1966) series.

But Moore never stopped writing poems, and while he good-humoredly acquiesced to his publisher's portrayal of him as a Rexroth-circle poet, he's apt to demur at the notion that his associations of the 1940s somehow account for his output of the ensuing 60 years.

"I never really felt a part of any school," Moore says. "If for no other reason than through my extensive reading encouraged by Kenneth and other poets, I was aware that there are a seemingly infinite number of individual voices and therefore no school. If you look at the New York School, Ashbery is totally different from Koch and Koch is totally different from O'Hara. So I wanted to reserve for myself the flexibility of using any form and any language set available to me."

As was frequently the case with poets he mentored, Rexroth's influence on Moore was more intellectual than prosodic, particularly with respect to what Moore calls "the attitude of philosophical anarchism."

"The importance of the Rexroth circle for me was that it provided

a kind of critical attitude towards all institutions and the ways in which institutions influence the individual," he explains. "The other important thing was his enormous acquaintance with other writers, ranging all the way from Madame Blavatsky and Gurdjieff to Kropotkin and the basics, beginning with the Greeks. Through Kenneth I learned about Martin Buber, who's been an important influence in my life. Herbert Read was another. All at once the universe enlarged exponentially through Kenneth."

If pressed on his poetic influences, Moore readily acknowledges Eliot, Pound, and Williams, though, he insists, "my head is as filled with Chaucer." The inspiration of Pound's use of both open and traditional forms clearly manifests itself in the formal restlessness evident throughout *Writing the Silences*, from the rhyming ballad "A Reminiscence" to the baroquely modern, stream of consciousness prose series "d e l e t e" to the austerely postmodern, dual-column title sequence. But Moore remains skeptical of the explanatory power of such influences.

"I'm not an imitative poet," he says, "nor am I the sum of my reading. There's a certain distaste to me in even trying to define it, like this is who I am. That's nonsense. Who the hell am I to say who I am?"

Such radical doubt about the province of the self in poetry seems to turn the question of influence on its head. Yet if it exudes a Buddhist air characteristic of the San Francisco Renaissance, Moore's skepticism is equally grounded in his study of Wittgenstein. "The role of language in perception, or the relationship between language and perception, fascinates me, and these things were not talked about in the Rexroth circle, nor with Duncan or any of the other poets," says Moore, and his interest in such matters in relation to poetry prefigures that of language poetry, even as the results are quite different.

*

At first, over email, Richard Tagett dismisses the question of associates and influences: "I had my associates and friend-peers then as I do new ones presently, all of whom had and have completely different aesthetics and styles. Of course you can see that all this associative stuff means nothing to me as to the artifact."

In person, however, he's more expansive, recalling his profound delight in the freedom of Spicer's varied line lengths in "Imaginary Elegies" from *New American Poetry*. As Tagett points out, however, influence itself isn't necessarily static, as a poet's interests and opinions evolve, nor is it always local or contemporary.

"I can see Spicer in me," he acknowledges. "But recently I find myself liking Oppen, of all things. Right now I feel like Spicer's over here, Oppen's over there, and I'm somewhere between the two. But it changes; at one time I liked Nicanor Parra a lot. When I was first writing I really liked the French symbolists and I've gone back to that."

"My favorite poems of mine," he adds, "are those skinny narrow ones." I find this admission intriguing, because, while I can "see" Spicer in Tagett's work, as in the opening lines of "Scherzo for Jack" ("It's alright to fuck over the dead. / No one listens. / In the emptiness a blue sheep."), I often feel a hint of Robert Creeley in Tagett's short-line poems. Take, for example, the first stanzas of "Rivus":

Immersed
we don't
ask
who entered
whose stream.

Take
my hand there
is no

line no

bridge only

fond

foolishness—

"I liked Creeley a lot and I think it shows up in my poetry," Tagett says. Yet too, he's exacting even in praise. "I used to have both volumes of Creeley's *Collected Poems* but the second volume I didn't like at all. He was just doing the same thing over and over."

Whether or not one agrees with such an assessment, Tagett's point is clear, insofar as his own work rejects Creeley's Mondrian-like commitment to a particular mode of poetry. While drawn to Creeley's minimalist lines, for example, Tagett also has reservoirs of surreality that burst forth in his work, as in the prose poem "Triptych for Believers": "The lips of old men are lockboxes in the terminal of no-knowing without gratitude for the despair of angels." There's little in Spicer and nothing in Creeley to suggest so thoroughly weird a sentence; the only SF Renaissance poet it evokes for me is Philip Lamantia, not that it seems imitative but that it's a truly irrational admixture of concrete and abstract imagery into a vividly felt but not-quite-visualizable whole.

Still, at the risk of overemphasis, I've dwelt on the Creeleyan strain in Tagett's work because I detect something similar in certain poems by Richard Moore. Moore—who was interested enough to include an episode on Creeley in *USA: Poetry*—is alive to this comparison, evident, for example, in the opening stanzas of the sequence "Holding On":

How account

for dimming

of the lights

baggage
of old age
tagged and waiting?

or light tricks
in snow
at sun-up?

"What I liked about Creeley was the spare, spare line," Moore says. "There are many of my poems that are comparable in the sense that they try to say something with the minimum of words. The word becomes an object, in a sense; you put them out there one by one by one."

I confess I'm uncertain whether this resemblance between Moore and Tagett supports or gives the lie to the significance of the poetic circle. Not being a long-term resident of San Francisco, Creeley obviously wasn't a member of either Rexroth's or Spicer's circles, but he certainly impacted the general ambiance of the SF Renaissance. While it hardly accounts for the depth and variety of their work, the influence of Creeley's spare line is what Moore's and Tagett's poetry have in common, but it has no basis in any personal association, either with Creeley or each other.

Though they had some mutual friends, Richard Tagett and Richard Moore never met back in the '60s. Moore, of course, knew Spicer from the Rexroth circle, but even on later occasions when he visited Spicer at Gino & Carlo's bar in North Beach, he never encountered Tagett. Tagett wasn't much of a drinker, nor did he enjoy seeing Spicer made belligerent through booze, so he usually limited himself to the Sunday poetry group. Moore and Tagett were in the same room on at least one occasion, Spicer's appearance at the Berkeley Poetry Conference in 1965, but even here they didn't connect. And their paths would

diverge widely after that. Moore went on to have a significant career in public broadcasting, both as a documentary filmmaker—making two films with Duke Ellington, for example, in 1967: *Love You Madly* and *A Concert of Sacred Music*—and as an executive, spending the '80s as president and CEO of Twin Cities Public Television in Minneapolis–St. Paul. After retiring in 1990, he and his wife Ruth moved back to Northern California, where they lived together until her death in 1997. Today he lives in a retirement community in Mill Valley.

Moore's return to the world of poetry was the result of meeting Brenda Hillman, who was teaching at a Squaw Valley Writer's Conference he attended in the mid-'90s. Hillman tells the story herself in her foreword to *Writing the Silences*, but the salient detail here is that Moore never mentioned his literary past and references to him in the existing secondary literature were so scant that several years elapsed before she came across his one fleeting appearance in Michael Davidson's book *The San Francisco Renaissance* (1989) and realized who he was. Only since *Writing the Silences* has further scholarship disclosed his presence in the Berkeley and San Francisco Renaissances, such as Lisa Jarnot's biography of Robert Duncan, *The Ambassador from Venus* (2012), which reveals that Moore was the object of his erotic overtures in 1946 as well as the inspiration of his "Treesbank Poems." Moore confirms that he and Duncan were briefly lovers. "But," he smiles wryly, "it didn't work," though they remained friends and Duncan is the only poet from *USA: Poetry* covered in Moore's later series, *The Writer in America* (1975). It's not that Moore was concealing the depth of his involvement in a major moment of American poetry so much as he doubted its explanatory power in relation to his poems, and still does.

Tagett's poetic life followed a considerably different path. Even here labels fail us, for despite their long association, he never had a sexual

affair with Duncan, in contrast to the otherwise heterosexual Moore. After starting *Manroot* in San Francisco, Tagett inherited $50,000 on the death of his father and moved with his partner, a painter named Jose Lafitte, in 1974 to Guerneville in the Russian River District, where he participated in a literary milieu that included the likes of Harold Norse and Andrei Codrescu. The couple bought a house with cash and was able to eke out a jobless, bohemian existence until 1978, when they sold the property and returned to San Francisco after a brief, unsuccessful experiment living in Spain with Lafitte's family. During the '80s, Tagett distanced himself from the poetry scene and finally stopped writing poems altogether.

"There was nothing happening for me creatively," he says. "I got into Marxism very heavily. I went back to school, to City College; I took anthropology and library science. I took a lot of things."

Not long after the death of his partner in 1989, Tagett got a job at the Mechanics' Institute Library in San Francisco, eventually becoming head card cataloguer in the mid-'90s. In 1994, a pair of young poets, Patrick Monnin and Brian Lucas, got jobs processing book returns at the library and it wasn't long before casual conversation unearthed Tagett's unexpectedly illustrious poetic past. Having not kept up with Spicer's literary fortunes, he was stunned at their interest in his old associations and even more surprised at their willingness to spend time hanging out discussing writing.

"How could they like all these people who were the same people I liked?" he recalls wondering. "I remember saying 'I feel funny because I'm so much older than you guys, you must have other people to hang out with.' That's what got me started writing poetry again."

Through the late '90s stapled magazine *Angle*, Brian Lucas would become Tagett's first publisher of this second phase of his poetic life, gradually nudging him back into circulation. Tagett has in the period

since become a prolific poet, as the generous selection of recent work in *Demodulating Angel* attests.

Despite their very different lives, given their connections and the sympathy that exists between their work, I can't help thinking that, had they ever crossed paths back in the '60s, Richard Tagett and Richard Moore would have had plenty to discuss. As it turned out, when Brian and I brought them together to be photographed for the original publication of this article, they did.

2011, 2013

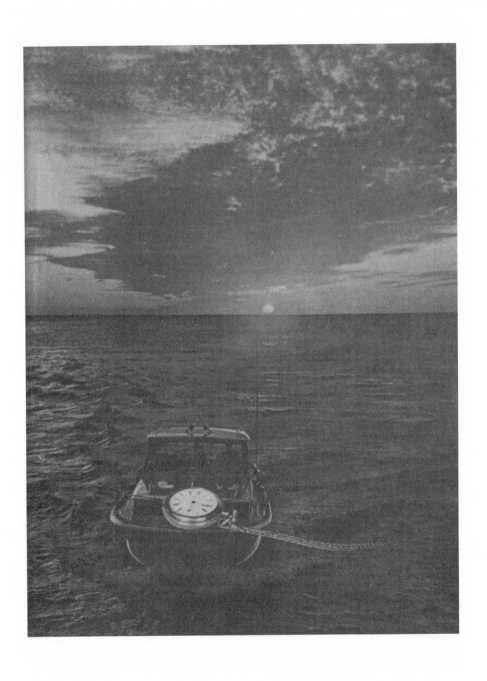

BECOMING VISIBLE
JEAN CONNER

When I began work on *Retrievals*, gathering those essays I'd written on various writers, artists, and ideas that, for one reason or another, had dropped off the cultural map or never fully made it on, I couldn't resist the natural temptation to add a few more. I'd begun thinking about Jean Conner, three of whose collages had just been acquired by SFMOMA, and, just as I was thinking about this, a card arrived in the mail—from Jean Conner! I'd written a piece a year earlier on a painting by her comparatively well-known husband, Bruce Conner, that he'd installed in a mutual friend's backyard—to be gradually destroyed by the elements—about six months before his 2008 death. Jean had recently visited the painting, which had practically torn from the stretcher at this point, and sent me a photograph of its progress, along with a note of appreciation for what I'd written. The uncanny arrival of her missive forced my hand, and I quickly wrote back, explaining what I was working on and asking if I could come by for an interview. I soon found myself heading for the Glen Park neighborhood of San Francisco, where she and Bruce had lived since the mid-'70s.

I'd been to the Conners' house three or four times before, but had met Jean only in passing. Usually, she'd say hi when you arrived then disappear while you conducted the business at hand with Bruce. Perhaps an hour later, she might appear and place a mug of tea in front of you, then disappear again. Bruce's personality, on the other hand,

FACING: Jean Conner, *At Sea* (1981). Collage.

was more than sufficient to dominate whatever space was available, even though he was extremely ill from a liver disease that sapped his energy and forced him to rest for most of the day. Given his outlandish usage of this personality to provoke the institutions of the art world—galleries, museums, universities, magazines, printmakers, you name it—Bruce necessarily spent much of his professional career *embattled*, refusing to participate rather than compromise, gambling that interest in his work would compel people to deal with him on his own demanding terms. His career was a hilarious yet abrasive rejection of career as applied to art, yet too, he'd always had something of a career to reject. By the time they met, for example, in the fall of 1954 as undergrad art students at the University of Nebraska in Jean's hometown of Lincoln, Bruce was already represented by a NY gallery, Charles Alan, and was basically allowed to skip class to make art.

Establishing an independent presence in the art world alongside such a companion would have been a challenge for the most ambitious soul, but it's clear from the moment she opens the door that career ambition isn't what drives Jean Conner. At 79, the artist remains reserved, even shy, yet at the same time, as she gives me "the tour" of those works of hers and Bruce's hanging in the house, punctuated by the occasional gift—a Dean Stockwell collage, a Dean Smith drawing, a slice of chocolate pie by Wayne Thiebaud—I can feel the steel of conviction behind her casually expressed opinions. This is someone who's been making art her entire life, whose form of rebellion her freshman year at Nebraska was to *not* take art classes; "I decided I was being pushed to be an artist," she says, yet she would soon return to art, receiving a B.F.A. in 1955 and heading to the University of Colorado–Boulder to work on an M.F.A. Bruce meanwhile remained

FACING: Jean Conner, *Two Nudists on the Beach* (1996). Collage.

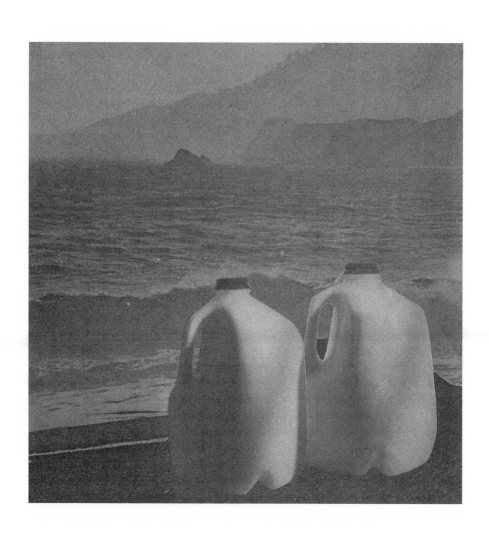

in Lincoln to complete his B.F.A., took a scholarship for a semester at Brooklyn Museum Art School, and finally wound up in Boulder on a scholarship. Yet it quickly grew apparent the Boulder faculty had little intention of abiding by Bruce's nonattendance policy, and he withdrew following her spring '57 graduation.

"That summer he went back to Wichita and worked and I went back to Lincoln and worked," she recalls. "We got married in the fall, and the day we got married we flew to San Francisco and we were met at the airport by Larry Jordan. We stayed with Michael McClure and Joanna McClure for what I thought was only a couple of days but it might have been longer. We got an apartment on Jackson around the corner from the famous Fillmore place where all the artists were: Jay DeFeo, Wally Hedrick, Sonia Gechtoff and James Kelly, Joan Brown and Bill Brown were there."

The addition of the Conners to this roster of creative couples signifies the full flowering of San Francisco's Beat visual culture, and Jean would participate in her first group show, *Something Akin to Dada*, at the Spatsa Gallery in 1959, showing a pair of collages. Two of the three collages purchased by SFMOMA, *Mercury* and *Voo Doo*, date from the following year and display one of her most characteristic modes: magazine collage. The sky in *Voo Doo*, for example, appears to be cut from a *National Geographic*–type of publication, an upside-down photo of a crowd of shirtless African men, shot from above and behind, whose originally ritually upraised hands instead dangle toward the horizon line. The closest of these men is obscured, however, by a forward-facing figure, seemingly a witch doctor–like presence clothed in a hybrid African and European garb who rests his hands on a gold disk, actually the yolk of an egg hanging by the white from the shell which forms a skull of sorts for an oversized face superimposed on a seated European woman. There are other details but this is the

collage's main movement, and the effect is striking: against the dark background and upside down, the eggwhite transforms into a beam of light sent from the shaman's orb into the woman's skull, pried apart by a pair of godlike hands. The restraint with which Conner places the individual elements, from which drama and mystery emerge unforced, was evident in other, later collages she showed me that afternoon, like *Two Nudists on the Beach* (1996), a pair of plastic milk jugs on a beach clearly gazing *out* to sea, such that the dent in the bottom of each jug unmistakably conjures the cleft of the buttocks. Or *At Sea* (1981), a ship bearing a large gold watch and chain, evoking both anchor and life preserver but putting them in tension with the concept of time, enemy of stability and eventual bringer of death. (And too, the sea appears to throw this mooring into the boat, rather than vice versa.)

What is ultimately most striking about her collages, even from so early a date as *Voo Doo*, is the complete freedom they exhibit, unconstrained by scale or genre as Conner blends photographic images with reproductions of paintings and drawings, creating an evenly textured, coherent whole with depth and movement from disparate source material. These days, however, she generally sticks to purely photographic images, in part due to changes in the nature of print technology.

"I want the collages to be as seamless as possible," she says. "But now magazines are digital and the color is different, more fluorescent; it's hard to find soft blues, and you don't have those subtle differences."

*

The Conners first lived in San Francisco until 1961, when they left for Mexico City, a move largely driven by Bruce's fear of a nuclear holocaust.

"That was Bruce's idea," Jean admits. "But I wanted to go. It was go-

ing to be fun. Bruce'd had several successful showings, here and in New York, not making much money, but he figured we could live inexpensively in Mexico, and he was worried about the bomb and wanted to get out of where the bomb would be dropped."

Before they left, however, Bruce organized her first solo shows, at the UCSF Medical Center—where Jean worked as a clerk in the women's clinic—and in the basement of City Lights, and throughout his life, she insists, he was her biggest supporter, seeking opportunities to show her work much as he lent behind-the-scenes assistance to such artists as Jay DeFeo and Joan Brown. I confess to probing a bit on this point, wondering if he might've done more to promote her work, but while Jean's reminiscences about her late husband run the gamut from admiration to exasperation, they never hint at anything like resentment.

"I didn't care about showing; I just liked to do the thing," she says simply, and while she seems to appreciate the attention her own work has drawn in the past few years, fame figures little into her calculus, as the following anecdote concerning Bruce's Hollywood connections illustrates.

"Bruce and I had gone down [to L.A.] to the Ferus Gallery and we were going to go to Barney's Beanery, because Dean Stockwell was supposed to meet us there," she recalls. "I had no idea who 'Dean' was but everybody was saying, 'Hey, Dean's going to be there.' I remember I got seated next to Dean and I just said, 'Hello.' I was very unimpressed. Everyone thought I was real cool but only later I found out he was Dean Stockwell, the movie star. And that's the way I felt about a lot of those people we got to know. Dean Stockwell, Dennis Hopper, Sam Francis. It didn't make any difference that they were famous movie stars, dancers, artists. They were just nice people."

The Conners would spend about a year in Mexico, meeting up with Philip Lamantia, who helped them find a place to live and introduced them to the curanderos market where Bruce bought various religious or magic talismans to incorporate into his assemblages. They also encountered Timothy Leary, with whom Bruce ventured into the Mexican countryside LOOKING FOR MUSHROOMS (1967/1997), as documented in his film of that title.

Still, Mexico proved to be a far more restrictive environment for Jean. Women didn't walk around alone in Mexico City, she says, and certain places, like the flea market where Bruce also bought materials, were deemed too dangerous for her to accompany him. For much of their stay, moreover, she was pregnant with their only child, Robert, who was born in September 1962 about five weeks before they returned to the U.S. The effect of these circumstances on her art—judging at least by those pieces she shows me that afternoon—is palpable, as the intensive hunting and gathering implicit in collage suddenly give way to comparatively stark pencil drawings, as though the artist were thrown back on her inner resources even as the imagery itself seems to derive to some extent from her external surroundings. She would pick up with her collages right where she left off—*Temptation of St. Wallace* (1963), the third of the SFMOMA acquisitions, follows seamlessly from *Mercury* and *Voo Doo* of three years before—but throughout her life, much like her notoriously protean husband, Conner has pursued whatever medium has suited her mood, even foraying into stained glass on occasion. And too, she is quick to add that she's volunteered for the past 25 years as a member of the Friends of Glen Canyon Park, "pulling weeds and planting native plants," as if to say, it takes more than making art to make an artist's life.

*

With their money running low, the Conners returned to the U.S. in 1962, briefly staying with Bruce's family in Wichita before accepting an invitation to live at Timothy Leary and Richard Alpert's commune in Newton, MA. But the family's residence there was brief.

"There was supposed to be a meeting," Jean recalls, "in which Timothy would talk about what his plans were, but before the meeting, Bruce was called in by Dick Alpert and was told how he was to vote. Both Bruce and I thought this was a co-op sort of thing and as a woman I felt pretty much like a slave because there were a lot of people there to feed."

Indeed, according to Jean, despite the fact that she and the only other woman resident at the time, Barbara Dunlap, did nearly all the cooking and cleaning—in addition to each caring for a child—women had no say in the affairs of the commune.

"Women weren't allowed to vote at this meeting, only men," she continues. "And the men were told how they were to vote. So we moved out after that and into an apartment in Brookline. We were there until Bruce managed to get a fellowship in filmmaking and it was enough money so we could get back to San Francisco and start over here."

The family settled in the Haight-Ashbury district in 1965, just in time to participate in the city's burgeoning psychedelic scene. Yet despite the freewheeling atmosphere, Jean says, their involvement with the then-still-legal LSD was minimal. After a harrowing experience with psilocybin administered by a psychiatrist, Jean had no interest in hallucinogenic experiences, while even Bruce was less inclined to such experimentation than his associations might suggest.

"I never really knew how much Bruce did with drugs, but it wasn't like some people seemed to think when we're living in Haight-Ash-

bury," Jean says. "People were taking LSD all the time but it was never like that with Bruce. He never brought any drugs in the house."

By the late '6os, in any case, the Conners decamped for Twin Peaks; during this period, in 1972, they would stage a "family show," including works by the 10-year-old Robert, at the Quay Gallery in San Francisco and restaged the following year in L.A. Bruce also staged another show of Jean's collages in the basement of City Lights in '73, the same year the family moved into the Glen Park home where she still lives today. Though she occasionally hung work locally—in nongallery spaces like the Glen Park Branch Library and various cafés—and appeared in a 1991 Spatsa Gallery retrospective in Davis, CA, and the 2005–07 traveling show, *Semina Culture: Wallace Berman and His Circle*, the '73 City Lights show seems to have been her last solo exhibition outside her own neighborhood until 2008, when Bruce persuaded his L.A. dealer, Michael Kohn Gallery, to mount an ambitious retrospective of her *Collages*. Incorrigible to the end—the show was still up when he died on July 7—Bruce was "furious" when he saw a DVD of how the show was hung.

"Golly, it was so big," Jean says, "and it was hard for them to figure out how to hang it. And of course Bruce couldn't go anyplace at that time so he couldn't be there. He thought if he had hung it, it would have made a big difference. Anyway, that wasn't very much of a success. But then after he died, we had a show together at Michael Kohn's which was successful for me, and for Bruce. That's where SFMOMA saw my collages and bought them."

The show in question, *Circa Sixty: Bruce Conner & Jean Conner* (November 2011–January 2012), chronicled the work of each artist between 1958 and 1964, or roughly from when they first arrived in San Francisco to just before they returned there from Brookline, suggest-

ing parallels in their output even as it foregrounded their individual identities as artists. Jean also recently took part in a group show at Smith Andersen Editions in Palo Alto, CA—*Gender Specific: Take It or Leave It*—alongside such iconic women artists as Helen Frankenthaler and Claire Falkenstein, and had a pair of collages in *Renaissance on Fillmore 1955–1965* at the di Rosa Gallery in Napa. Hopefully, SFMOMA's acquisition of the three collages is just the beginning of Conner's emergence into the art world's consciousness as a major artist in her own right.

2014

"DEATH WILL BE MY FINAL LOVER" THE LIFE OF ALDEN VAN BUSKIRK

God wants to fuck me too,

and death will be my final lover.

I give her all.

　—*"Last will and,"* Lami

In December 2011, at poet David Highsmith's shop Books & Book-shelves in San Francisco, I participated in an event memorializing the 50th anniversary of the death of a poet still obscure today: Alden Van Buskirk. When he died on December 11, 1961, Van Buskirk, or "Van," as he was known to most of his friends, was only 23 years old and, apart from appearances in student periodicals, had yet to publish a poem. What I found astonishing, therefore, was just how many people who had known him turned out to share their reminiscences and read from his work.

Though Van spent the last four months of his life in Oakland, and died at Moffitt Hospital on the UCSF campus, his roots were in Vermont and most of those present had known him at Dartmouth College in New Hampshire or later at Washington University in St. Louis. Some, including his sister, Lauren Pike, had made the trip just for this

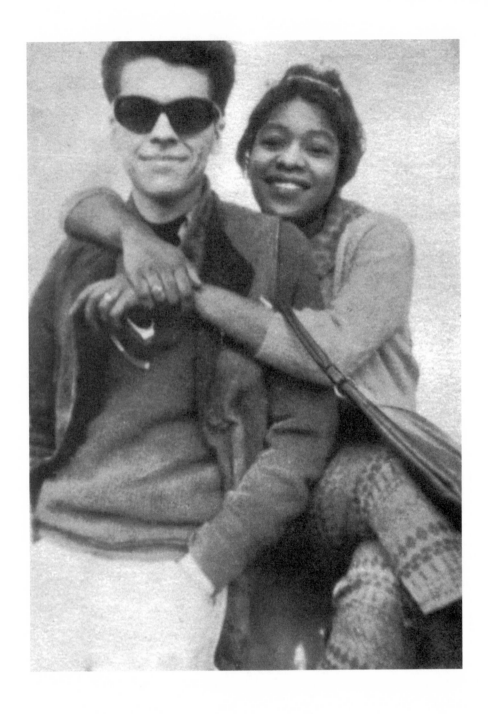

reading, but many—including his girlfriend Martha Muhs, his close friends Peter and Pinky Kushner, and his Dartmouth mentor Jack Hirschman—had chanced to move to the Bay Area only many years later. Even his Oakland roommate, poet John Ceely, had spent many intervening years in New York City and rural Wisconsin, before returning to live not terribly far from where he and Van once shared an apartment. Though I'd been reading Van for almost a dozen years, I'd never truly grasped how magnetic a character he must have been, to inspire such devotion as I witnessed that evening. As many of the participants were in their 70s, moreover, I also realized it was high time to write a portrait of Alden Van Buskirk, before the living memories disappear.

*

Who was Alden Van Buskirk? His literary remains have a picturesque randomness worthy of a character in a Borges story. They are:

(1) *Lami*, a curiously titled, 91-page, posthumous volume of poems largely written during the last year of the poet's life and published by Auerhahn in 1965, with an introductory note by Allen Ginsberg. The book is divided into four sections corresponding to Van's life and travels: "Lami in Oakland," which features the long, nine-part title poem; "Lami in St. Louis," which includes 14 numbered "Tales" set in St. Louis; a section of miscellaneous early poems mostly set in Vermont; and a final section composed of a poem and a letter dated "November '61."

(2) Three overlapping essays, "Van," "The Angel," and "Harvest," in *How I Became One of the Invisible* (1992), by David Rattray, himself an only slightly less shadowy literary figure, perhaps best known as a translator of Artaud, and also the editor of *Lami*.

FACING: Alden Van Buskirk and Freddie Quinn, ca. 1961. Frontispiece photograph for *Lami*. Photographer unknown.

(3) An article in the *New England Journal of Medicine* (8/31/61), "Paroxysmal Nocturnal Hemoglobinuria: A Successful Imposter," by James G. Gaither, M.D., who, as a med student, first correctly diagnosed the rare blood disease from which Van would soon die. Van is the "22-year-old . . . graduate student in English literature" who serves as the basis of the "Case Report."

(4) A passing and incorrect listing of Van Buskirk in the chapter on "negro poetry" in *American Poetry in the Twentieth Century* (1971) by Kenneth Rexroth.

Rexroth's error here is worth remarking, insofar as I've seen it perpetuated over the years in the odd reference book that will list Van as an African American poet. As far as I can tell, the mistake stems from the iconic b&w frontis photo of Van tipped into *Lami* and also reproduced in Paul Carroll's *The Young American Poets* (1968). In the photo, Van stares at the camera from behind dark, wraparound shades, something between a smirk and a sly grin on his face, while a young black woman—identified as "Freddie" in the frontis version—drapes her arms around him affectionately. Even with his coif of dark curls, he still seems self-evidently white in this photo, but viewing it through the lens of Van's own poetry apparently led Rexroth to assume the poet was a very light-skinned black man. For the poems themselves display a singular preoccupation with black American experience, notably in the title character, whom Rattray glosses in an editorial note as "Lami: Negro sometimes Oriental demon of uncertain sex." Who would expect, moreover, a white poet in 1961 to write a poem on the theme of hair-straightening, "Process," juxtaposing his own wonderment at the elaborate tonsorial effects with a final line of dialogue from a poor but proud black man: "'who cd be ashamed of their own hair?'" This is precisely the sort of cultural issue addressed with increasing frequency in African American poetry as the '60s unfolded,

and viewed in this context, as well as in light of the paucity of information on Van Buskirk available, Rexroth's error isn't quite as preposterous as it may first appear.

"He would have really loved that," Martha Muhs suggests, imagining Van's feelings about Rexroth's mistake. When she met him in February '61, Van was living in a mixed household in the black section of St. Louis, and when he moved to the Bay Area, he settled in a black neighborhood where Downtown and West Oakland meet. Van's interest in, even identification with, black American culture was pronounced and broadly places his work in the lineage of Beat literature. His attraction to black culture, moreover, seems part and parcel of an overall rejection of late '50s/early '60s mainstream American culture, an attitude summed up early in "Van" when Rattray depicts his friend taking in the Dartmouth campus with "a sweeping gesture" and saying, "No one in their right mind would be willing to fire shots in anger to defend this." As Rattray's textual note suggests, "Lami" isn't simply racially ambiguous, but its gender and sexuality (even its humanity) are also "uncertain." As a poet, that is, Van was drawn to transgressive figures, be they drug users, petty criminals, sexual deviants, or the weird Ariel-cum-*Doctor-Sax* persona of his title character.

Ceely links this aspect of Van's sensibility to his poetics as expressed in "Poetry now—1961," where he writes, "Fuck Olson & the crowd. Only Ginsb., McClure, and Wieners for me."

"Every one of those three is totally original," Ceely says. "It's not like 'Howl' reflects the reality of that time; it sets it. So Van is saying, 'I'm off to set a new reality here.' That's the way I take it, because 'Olson & the crowd' were writing these nuanced, reflective, reality-type sentence takes on what's happening. I think it was *Dark Brown*, *The Hotel Wentley Poems*, and *Howl* that showed Van you could do new stuff now."

*

Alden Van Buskirk was born on July 3, 1938, in Rutland, Vermont, to Robert and Martha Elizabeth "Betty" Van Buskirk, the oldest of their three children. Though the surname is Dutch, the family's ethnic makeup, according to his sister Lauren, is primarily Danish and English, with a hint of Irish. Their economic background was middle-class; Robert worked as secretary-treasurer of the local utility company, while Betty was a substitute teacher. An accomplished ice skater and skier in his teens, Van was at least partly motivated to enroll in Dartmouth in 1956 to join the ski team, though he had to accept a Naval ROTC scholarship to afford to attend. Peter Kushner, who met him during freshman orientation, also recalls Van working in the cafeteria to help pay for his studies.

Van's early undergraduate days were marked by two significant events, the first of which was the death of his mother, in 1958, after a long battle with cancer. According to Peter Kushner, though he didn't discuss her death directly, Van spoke of the "terrible dreams" he had of her afterward, as recorded in his poem "from Forest Park fragments." Later that winter, he also experienced his first attack of Paroxysmal Nocturnal Hemoglobinuria (PNH). As the word "paroxysmal" suggests, such attacks were violent and painful, accompanied by severe vomiting and usually requiring hospitalization. According to the *New England Journal of Medicine* article that uses Van as a case study, "the most typical presentation" of PNH is "abdominal pain, fatigue, weakness, anemia and dark urine," all symptoms Van suffered from, alluding, for example, to the characteristic "black piss in the / morning bowl" in "Lami in Oakland." An extremely rare disease—affecting "only 1 out of every 500,000 people"—PNH is difficult to pinpoint, and Van wouldn't receive a correct diagnosis for another two years, by which time he had mistakenly undergone a splenectomy. This may

have hastened his death, but PNH was pretty much a death sentence; fifty years later, it is better understood but remains difficult to treat.

"If his disease hadn't overtaken his physical strength, he might not have gone so thoroughly into poetry," suggests Ceely, who met him around this time. "He came to Dartmouth to be an athlete. He was still on the ski team but he wasn't doing that great so he started putting more energy into poetry."

Fate also seems to have played a role in his development into a poet, in the form of two decisive encounters during his senior year. Though they met briefly Van's freshman year, he and then-graduating-senior David Rattray wouldn't really become friends until the latter returned to town in 1960 after an extended European sojourn. This return occurred midway through a two-year teaching stint at Dartmouth by communist poet and perpetual nonconformist Jack Hirschman. Peter Kushner recalls the potent combination of these encounters.

"I think his literary influences came mostly from Rattray," Kushner says, a statement echoed by both Ceely and Muhs. "Rattray was extremely worldly. He'd gone from Dartmouth to France and Germany and spoke seven or eight languages to some degree. He had discovered Stefan George and people like that, Büchner, Rilke, Verlaine and Rimbaud, Artaud, but not the Beats."

"The Beats came to Dartmouth via Jack Hirschman," Kushner continues. "When Jack came to Dartmouth, the first thing he did was have a poetry reading. Jack read from Mayakovsky, he read one of his own poems, and then he read 'Howl,' the whole thing with the footnote. The college had never heard anything like this."

I asked Hirschman whether he recalled such a set-list and he smiled broadly and nodded, still savoring the triumph. In an as-yet-unpublished reminiscence, he mentions visits to his apartment from

Van and Rattray, as well as a "multilingual reading series" organized by his first wife, Ruth, which roughly tallies with Rattray's own recollection in "Van" of reuniting with his friend in 1960 at "a reading of works by Rilke and John Wieners that had been organized by Jack Hirschman."

The impact of these encounters with Rattray and Hirschman can't be overestimated, as they put Van in touch with both the early European avant-garde and the most contemporary American poetry of the period. Wieners would become Van's favorite poet and an enduring influence, though a May 1960 letter to Ceely—who had already graduated from Dartmouth and was living in San Francisco—first recommends Robert Duncan and the essay on "Projective Verse" by Charles Olson from the just-published *New American Poetry: 1945–1960*. Not until August did Van write Ceely from a hospital—following another PNH attack and his subsequent splenectomy—requesting a copy of *The Hotel Wentley Poems* (1958) because it's "Sold out in New York" but it's the "Best poetry since Ginsberg in this country." In "Van," Rattray recalls a poignant scene of reading the Wieners book aloud to his barely conscious friend shortly after the operation. Van would spend the rest of the summer recuperating with Peter Kushner's family in Long Island.

*

According to his friends, Van wasn't a particularly assiduous student in his early days at Dartmouth, yet by the end, he was a standout member of the English department, earning a graduate scholarship at Washington University in St. Louis. Yet judging from his appearance in St. Louis in September 1960, he didn't seem to be preparing for an academic future. At a time when grad school was more of a shirt-and-tie affair, "Van," in Rattray's words, "sauntered in in ink-stained

khakis, a teeshirt full of holes, and bare feet in the filthiest tennis sneakers west of the Bowery." Pinky Kushner, who met Van at this time in a modern poetry class, confirms this was his habitual wardrobe, which, combined with his quiet but confident eccentricity, caused something of a stir on campus that year. The tone of Van's letters to Ceely, in any case, suggests little interest in, indeed a certain contempt for, pursuing graduate study. Acceptance of the scholarship seems to have been motivated more by the stipend, and perhaps the necessity of access to medical care. By the end of that first month, he would meet James Gaither and receive the grim diagnosis of PNH, the then invariably fatal nature of which no doubt made studying for an advanced degree seem like an even greater waste of time.

But the final straw appears to have been his encounter—on Halloween night, according to Rattray—with "a man recently freed from prison," as Van puts it in his St. Louis-based "Tales": Johnny Sherrill, a colorfully verbose conman "whose words were objects." A white man who largely inhabited the black world of St. Louis, Sherrill essentially became a Neal Cassady–like figure to Van's group of friends, though he lacked Cassady's own literary/intellectual ambitions. Through Sherrill, Van would quickly enter a whole new world. By the end of the following month (not, as Rattray suggests, after the New Year holiday), Van would write to Ceely that "I am now living w/ a 19 yr old negro girl in an old, nearly empty hotel whose mgr. is a heroin connection. I seldom go to classes & pity the dead souls there." This "19 yr old negro girl," Carol, subject of an eponymous poem, was a prostitute, "eager to support him," Rattray writes, though Van "wanted her to quit turning tricks." It's not entirely clear how long they lived together, though he eventually left her after she gave him gonorrhea, which in turn sent him to the hospital with a severe PNH crisis.

Despite this setback, Van's meeting Johnny Sherrill and Carol

seems to have inspired the beginning of the poems later gathered by Rattray as "Lami in St. Louis." It's clear that Van began "Lami in St. Louis" fairly immediately, telling Ceely in a December 5–7, 1960 letter that he's writing "fairy tales," which begin with the story of meeting Johnny and crossing the Mississippi into Illinois to an after-hours roadhouse called the Harlem Club. There Johnny unsuccessfully propositions a young transvestite for a threesome but is rebuffed. She only has eyes for Van.

But it's late & just before we go she calls me over, says, Come here "pretty boy" & I lean, she touches the soft glove to the nape curls & gently pulls me into her face, murmuring,

"Give me some sugar, baby,"

kisses lightly my cheek, I could just feel the outer edges of the lips grace the skin, without breath or pressure . . .

The scene is at once literal autobiography—Rattray fleshes out more details in "Van," presumably from a letter—and a symbolic journey into a realm outside of the American culture Van grew up in, complete with a guide, the crossing of a river boundary, and an initiatory kiss. "The idea of having sex with a boy was out of the question," according to Rattray, who, by the time of his friendship with Van, was already openly bisexual. "However, what blew Van's mind was that he could not only sit still for such a flirtation, but open his heart to it and be deeply moved by what he saw and felt in the stranger's eyes, a love that to his amazement he found himself wholeheartedly accepting." Rattray's point is worth noting here insofar as it illuminates the homosexual themes running through *Lami* and particularly in "Tales." Though by all accounts heterosexual, Van exhibits a marked interest in gay street life in his poetry and was quite evidently fascinated with Wieners's homosexuality and Rattray's bisexuality. If his interest

was, as Rattray suggests, "never consummated," his sympathies were piqued, and it is only after this initiatory kiss that the persona of Lami emerges. Influenced by both the style and the vampiric, *Shadow*-like title character of Kerouac's *Doctor Sax* (1959), the pointy-eared, black-leather-winged Lami is a polymorphous figure collaging Van's own experiences with Johnny's and others' into an ultimate transgressor, starring in the 14 numbered "Tales," as well as various subsequent poems.

During the winter break of 1960–61, Van would visit Rattray, who by then was living in NYC and had made contact with various poets there, including Wieners. Of his own meeting with Wieners, much anticipated in letters to Ceely leading up to the event, Van has little to say; I infer mild disappointment that Wieners was "so far out [he could] hardly talk," though the encounter doesn't seem to have affected Van's admiration for him. He also writes of a New Year's Eve party at LeRoi Jones's, where he played jazz with Larry Rivers and Ted Joans, though a promised appearance by Ginsberg failed to occur. Other writers he met on this trip include Ray and Bonnie Bremser and Bill Berkson. This NY trip was Van's only extensive foray into the poetry world; by the time he lived in Oakland, according to Ceely, "It wasn't even in his mind to go meet Jack Spicer or Robert Duncan. It was totally irrelevant to him." It's hard not to wonder whether such an attitude stemmed from his NY experience, finding the poetry scene wanting, or whether, as it perhaps grew apparent that his days were numbered, he simply didn't have time to spend on such ancillary activities.

Back in St. Louis for the spring semester, Van moved into a house at 459 Laurel St. with Johnny and his girlfriend Freddie Quinn, the woman from the frontis photograph of *Lami*, as well as her cousin Nackie, a student friend of Van's named Gary Merritt, and others for

varying durations. Though it was a segregated city, such interracial households were permitted, according to Pinky Kushner, a St. Louis native. "There were white people in the black neighborhood even then," she says, "that had been there for generations." Nonetheless, "the House," as it's invariably referred to among Van's St. Louis friends, quickly became a hotspot for curious students and neighborhood residents alike.

"The House happened and everyone went to the House," Pinky Kushner recalls. "That year Alden was in St. Louis, he was the center of attention. He collected all these things around him, and people just naturally gravitated there."

One of those people was 19-year-old undergraduate Martha Muhs, who soon became his girlfriend.

"He was very charismatic, but in a calm way," she says. "People would come to spend time with him because he was unusual. And Johnny was always sorta on, a naturally exuberant type of person. Alden was really entranced with his verbal abilities."

Muhs provides tantalizing details of her time together with Van, many centered on music. Their listening included Coltrane—whom Van had seen live in NYC with Peter Kushner—Monk, and Davis, cool jazz like Dave Brubeck and Paul Desmond, and less obvious figures like jazz-blues singer-pianist Mose Allison. The couple also caught Ray Charles live in St. Louis on Easter Sunday (4/2/61). Most memorably, she recalls accompanying Van to practice rooms at Washington U to hear to him play, for, as Rattray also testifies, he was an astonishingly adept jazz pianist. Though Muhs never recorded Van, she possesses a copy of a tape, made by his childhood friend Lisa Yeomans, of the poet running through Jerome Kern's "Pick Yourself Up" with such offhanded mastery it's a wonder he didn't pursue music instead.

"In Oakland, he was thinking of renting a piano and having it in our apartment," Ceely recalls, "but then he finally said, 'I don't want to do it, because it would take away from my writing.' He was too good as a pianist; he couldn't just fiddle around."

Another memorable experience involved a box of peyote buttons Rattray had sent from NY. Though Muhs didn't go into details, Pinky Kushner recalls encountering the pair at the House after they'd eaten several.

"I got over there after the stuff had started," she says. "From downstairs I could smell the vomit. When I got up there it just reeked. They were getting ready to go out and said to me, 'Would you like to eat some of this?' I said, 'NO!' We went out for a walk and it was just beginning to rain. All of a sudden they started talking about how the raindrops were turning all these different colors. Well, I saw it too! We were all walking down the middle of the street marveling at how gorgeous the whole world was."

The incident is significant as the first of at least three experiences Van will have with hallucinogens in the year leading up to his death.

Among Van's friends, there's some uncertainty about whether he dropped out of Washington University or completed his course work that year; his classroom attendance, in any event, was minimal and he seems to have decided not to return well before the end of the academic year. Instead he and Rattray decided to go "on the road" to Mexico, in order to live cheaply and write for an unspecified period. This plan predated his relationship with Martha Muhs, which complicated things but didn't deter him. Though he was leery of making firm commitments due to his disease, Van and Muhs decided they would live together in NYC after his Mexican adventure. In mid-June 1961, having dropped out of Washington U, Muhs went to NYC to find an apart-

ment, while Van and Rattray began an amphetamine-fueled drive to El Paso, Texas, where they left their car, "crossed the border and caught a southbound bus out of Juárez."

*

For Van Buskirk and Rattray's adventures in Puerto Ángel, Oaxaca, Mexico, I refer the reader to *How I Became One of the Invisible*. Rattray is the only source here and summary would be an injustice to that idiosyncratic book. The consensus among Van's friends is that Rattray tends to embellish his tales in the telling, so it's difficult to know the extent to which events have been transformed by his imagination. Nonetheless, it does seem to be the case that they nearly got themselves killed trying to steal a shipment of high-grade marijuana from a drug cartel in Nochistlán—somehow I doubt they'd have made it out alive today—and needed to flee in a hurry. As they retreated back to the U.S., they bought a pound and a half of marijuana that they smuggled over the border taped to their legs and torsos.

"That was my introduction to marijuana," Ceely recalls, confirming the existence of this stash, which they smoked and occasionally sold at parties after the pair's sudden arrival in the Bay Area in late July/early August.

This story of attempted robbery and successful smuggling is one of the stranger episodes in Van's life. The behavior seems insanely dangerous, though I suppose 50 years ago the Mexican drug wars and the U.S. war on drugs weren't quite what they are today. But Van was only 23, young enough not to fully appreciate the danger, and perhaps some of Johnny Sherrill's criminal tales had fired his imagination. But there was also a dark side to Van's personality brought out by the knowledge of his deadly disease.

"He would say things that would strike me as cruel," Ceely recalls. "He'd say he was all for nuclear annihilation, that that was the only way for international lovemaking to occur."

Asked whether this was genuine nihilism or a blackly humorous stance, Ceely replies: "A bit of both, I think. He was struggling to find a way to face his own death and humor was one of those ways."

As for Rattray—who, Bataille-like, finds himself "horny" at the prospect of his possible death as he and Van prepare for the robbery—he too was plagued with mental demons, according to Muhs, who became his lifelong friend.

"David himself was an incredible personality," she says. "I think everyone who knew him, either didn't like him at all, or were ambivalent because he had some wonderful qualities. He was truly altruistic. He wanted to help other people and wanted them to love what he loved. You became very interested in what David could tell you, because it was living. But his inner emotional life was rocky."

Indeed, not long after their arrival in the Bay Area, Van and Rattray argued, with the curious result that Rattray was sent packing to St. Louis to visit Van's friends.

"Dave was a mentor, definitely, to Alden," Muhs says, "but—not but, and, Dave was in love with him. Dave became a bit too much *there* when they were living together in San Francisco. It was overwhelming and Alden said, 'I can't do this; you're gonna have to go.' I met him for the first time when he came back to New York and there was no question he was tormented." Though they remained in touch by letter, and planned to meet back up in New York City, Rattray would never see Van alive again.

*

When Van arrived in the Bay Area, John Ceely was living in San Francisco, but by September, the two poets had moved across the Bay to a residential hotel at 2351 San Pablo Avenue in Downtown Oakland. No one is sure why Van decided to linger in Oakland; my guess is he'd planned to remain in Mexico far longer than he did and was still "on the road." To a guy from Rutland, Vermont, Oakland must have been at least as exotic as Mexico, because, with its heavily multicultural mix, Oakland is Africa, Asia, and Latin America rolled into one raucous and vibrant American city. My sense from his poetry is that he fell in love with the place:

> *sirens in the night—*
>> *the city is crying for her lost lovers*

> *Broadway, Oakland—*
>> *endless Army Stores, Western Swing*
> *Bars, 40¢ movies the backdrop for a parade, no the orbit of*
> *sailors apprentice hipsters & 2 bit hustlers . . .*

> *cool bodies circling in neon light—*
>> *pure light of the spirit the senses' live-wire ends*
> *known in pot paranoia*
> *.*
> *. . . a plate of carnival colors over the coast hills*
> *whirls a saturn of rainbow stripes into eternity in the hands of*
> *Wm Blake who guards the world tonight*

These lines from section 5 of the title poem of "Lami in Oakland" give a sense of the stimulation Van found in the city known as the Town. Though the army stores and western swing bars are long gone, and the movies in a multiplex, there remain downtown stretches of Broadway that decant a similar atmosphere today. The echo of "Howl," and

back of that Whitman, in the rolling catalogue of imagery isn't the most typical mode of Van's late work, but what is especially characteristic here is the way the city enters his writing in the aggregate. Whereas the people of St. Louis made a huge impression on him, here Oakland itself becomes a phantasmagoric being whose cryptic communications he receives like Aragon in *Paris Peasant* or Breton in *Nadja*. In a sense, Oakland displaces the literary persona of Lami in "Lami in Oakland"—which is thus nothing like "Lami in St. Louis"— and in so doing puts Van in direct contact with himself: "dreamt this city Oakland from a school map," as he writes in section 1, "but not this emptiness in myself." But the last lines of this section 5 show Van at his most intense and original; at such moments I feel the need to slow down lest the verbal momentum rush me past the elaborate, unstable image before it begins to form. The amount of ground he covers from this section's limpid opening to its dense conclusion declares his sophistication and ability as a poet even at so young an age.

Another reason Van might have remained in Oakland was medical. En route to the Bay Area, as Rattray reports, Van was stricken with another attack of PNH; during his hospitalization, he was referred to the Donner Laboratory, a semi-autonomous clinic for nuclear medicine within the Lawrence Berkeley Laboratory on the UC Berkeley campus. Here he met Tony Sargent, the "hip biophysicist" of the third section of "Lami in Oakland," who was studying under John Lawrence, director of the clinic and brother of cyclotron inventor and Lawrence Lab founder, Ernest.

"Dr. Lawrence wanted me to build a whole-body counter, for measuring variable levels of radioactivity in human subjects," Sargent recalls. "We were studying leukemia and other diseases, particularly strange iron or blood diseases like PNH, using radioactive iron 59 to

study how it was metabolized in the blood cells and how fast it was lost. The whole-body counter measured the loss of iron over a long period of time."

In a move that seems both characteristic of his desire to be a poet without the distraction of a job and indicative of his increasing anxiety about his health, Van signed on for this experimental research for a small stipend. During daily visits to the lab for tests, he and Sargent grew friendly, the talk soon turning to the biophysicist's sideline research into LSD. Van had apparently tried LSD in Mexico, courtesy of Rattray, with somewhat inglorious results, though he concealed this prior experience. What he hoped Sargent could do was arrange for a guided LSD trip with a psychiatrist—as Alan Watts had written of— to help him prepare mentally and spiritually for death. Though Sargent was ultimately unable to do so, he did tell Van about a paper he'd read in German by Albert Hofmann, discoverer of LSD, concerning the use of morning glory seeds as a hallucinogen by certain native Mexican peoples.

"I figured if one ground up morning glory seeds and ate them you'd have something like an LSD experience," Sargent says, citing their lysergic acid amide (LSA) content. "I told this to Van who proceeded to grind up the seeds, but he smoked marijuana with them so it was a mixed experiment. But he had a very profound experience that he talks about in [*Lami*]. As far as I know that's the first published experience in English of morning glory seeds."

The text in question—"9-17-61"—isn't a poem so much as a letter to his friends in which Van writes "I've lived my life a million times over in a few hours," describing "the endless picture/ideograms that spell all knowledge, unlock forgotten nightmares, diabolic comic strip of old illusions running on the wrong reel too fast." Despite the "terror" and "humility of weeping repentance," he recommends the expe-

rience and gives a recipe for consuming the seeds. Later, in 1966, Sargent would discuss this text with Allen Ginsberg, who wrote the intro to *Lami*, at the Berkeley LSD conference.

"I was regretting that I couldn't give Van the experience with that psychiatrist," Sargent remembers, "but Ginsberg said, 'Don't regret that, because you gave him something really important.'"

In contrast to his life in St. Louis or his adventures in Mexico, Van's time in Oakland was quiet and reflective, spent wandering the city with Ceely or in their apartment writing. Unlike his friendship with Rattray, his friendship with Ceely was uncomplicated and devoid of tension. Their one dispute centered on Van's uncharacteristic behavior on the back of Ceely's motor scooter when catching a ride to the clinic, for in traffic the normally cool Van would grow livid, loudly cursing the drivers around them and disconcerting his laid-back friend.

"It's clear to me now he knew he was going to die," Ceely says, "and he felt outraged and swindled because he had this poetry talent, so he let it out that way."

The extent to which Van was aware of his impending death isn't fully known. Even as he was hospitalized in November '61 with a final attack of PNH, Van was making plans to move to NYC with Ceely, where Rattray and Martha Muhs were expecting them. In December, Van booked a plane ticket to land in Newark on the 18th, insisting in the meantime that Ceely head there without him.

"Van always maintained the fiction that we were going to meet in New York because he knew I was in denial that he could possibly die," Ceely says. "And grief-stricken."

The last of Van's friends to see him alive was Tony Sargent, "about three or four days before he died."

"He already had severe septicemia and he knew he was dying,"

Sargent says. "From the way he talked the last time I met him it was clear."

On December 11, 1961, Alden Van Buskirk died of heart failure associated with PNH.

*

The epilogue to Van's life that to some extent mitigates the tragedy of his early death was the creation of the book *Lami*. Edited by Rattray and collected from handwritten MSS in the possession of Van's friends, *Lami* was first typed up by Clive Matson, an early enthusiast, who, in turn, got Herbert Huncke fired up about the poems. Huncke, after months of pestering, finally got Ginsberg to take a look and he was suitably impressed. He began sending the poems out to magazines, including *Poetry*, *Evergreen Review*, and *City Lights Journal*, demanding they publish Van, and Ginsberg being Ginsberg, he was good at getting his way. Armed with Ginsberg's introduction, Ceely and Rattray persuaded Dave Haselwood and Andrew Hoyem of Auerhahn to print *Lami* in an edition of 1,000 copies. *Lami* has never been considered a major Beat/SF Renaissance book but it's managed to hang on, the introduction and the press imparting a modicum of collectibility. Inexplicably it was translated into Spanish and published in Madrid in 2003 (TF Editores). Clearly a copy fell into the right hands but otherwise, I find, even fans of Rattray tend not to know about it. Though he edited it and quotes from it, Rattray neglects to mention *Lami* anywhere in *How I Became One of the Invisible*, not even in the otherwise extensive acknowledgments. This is so weird an oversight I wonder if it's by design, to leave some work for the reader to do, because unlike his work on Artaud or Crevel, in "Van" Rattray is sharing not his research but his life.

The other epilogue is the network of friendships for which Van

served as a catalyst and which maintains itself today. The most dramatic example of this is Peter and Pinky Kushner, who didn't know each other when Van was alive, but met after his death, fell in love, and got married. They live in San Francisco; for the last few years of his life, Johnny Sherrill lived in their house. After living in NYC in David Rattray's general orbit until 1968, Martha Muhs moved to the Bay Area and lives in Berkeley. Rattray himself died of a brain tumor in 1993. After stints in NYC and Wisconsin, John Ceely returned to Oakland, where I met him a dozen years ago just when I'd gotten into Van. Talk about luck. Never have I had more help from such an extraordinary group of people as the friends of Alden Van Buskirk, and in addition to John, Peter, Pinky, and Martha, I'd like to thank Elizabeth Hunt (a.k.a. Lisa Yeomans, who made the recording of Van on piano), Gary Merritt, Jack Hirschman, Tony Sargent, and Dr. James Gaither; also Clive Matson, David Highsmith, and everyone who participated in the Books & Bookshelves memorial; and finally his sister and brother Lauren Pike and Robert Van Buskirk. This essay is for all of them.

2012

THE
INCORRIGIBLE
TORREGIAN

In Sotère Torregian, we have not simply one of the most unique poets of the New York School, but one of the most unique poets writing today. For I know no other poet who has so melded the quotidian impulse of Frank O'Hara—and Sotère did win the Kulchur Foundation's Frank O'Hara Award in 1968—with the full-tilt madness of authentic surrealism. Unlike any number of New York School poets, including O'Hara himself, Sotère is not merely influenced by surrealism; he *is* a surrealist, in ways that have resulted in great pain in his life. Though he's had his academic days—helping establish African American studies at Stanford in some capacity in the late '60s—he wasn't one of those poets who could really "make it" in the university system, and today despite unimpeachable New York School-to-Bolinas historical cred, he lives old and near-destitute in Stockton, California, a horrifying city but surrealist for all that, insofar as it's an *inland port*.

Yet he still has his champions, so I was surprised but by no means astonished to come across Coffee House Press's new and selected poems by Sotère, *On the Planet Without Visa*, with an introduction by Bill Berkson that deftly describes the poet's peculiar amalgam of the real and the surreal:

Like Arshile Gorky—with whom he shares a history of personal displacement countered by radical self-invention, as well as a brief but helpful brush with Surrealism in its official guise—his surreal moments feel instinctive rather than programmatic. There are no unearned ambiguities,

FACING: *Surrealism in California* (Sotère Torregian, Philip Lamantia, Andrew Joron, and unidentified surrealists). Photocollage by Garrett Caples, ca. 2000.

no absolutes without some direct perceptual base. . . . Torregian doesn't seek out mystery, he just encounters it in his experiences as they come, as he articulates them. Likewise, if Surrealism gave us the possibility of the twentieth-century love poem as a form of rhetorical liftoff, Torregian has naturalized it as an everyday eventuality.

Because Berkson's a poet, the economy of phrasing here is almost too splendid, so I feel the need to unpack a little. The "radical self-invention" refers to the ever-expanding ethnicities the Newark, NJ–born Sotère will declare in jacket copy. Where his bio in Paul Carroll's *The Young American Poets* (1969) begins "I am of North African (Black and Arab) and all-around Mediterranean descent (My grandparents came from the Island of Sicily, were Christians),"* the litany by 2012's *Without Visa* grows both more specific ("trac[ing] his varied ancestry to the Aghlabid Moors of the island of Sicily") and more general ("including Ethiopic, Arabic, Greek, Armenian (Byzantine), and central Asian admixture in his ancestry"). The comparison with Gorky here is more motivated than it seems, inasmuch as Torregian's surname suggests Armenian ancestry—the *ian* of names like *Kardashian*—though he was primarily classed as an African American poet during the turn-of-the-'70s moment at which he emerged.

What remains consistent throughout his evolving ethnicity, however, is his identification with the non-white peoples of the world and his rejection of the values of mainstream American society. This is

* Only once *Retrievals* was in production, thanks to the editorial work of Heidi Broadhead, did I learn that even this original bio had changed between the second and third printings. The second (1968) printing begins "I am of Sephardic-Jewish and all-around Mediterranean descent," which explains the subsequent parenthetical opposition to "Christians," while the third (1969) printing that I quoted changes "Sephardic-Jewish" to "North African (Black and Arab)." Thus we can seemingly pinpoint the beginning of Torregian's self-reinvention as an African American/Moorish poet.

evident in the "brush with Surrealism in its official guise," which I gather refers to Sotère's correspondence with Léopold Senghor and Aimé Césaire, surrealist poets of negritude. Yet too, it could equally refer to his early '70s association with Philip Lamantia, who wrote the introduction to Torregian's 1970 volume, *The Wounded Mattress*, and who represented for him a direct link to Bretonian surrealism. And while Sotère has read deeply in the subject—beginning, he has said, with his discovery of the work of David Gascoyne in the reading room of the Newark Public Library—I think Berkson's assessment of Torregian's surrealism as "instinctive rather than programmatic" is just insofar as it is *effortless*; there is no deliberate straining after weird imagery, no "apple of the automatic zebra's eye," to invoke his Chicago contemporaries, but rather a surrealist purchase on the world that emerges from the most mundane encounters. In this we see the influence of his early days in the New York School, into whose company he was introduced by Joseph Ceravolo and among whom Ted Berrigan and O'Hara (and Ceravolo) remain his primary touchstones.

Speaking of *Without Visa* as a book, I would have cherished a bit more apparatus divulging the sources of the published work, as many of Torregian's early publications are highly fugitive and even a sympathetic observer like me has never observed such rarities as *The Golden Palomino Bites the Clock* (1967) or *Amtrak Trek* (1979). But otherwise, at over 250 pages, the book does an excellent job drawing on all phases of Torregian's career, opening with a 1960 poem—"Death of a Poet," for Boris Pasternak—that neatly encapsulates the themes of much of Sotère's work:

> How does the world go "on" when a poet dies?
> The man next door (the husband) gets into his car
> and starts his engine, about 8 in the morning, getting ready
> for "work". His wife, the neighbour,

Mrs. Czapalinski, his wife, looks out
her window for a few moments; on Columbia Avenue the girls
idly saunter by on their way to school with textbooks
 chatting between bursts of bubblegum

..

Here in this room, it is only I
 who look on, a solitary,
who knows your name, who lives on

..

Here the TV blares the words
of murderers (Those who govern the nation and those called
"distinguished" leaders of industry)
And their words are taken as "true"

Here we glimpse the ingredients of many subsequent meditations: the lone poet contemplating another, "suicided by society," in Artaud's phrase; his alienation from practical, workaday life, regarded in quotation marks; his Marxist indignation at the tragedies and inequities of the industrialized world; his generalized and permanent romantic longing. This last element dwells at the heart of his poetics, the "love poem as a form of rhetorical liftoff" that he has "naturalized" "as an everyday eventuality," in Berkson's apt phrase. For Torregian is blithely, enthusiastically, incorrigibly in love with "Woman"—specifically "the beauty and courage of Woman!—who *inspires* (yes, I use that word!) me on my journey towards the Marvellous," as he writes in his handwritten "To the Reader"—in a way that has so long been identified as "problematic" I have difficulty knowing what to say about it, particularly as it occasions his strangest, most individual lyricism. It's a kind of libidinal madness. The list of women who serve as inspirational vehicles to the marvelous as gleaned from titles and dedications is comically vast and poignantly varied, including but not limited to Donna Reed, Vanna White, Anne Hathaway, Lisa Nowak, Amber Tam-

blyn, Anne Waldman, Sandy Berrigan, Alice Notley, Tom Clark's wife, Andrew Joron's wife, my ex-girlfriend. Barbie. Among its new work, *Without Visa* contains not one but two poems for Paris Hilton, the first of which, "An Heiress," gives an indication of the world seen through Sotère-tinted lenses:

> *As you may have chanced upon*
>
> *the word for Person derives from the Latin*
> *Persona meaning an actor's mask*
>
> *It's been some eighty-four or more years since*
> *they excavated the tomb of the young African boy*
>
> *Pharaoh Tutankhamen (You could*
>
> *Easily have been the boy-king's consort*
>
> *Or for that matter, a resident of*
> *Ludwig of Bavaria's castle)*
>
> *"The Moving Finger writes"*
>
> *A malingerer my self when it comes to anything external*
>
> *to the realm of poetry My own attribution to longevity*
> *is to follow the dietary regimen of "the oldest woman*
> *in the world", Khfaf Lasuria of Abhazia,—imbibe*
> * a glass of vodka daily*
>
> *But even to take the name of Woman*
>
> *La Femme it is your face reflected in*
>
> *The mirror of Venus at her toilette*
> * by Boucher*
>
> *When they ask: "Who are you, Paris Hilton?"*

What is typical Torregian are the frames of reference no other poet who would write a poem to Paris Hilton would bring to bear on such a theme: Latin etymology, Egypt's King Tut, a mad German king, a

line from FitzGerald's *Omar Khayyám* referring to the Old Testament "writing on the wall," a woman from the Caucasus Mountains determined by *National Geographic* in 1939 to be between 130 and 140 years of age, a French rococo painter. What is atypical is the dissonance felt by the poet toward the object of his inspiration, for his poems in this vein are usually conceived in pure affirmation for, say, a publisher of his work or a woman he's met once but with whom he sustains a purely imaginative relationship based on knowing her partner. But Paris Hilton is an ideologically fraught muse for a poet who otherwise venerates the likes of Che Guevara or Lenin, and he wrestles with this accordingly, associating her with decadent regimes while attempting to take refuge in the venerable, impoverished dignity of Caucasus Mountain tea-picker Khfaf Lasuria. If you track down the right *Toilet of Venus*—Boucher has several, the one in question seemingly at the Hermitage in St. Petersburg—you might detect a faint resemblance between the profile reflection of Venus and the onetime reality-TV star. You also might note the painting's displaced vagina in the tangle of fabric, ribbon, and pearls Venus fingers in the center of the painting, think back to the whole "Moving Finger" business a few lines prior, and begin to sense a pervy causality behind the poem's apparently casual if bookish construction.

Having been associated with so many major American poets, Sotère Torregian can hardly be considered an "outsider" artist, yet the anachronistic fever-dream of Woman that engenders so much of his work places it in that strange company of products by the likes of Adolf Wölfli, Henry Darger, or A. G. Rizzoli.

2012

JOHN ANDERSON, MASTER

John Anderson is among the great unknown painters of the 20th century. I say "20th" because, though he lived until 2011, he was forced to stop painting ca. 2003 due to Parkinson's disease. He painted voluminously, beginning in the '50s, but seldom exhibited, and he never before had a show on the scale of the wonderful retrospective staged by the Weinstein Gallery in 2009. As Gordon Onslow Ford's studio assistant, he learned about abstract automatism from a master, and was invited to live on Onslow Ford's extensive Inverness estate in 1966, where he remained the rest of his life. Thus he was able to pursue a pure artistic vision without needing to accommodate (or even notice) the fashions of the professional art world.

The results are astonishing. If you walked by Weinstein during the retrospective, you might have seen in the window his painting *Real Red* (2000), which seemed to run an entire block down Powell St. Large-scale works were his forte, and *Real Red* amply illustrates both what he learned and how he departed from Onslow Ford's aesthetics. For even as he embraced the latter's Zen vision of circle, line, and dot as the basis of visual experience, Anderson ultimately rejected the equation of automatism with speed. For him, spontaneity wasn't incompatible with a more deliberate architecture, within which the improvised elements could play. (The show did, however, include a pair of early exercises—paintings executed in 15 minutes—that are splendid though atypical.)

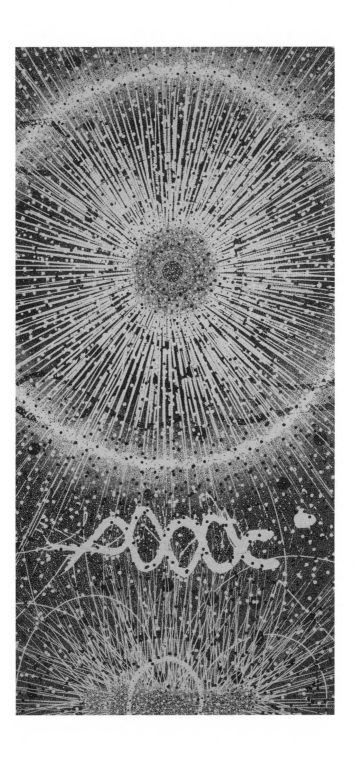

While some of his work displays Onslow Ford's influence, Anderson clearly developed along his own lines over the years. A series of blue-and-white paintings from the '70s are unlike anything I've ever seen, often composed in straight lines across the canvas that nonetheless yields various circular forms as though emerging below the surface. There are fluid abstractions from the '90s that at once give the impression of an impossible circuitry and the energy coursing through it. An electric blue often serves as the dominant tone, though his black-and-white work is equal to his use of color. This show was the first opportunity to see most of these works, but hopefully not the last for a painter who merits the designation of "master."

*

I had the fortune to meet John Anderson once before he died, before the retrospective had been staged. It was circa 2004, at the same function described in "Gordon Onslow Ford: Cosmos and Death." As it turned out, the post-reading cocktail party was held in a building built with Anderson's own two hands on the Onslow Ford compound. Somehow I was already aware of his work, probably through a collective Lucid Art Foundation show, and this recognition made him affably grumpy. He cut a ridiculous, uncomfortable figure at the party in tweed jacket and ascot, but I hadn't known then about his illness. His stiffness in retrospect was probably that of someone battling Parkinson's. Yet too, there seemed to be a lingering discomfort with the well-heeled environment in which the South Side, Chicago–born painter had found himself installed, since a chance meeting with Onslow Ford in 1958 had changed the course of his life. That brief encounter

FACING: John Anderson, *Untitled* (1995–2004). Acrylic on Masonite, 96 × 48 inches.

was the extent of our personal contact, though during his 2009 retrospective, I also arranged for City Lights to reproduce a usefully molecular-looking detail from a massive, untitled 1991 painting on the cover of Anselm Berrigan's *Free Cell* (2009). I dealt with the Weinstein Gallery rather than Anderson personally, and though I never had a chance to speak to him about it, I'm told he was pleased with the result, keeping the finished volume on his coffee table.

In composing *Retrievals*, I was searching online for Anderson's obituary because I couldn't recall the year of his death. In doing so, I came across an informative account I'd never seen by Ryan M. Jacobs, originally published in the December 1, 2011, issue of *Point Reyes Light*. Rather than summarize its contents, I direct readers to Jacobs's article for a brief account of Anderson's life. What I wish to do here, however, is quote the end of the article:

The paintings sold so well at a group exhibition that the gallery decided to host his first major solo exhibition in 2009. Weinstein said he had never seen such passion for a completely unknown name. Hosting Anderson was the most fulfilling and meaningful experience of his career.

"The moment when you see him walking into the exhibition and people start clapping and you see the tears streaming down his face, that's a moment I will never forget," he said.

The reception was astounding. Roughly 100 of Anderson's paintings flew off the walls and into collectors' homes in Houston and Scottsdale and elsewhere across the country, some of them for as much as $140,000. Anderson was elated and overwhelmed.

"This show is the first opportunity to see most of these works, but hopefully not the last for a painter who merits the designation of 'master,'" raved art critic Garrett Caples in his review for the San Francisco Bay Guardian.

Tama started calling her father a rock star. [His other daughter] Ana said the late recognition is what kept his ailing body going for as long as it did. For once, Anderson was willing to boast. He even convinced the clerk at the Inverness Store to refer to him as "master."

"I think it couldn't have happened any better," [Peter] De Swart said. "It is, in a sense, a storybook ending."

While I'd unfortunately missed the 2009 opening reception due to work, I'm both surprised and delighted to see the role I'd played in this "storybook ending." I don't think I've ever been tagged as an "art critic" before or since, and I'm happy to be the outside authority "raving" over Anderson's genius. Having written my share of journalism, I know such quotations are extremely handy and I can't even bring myself to cringe at how clichéd it looks isolated from the rest of the review that preceded it. I'd had 350 words, and had to situate the unknown Anderson by introducing him as Onslow Ford's studio assistant, so the whole "master" business was merely journalistic shorthand to then dispel any impression of apprenticeship such an intro might have left behind. (It's amazing what chintz a writer will stoop to when caught between a word count and a purpose.) But what I love about Anderson's response is that he took the compliment in the exact spirit in which it was given. That is, on the one hand, his sense of humor underlined the inherently melodramatic quality of a word like "master" and he treated the designation with all due absurdity. On the other hand, he knew what I meant and appreciated someone saying it, and the implication that such things helped extend his life after he could no longer paint, or even comfortably exist, is profoundly moving to me.

2009, 2012

THE HYPHY
HUMP

One day in 2006 I was driving around Oakland with Dontrell May-
field, a.k.a. DOT, or Dotrix4000, or 4Rax. Dot is half of the production
duo the Mekanix, having helped launch the careers of such Bay Area
luminaries as J-Stalin, Eddi Projex, Stevie Joe, Shady Nate, and G-
Stack. More recently, he and fellow Mekanic Kenny Tweed even man-
aged to land a beat on the deluxe iTunes version of E-40's *Revenue Re-
trievin'* (2011), and 40 has returned the favor with a verse on the duo's
compilation, *The Chop Shop, Vol. 2*. But back in the '90s, Dot was a DJ,
for the Luniz, Yukmouth, Saafir, and first and most importantly, Dig-
ital Underground. DU was the first rap group I ever got into, and if I
hadn't met Dot backstage at one of the group's shows, I doubt I would
have been as successful a writer on Bay Area hip-hop as I became. He
brought me into the scene, introduced me to people, tracked down dif-
ficult phone numbers. A new style of hip-hop called "hyphy" was pop-
ping off in the Bay, and with Dot's vast industry network at my dis-
posal, I was able to step into the role of journalist with considerably
more ease than otherwise would have been possible.

Back in 2006, I had no regular employment; I couldn't afford a CD
player for the car, let alone an iPod, so we were forced to make do with
my aging cassette collection, and were listening to DU's debut album,
Sex Packets (1990), for the millionth time. As the tape flipped auto-
matically to side 1 and the group's platinum hit "The Humpty Dance"
came on, I was reminded of something I'd thought of a few days be-
fore.

FACING: *Humpty Hump* (date unknown). Drawing by Shock-G.

"You know, Dot, Humpty Hump really is the original hyphy rapper," I said, citing the Groucho-nosed emcee's preference for wild partying and incoherent behavior over the gangsterism more customary in rap today. "You guys should remake 'The Humpty Dance' for the hyphy movement."

Dot looked at me out of the corner of his eye.

"'The Hyphy Hump,' huh?" he asked. He handed me the blunt and stroked his chin thoughtfully. "That might win. That just might win."

We weighed the pros and cons. On the pro side, hyphy was still a rising force in music; rappers from the Bay Area were signing major label deals for the first time in almost a decade based on its perceived commercial potential. The music had yet to suffer its artificially engineered death at the hands of those same labels and the Clear Channel–owned local rap station. It had always been my impression, moreover, that—DU leader Shock-G's artistic restlessness aside—the main cause for the group's commercial decline in the mid-'90s was the homogenization of major-label rap into the kind of gangsta-couture-speak epitomized by Jay-Z. The cartoon insanity of hyphy—from its affectation of ridiculous accessories, like grossly oversized "stunna shades" and spinning 26-inch rims, to its ol' skool, Dionysian conception of hip-hop as "going stupid" or "dumb"—was tailor-made for Humpty. He practically invented the concept of the rapper as sublime fool. And though DU was now based in L.A., the group was founded in Oakland and still fundamentally considered an Oakland group, from the platinum era of rap out here, the group that brought out 2pac. Maybe all the hyphy movement needed was the DU mothership to land to bring the situation to a head.

On the con side, well, it wasn't Dot's decision to make. After touring with DU as its DJ from '96 through 2000, Dot had dropped out to begin his production career in Oakland and was strictly a part-time

member of the crew. It was up to Shock, because Humpty Hump is Shock, or rather, one of a myriad of characters (like M.C. Blowfish, Piano Man, Rackadelic, Peanut Hakeem Anafu Washington, et al.) Shock created to people the DU universe. Humpty, however, was the one who blew up—"The Humpty Dance" was the first platinum 12-inch single in history—and after 20 years of satisfying fan demand for this character, Shock was a little tired of Humpty. (He told me once he had a nightmare where he'd died and "Humpty Hump" was written on his tombstone.) He still loved Humpty and sprinkled the character into his new music. But he'd spent a lot of energy resisting record company demands to make obvious "Humpty" records; it was the first thing any label head wanted to discuss. In many ways, the last thing Shock needed was someone in his own crew pressuring him to make a Humpty record.

But still, "The Hyphy Hump"—even the alliteration seemed to beg for it . . .

The next time I saw Dot, he was in the studio with Tweed. Even at the time, the Mekanix went against the grain by not making hyphy music, which came in handy later on when there was considerable local backlash against it after it failed to explode nationally. But the Mekanix could make anything, so I was hardly surprised to hear the hyphy-style keyboard drone surging out of the studio speakers.

"It's 'The Hyphy Hump,'" Dot said, grinning in triumph. "It goes like this: *I'm still gettin' in the girls' pants and I even got my own dance* / DO THE HYPHY HUMP / *I'm still gettin' in the girls' pants and I even got my own dance* / DO THE HYPHY HUMP."

I was impressed. This wasn't the lyric from "The Humpty Dance" that I necessarily imagined serving as the hook, but it was already out of my hands and with the professionals. But would Shock go for it? That was a delicate question even to raise. In the meantime, however,

Dot and I kept winding each other up with extravagant visions, imagining videos, record deals, a new DU album, based on this purely hypothetical hit single that Shock probably wouldn't want to do. Then one day I showed up at Dot's place in San Leandro. He was hungover but smiling, alongside an empty bottle of 1800 Silver.

"I couldn't take it anymore," he said. "I got drunk last night and called Mun."

"Mun" was Money B, the husky-voiced, pint-sized Oakland native who formed the perfect complement to Shock's lanky 6´6˝ frame. Money B was DU's second-in-command, the one responsible for bringing Dot into the crew.

"And?"

"I told him all about the idea," Dot said, "but I didn't know how to ask Shock. Then Mun was like, 'Hold on, that nigga's right here.'" He smiled ruefully at the 1800 bottle. "I kinda went off on it."

"What'd he say?"

"He didn't say 'No.' And he said they'll be in town in a couple of weeks."

The next couple weeks were a time of distracted anticipation. "The Hyphy Hump" seemed like such a good idea to me and it seemed like it might actually happen. Then I got nervous. I remembered Shock telling me that he wasn't a fast lyric writer. He had a story about making "I Get Around" with 2pac: after several hours in the studio recreating the crispy beat he'd demoed at home, Shock didn't feel up to writing a verse that day. "I'll write it later and send you the track," he told Pac. "But Shock, I need it *now*," Pac said. "I'm going back to L.A. *tomorrow* to mix the album." He grabbed a pad and pen and started pacing through the studio while Shock tinkered with the beat. After twenty minutes, he ripped out a page and handed it to Shock. "Say this!" "Back then, it was kinda forbidden to let someone else write

your verse," Shock said, "but I looked it over and I could tell he was really feeling where I was coming from. So I made a few adjustments and laid it. Nowadays I'm like, 'Hell yeah, Pac wrote my verse.'"

This is a great story, but again, the point Shock had used it to illustrate—that he didn't just peel off lyrics like that—had me anxious. I'd been around enough situations in the rap world to know sometimes there's only one shot to capture something, especially when a guy's just touching down for a night and the song's not his idea. So, although I've never been able to write a 16-bar rap as myself even in jest —Lord knows I've tried—in my intense anxiety to bring "The Hyphy Hump" into being, I decided to sketch out a verse of what I was driving at and found that I could write a rap as Humpty Hump, having listened to DU enough and long enough that I could, to a limited extent, generate material in that character. Not that it took any genius, because the concept was so simple; I just typed out the first verse of "The Humpty Dance" and gave it a line-by-line Foucauldian tune-up through the discourse of hyphy. In the palimpsest version that follows, the portions in **Cholla** are the original "Humpty Dance" showing through, while the portions in **Cooper** represent hyphy encrustations upon an already baroque sensibility. The phrases in 𝕾𝖆𝖇-𝖇𝖆𝖙𝖍 are allusions to specific lines from previous DU songs and the rest is just shit I imagine Humpty Hump would say:

THE HYPHY HUMP

Awright, stop what you're doin',
'cause i'm about to ruin
the image and the style that you're used to.
I get hyphy
so, yo, you just might see me
rock a **purple stunna nose and a white T**.
Now lemme see: I'm the 𝕭𝖎𝖌𝖓𝖔𝖘𝖊 O.G.

and my sound's laid down by 4-Thow and Kenny Tweed.

There ain't seeds in my **grapes**.

I been havin' records since CDs came out on tapes.

My name is Humpty

A.K.A. Shock.

The Yay already know the way DU rock.

My original Humpty dancers were Money B and 2pac.

We **go dumb**, *bro,*

sometimes we just **go**.

𝔚𝔢 𝔟𝔢𝔢𝔫 𝔞𝔯𝔬𝔲𝔫𝔡 𝔱𝔥𝔢 𝔴𝔬𝔯𝔩𝔡 *but come* 𝔟𝔞𝔠𝔨 𝔱𝔬 𝔱𝔥𝔢 𝕺.

You ain't know? 𝔍 𝔤𝔬𝔱 𝔰𝔬𝔪𝔢 𝔪𝔬𝔯𝔢 𝔦𝔫 𝔪𝔶 𝔧𝔞𝔠𝔨𝔢𝔱.

Yeah, I like to **thizz** *but I call 'em* 𝔖𝔢𝔵 𝔓𝔞𝔠𝔨𝔢𝔱𝔰.

I raise a racket, just like **Mac Dre**:

that tall skinny dude with the **dreads** *who gets paid and played*

on the radio.

Now blow 'fore I spray you with my big **purple** 𝔭𝔩𝔞𝔰𝔱𝔦𝔠 𝔫𝔬𝔰𝔢.

I knock holes in one; I'm like golf.

I love it when nurses say turn your head and cough.

I get off, and even though I got paper,

I once got busy in a **'94 scraper**.

I'm a musician, 𝔍'𝔪 𝔬𝔫 𝔞 𝔪𝔦𝔰𝔰𝔦𝔬𝔫.

I got my **runners** *in scoring position.*

I'm still gettin' in the girls' pants

and I even got my own dance.

Understand I didn't write this verse imagining Shock would use it—I'm not brazen enough to try to write for the guy who discovered 2pac—but just as a guide to the concept, an illustration of the kinds of connections DU could make between Humpty and hyphy. Where a hyphy artist would have stunna shades, for example, Humpty would have a stunna nose. Or the physical and spiritual connection between hyphy's late patron saint, the thizz-popping, dance-inventing Mac Dre, and Shock's sex-packet-gobbling, M.C.-Hammer-on-crack alter ego

could be underlined. In short, I wanted to give Shock a few luminous details in order to spark his own lyricism.

A few days before DU hit town—to play a gig at the Red Devil Lounge in SF—Dot happened to drop by my apartment. With much embarrassment, but still too anxious not to, I handed over a printout of the above in verse form. He looked at me out of the corner of his eye.

"You wrote this?" he asked. I nodded sheepishly. He smiled and nodded thoughtfully. "Not bad." He folded the paper and stuffed it in one of the pockets of his voluminous peacoat.

I'm not sure what I was doing the day of the show. I must have had a temp gig earlier, because I got to the hotel late, intending to roll to the club with the crew. At the front desk, I tried Shock's room; no answer. I tried Mun's room; no answer. I texted Dot. He texted me a room number. As I walked up the stairs, however, I bumped into Shock. "Shock!" "G!" He gave me a huge hug.

"Man, I just laid your verse!" he said. He pulled a piece of paper out of his pocket and unfolded it; it was the printout I gave to Dot. "Well, not all of it," he said, "but I took some of it. And check this out; you ain't gonna believe it . . ." He reached into another pocket to find his Humpty nose-and-glasses. In more prosperous times, when he had label support, Shock was getting his glasses with a custom brown plastic nose attached, but when money was tight, he'd buy a bulk box of Groucho nose-and-glasses and color the noses with various shades of magic marker. "I did this on the tour bus today before I'd even seen your verse," he said, brandishing a bright-purple Humpty nose, just as "The Hyphy Hump" called for. Offhand I don't think he knows the term, but I'd say from this and other conversations I've had with Shock that he's alive to the surrealist concept of objective chance.

As I learned when I reached Money B's room, the Mekanix had

been there for a couple of hours and recorded a verse, a chorus, and some ad-libs by Humpty on their laptop and portable mixer. Only two lines of "my verse" had actually made it to the real song: "I rock a purple stunna nose and a white T" and "I once got busy in a '94 scraper," the latter of which being an almost verbatim lift from "The Humpty Dance": "I once got busy in a Burger King bathroom." Nonetheless, I was walking on air; I'd contributed to a DU song! "I like that verse," Mun said, which completely blew my mind, because Mun doesn't hand out compliments and because, even now, if it didn't seem necessary to the story, I'd be way too embarrassed to publish my version here. I'll just assume it sold him on the *concept*.

I have no memory of that night's show, just after the show back in Mun's room with the Mekanix blasting "The Hyphy Hump" and editing Shock's ad-libs. Shock had another session elsewhere that evening and vetoed doing two more verses. "We've done that," he said, referring to "The Humpty Dance" itself as he slipped into a cab. "Do something else." The idea back at Mun's was for him to do a verse (recorded later), then to have a new Bay Area artist hop on the third verse, which turned out to be J-Stalin. Meanwhile hotel security was dropping by every 15 minutes, threatening to call the police due to the noise level as it was after 3 a.m., but nobody seemed uptight about this. There were many things going on in that hotel room besides the making of "The Hyphy Hump," but "The Hyphy Hump" was making almost all the noise. But finally Dot and Tweed broke the studio down and shoved speakers, mixer, mic-stand, and all in one massive army-green canvas bag, and the three of us literally filed through the lobby of the hotel past the three policemen brought in by management to put a stop to the mayhem. It was cinematic. Back at the room, Mun even got to pull a "what stereo?" routine to the point of extracting an

apology from the cops for disturbing him at such a late hour. Such are the conditions under which a DU classic is born.

Of course, I'd love to report that I'm writing this poolside from my mansion, and that the 2pac hologram couldn't make the Coachella gig with Dre because he's here discussing the 25th Anniversary Digital Underground stadium tour with me and Dot, but things didn't turn out that way. Within a year, before Shock and Dot worked out what to do with the track, hyphy'd been squashed like a bug, without being given a real chance on a national stage, though now here comes Drake with "The Motto," doing to the adulation of millions what the Bay did five years ago. Timing is everything in this business, so "The Hyphy Hump" hit its commercial expiration date along with everything else labeled "hyphy" in mid-2007. The song eventually saw the light of day, however, as part of a rarities disc called *The Greenlight EP* (Jake Records, 2010), so it's officially joined the DU canon. I admit I sometimes wonder what might have happened if Dot leaked it to Bay Area radio when things were popping out here. I'm not regretting the mansion, but I always feel like Shock-G's an underacknowledged pioneer of hip-hop so I always try to direct attention his way. I want him to win. As a poet, in any case, I've seldom had a creative experience more its own reward than collaborating with Humpty Hump.

2012

THEORY OF RETRIEVAL

We are not among those whose joy or sadness is a matter of importance to the world

at large, and if we sometimes make use of our own personality in these notes of travel,

it is only as a means of transition and to escape the embarrassment of forms: and then

it is not without interest to mingle the real Venice with the Venice of our dreams.

—*Théophile Gautier,* Journeys in Italy *(Daniel B. Vermilye, trans.)*

1

With the exception of its prologue, *Retrievals* is arranged in broadly chronological order by subject. The individual essays were written on various occasions over the last ten years, sometimes for a newspaper, sometimes for a zine, a blog, a journal, or a book, in a couple cases, specifically for this book. As such, there's no uniformity in manner or proportion among its constituent parts. But it makes a book nonetheless. On the one hand, it's a collection of miscellaneous prose from a poet-critic, in the tradition of books like Mallarmé's *Divagations* (1897), Max Beerbohm's *More* (1899), David Rattray's *How I Became One of the Invisible* (1992), and Andrew Joron's *The Cry at Zero* (2007). It draws chief inspiration from André Breton's four volumes of short essays—*The Lost Steps* (1924), *Break of Day* (1934), *Free Rein* (1953), and the still-untranslated *Perspective Cavalière* (1970)—though less deliberately arranged collections of poet journalism like Djuna Barnes's *Interviews* and *New York* (1985 and 1989) have also exerted their influence. On the other hand, like Barbara Guest's *Forces of Imagination: Writing on Writing* (2003), the theme only drew certain pieces to it while leaving other worthwhile material behind. The idea emerged in the wake of completing the essay on Alden Van Buskirk: to gather

those pieces concerned with writers, artists, or concepts that, for one reason or another, had either fallen off the cultural map or never fully made it on there in the first place. Or had been discredited for no good reason. Or, most importantly, whenever possible, were still alive and significant, if underappreciated, underknown.

In some respects, Retrieval has been a lifelong orientation. I remember being a kid in the pre-Internet 1980s, launching on absurd quests, like trying to find music by the Yardbirds back when all you could get by that band were terrible cassette compilations that sometimes faded out mid-song, so cruelly indifferent were the manufacturers to the actual content of the product they were selling. It made no sense to me. I'd found out by reading some liner notes or Led Zep bio that the Yardbirds' successive lead guitarists were Eric Clapton, Jeff Beck, and Jimmy Page, and couldn't believe that this music wasn't generally available, particularly the three elusive tracks—"Happenings Ten Years Time Ago," "Psycho Daisies," and "Stroll On"—that featured Beck and Page together. I wanted to hear these songs so bad it was painful, but it took years to get my hands on them. (I did manage to rent Antonioni's *Blow-Up* to catch the Beck/Page lineup mime "Stroll On," which in any case is just a souped-up "Train Kept A-Rollin'.") In the interim, I'd kept buying compilations I came across just to get my hands on one or two songs I didn't already have. It was like panning for gold in a sewer; the YouTube generation has no idea. Even after finally acquiring these tracks on an eventual trip to England, after scoring *Roger the Engineer* (1966) and *Little Games* (1967), the *Live at the Anderson Theatre* bootleg (1968) featuring "Dazed and Confused" and the unlistenable L.A. bootleg (1968) featuring a cover of Velvet Underground's "I'm Waiting for the Man," the hunger wasn't assuaged; I found myself buying, say, vinyl LPs by Renaissance and Armageddon to hear what lead singer Keith Relf was up to after the

Yardbirds. Yet throughout this obsessive period, I never exhausted the widely available Cream albums. I *meant* to, but it wasn't nearly as urgent as the quest I was on to find this unavailable music.

Still, it's easy to get lost. Many years later, I found myself at a weird impasse. I wanted to quit academia because it was hindering my development as a writer. You had to tailor your essays to fit a certain limited framework, and I either couldn't or wouldn't do this. But I felt the need to finish my dissertation, because I'd already started it and I'd been in grad school for so long I was afraid to leave without the degree. I was a hardheaded young man, and this hardheadedness had led me to write on *Finnegans Wake* and Gertrude Stein. I figured, since I couldn't do what I was supposed to do, I'd just pick the most difficult texts in the hope that people would leave me alone and then sign off at the end. The trouble was, I couldn't stand my dissertation. I was bored with it, chiefly because, not long after moving to Berkeley to begin grad school, I'd accidentally become a poet. After five years, when I technically should've been finishing the dissertation, I was publishing my first book of poems, *The Garrett Caples Reader* (1999), and hanging out with the likes of Andrew Joron and Will Alexander, Brian Lucas and Jeff Clark, Barbara Guest and Philip Lamantia. Where I felt fundamentally alienated from my academic colleagues, I felt quite at home among these supreme practitioners. It wasn't that my academic colleagues preferred the subjects of their studies to be dead and gone—though they usually did, when confronted with live ones—so much as they were unable to make judgments that weren't already sanctioned by time. Whereas the protocol among the poets I knew was entirely the opposite. The poet will disclose that which is peripheral yet paradoxically essential through the prism of his or her enthusiasm. When we were working on *The Reader*, as we inevitably referred to it, I used to drop by Jeff's place regularly, only to find him gripped

by a passage from Harry Crosby's *Shadows of the Sun* (1976) or Jonathan Williams's *Magpie's Bagpipe* (1983), out-of-the-way tomes that would become touchstones for me as well. Later, when I knew Lamantia, he would present a volume by Marcel Schwob, or a book of paintings by Clovis Trouille, as though offering some rare and exquisite drug only available to initiates of a certain level. Among poets, the whole point is, *this opinion is not sanctioned, or is sanctioned only among initiates, because this author/artist/work has escaped general notice*— with the corollary, of course, that *I, poet, am perpetuator of this esoteric knowledge.*

It took another three and half years after *The Reader* to finish the dissertation; like a lot of people, I got distracted by 9/11 and spent a lot of time protesting the war in Afghanistan and the buildup to the war in Iraq—fat lotta good *that* did—when I should have been home dissertating. But one day I finished. And when I was through, holding a blue-bound UMI hardback with my name stamped in chalk-white on the spine, I remember thinking, *what horseshit!* It wasn't so much that it was a stupid idea—it was!—as, *who cares?* It could have been the greatest dissertation in the history of literary criticism and I still would have felt like a fool. The part on *Finnegans Wake* is pretty good, but the world doesn't need me to tell it to read *Finnegans Wake*. The part on Stein sucks—she leads you in circles—and while writing on the particular novel I'd picked, *A Novel of Thank You* (1925), might have had value inasmuch as only three things had ever been written on it, Stein doesn't need me either. Stein and Joyce both made it long ago, and the most a critic could do at this point in history was showcase his or her own virtuosity as a critic. Such activity has its place, here and there, but it's not the true cultural work. As a critic, as a poet-critic, I knew I had to do better.

The concept of the *poet-critic* has always been a compelling one to me; it's hard not to admire 19th-century French poets like Gautier, writing elegant prose in newspapers on topics the general public was more interested in reading about than it was in reading his poetry. (I've never been one to hold the general public's lack of interest in poetry against it; that's the way of the world.) The compensation was that being a poet gave one a certain license as a critic to roam among all the arts. You could write about painting, like Apollinaire, or film, like Vachel Lindsay, or ballet, like Edwin Denby, or music, like Pound. And too, the compensation was money. Someone might pay you to write about painting or film or ballet or music, way more than they'd pay you for writing, or writing about, poetry. I'd left academia specifically because I thought I'd never be a successful *writer* there, but I still wanted to write, and I was so bad at finding post-academic employment, I needed to try to monetize the one thing I knew how to do. Yet being a poet—the blithering around I'd done over an embarrassing nine years of grad school—is ultimately what enabled me to do it. Like Huysmans before me shit-talking his way backstage as a *drama critic* so he could befriend an actress he was smitten with, all my publishing credentials stemmed from the poetry world when, in 2002, I talked my way backstage at a Digital Underground show as a writer of some sort. In fairness, I suppose, I'd had a brief run reviewing poetry in the *San Francisco Chronicle Book Review* in 1999, though even that had come about through a short story I'd published in an anthology called *Fetish* (4Walls8Windows, 1998), and the book section of the *Chron* didn't exactly confer the level of street cred one would want in approaching a bunch of rappers. (Does Humpty Hump read *Chicago Review*?) But I was convinced Gregory "Shock-G" Jacobs was an underrecognized musical genius, and I must've conveyed the requisite

respect and knowledge of his catalogue, because after a few minutes of small talk, he really pulled back the curtain; it was first on the tour bus to hang out and then back to the hotel for an epic interview that lasted till five in the morning.

"These are good questions," I remember Shock saying, because I didn't have the usual 2pac queries; I wanted to know about Big Money Odis, Pee Wee, Saafir, DJ Fuze, and DJ-JZ, the far-flung corners of the DU universe, and Shock appreciated that, even relished telling (and acting out) anecdotes like recovering-pimp-turned-rapper Odis sitting up asleep all night in the back of the tour bus so his suits could lay flat in his sleeping berth, or teaching Shock how to put on cologne (spray a cloud, wait a sec, and then step into it like a topcoat), or eventually retiring from rap altogether to work in the Richmond Unified School District. This last might sound like failure, but it was actually success, for Odis was part of an informal program Shock and 2pac were running called the Underground Railroad, whose purpose was to use music to help various thugged-out characters transition from criminal endeavors to more legal forms of employment.* If you look

* 2pac spoke of the Underground Railroad concept in a 1991 interview with journalist Davey D:

> 2PAC: I have a crew called the Underground Railroad and a program called the Underground Railroad . . . I wanna build all this up, so that by next year you will know the name Underground Railroad . . .
>
> DAVEY D: So what's the concept behind The Underground Railroad?
>
> 2PAC: The concept behind this is the same concept behind Harriet Tubman, to get my brothers who might be into drug dealing or whatever it is that's illegal or who are disenfranchised by today's society—I want to get them back into by turning them onto music. It could be R&B, hip hop or pop, as long as I can get them involved. While I'm doing that, I'm teaching them to find a love for themselves so they can love others and do the same thing we did for them to others.

in the credits to Pac's first album, *2pacalypse Now* (Interscope, 1991), you'll find several tracks whose production is credited to the Underground Railroad, and it was characteristic of Shock to make music under a collective, inclusive pseudonym, even as he was doing the heavy lifting. Indeed, this generosity has hurt his career to an extent; for years, for example, people didn't know that Shock produced one of Pac's hugest hits, "I Get Around," because he did it under the name "The D-Flow Production Squad," possibly to acknowledge input he might have received during the session from Money B or Pac. As an artist, moreover, Shock has been a proliferator of identities; so many "members" of Digital Underground—Humpty Hump, M.C. Blowfish, Piano Man, Rackadelic, et al.—turned out to be Shock himself, yet DU was also a genuine crew that had spawned other major label acts like Pac, Saafir, and the Luniz, so the deception was all the more difficult to uncover. In this, he said, he was inspired by George Clinton's continuous parade of personae throughout the heyday of Parliament-Funkadelic, but where Clinton's pioneering funk genius has long been recognized—DU were the first rappers to bring him back live in the studio for *Sons of the P* (Tommy Boy, 1991)—Shock-G's own pioneering hip-hop genius has yet to be fully acknowledged. This is because the outrageous cartoonishness of DU's biggest hit, "The Humpty Dance," has frequently relegated the group to the ranks of novelty acts in people's minds. But quite aside from his discovery of 2pac, Shock changed the game for hip-hop, musically. Where this music had been thin, minimalist, James Brown, Shock made it thick, maximalist, George Clinton; Shock brought the P-Funk well before Dr. Dre did, and I defy anyone to play me a rap record from 1990 that can hold up in the mix with contemporary digital production better than DU's *Sex Packets* (Tommy Boy), though Shock only had 24 tracks at his disposal. You never heard Digital Underground mentioned as a golden

age group of commensurate importance with Public Enemy, NWA, or De La Soul, but I was listening at the time, so I knew it was true.

If I recall correctly, Huysmans's adventure backstage didn't get him laid, but he did successfully place a review of the production starring the actress he was smitten with into a Parisian newspaper, and so his career as a poet-critic was begun, though obviously he went on to find his greatest fame as a novelist. In my case, the results weren't so instantaneous; nonetheless, the meeting with Shock more or less inaugurated my own foray into music journalism. It started small, not long after I finished up at Berkeley. My friend Jeff Mellin was living in Norfolk, VA, doing graphic design for the local weekly, *Port Folio*, which also housed a separate, music-only monthly called *Ninevolt*, an indie endeavor born of record stores that the weekly's corporate overlords had compulsively acquired and then didn't know what to do with. But it needed cheap content, and thus *The Philistine* was born. Broadly speaking, *The Philistine* was a monthly hip-hop column written from the perspective of a late 19th-century flâneur, not even so much Gautier (who probably would have been pretty hip) but more a blithe fool like Richard Le Gallienne. The character of the Philistine was more implied by the diction rather than fully fleshed out, and many of his investigations were purely armchair: I devoted one column to a consideration of the Snoop Dogg doll, and whether it was the first stoned doll.* But the Philistine also would sally forth into the world; I'd buy a CD, call a phone number, and wind up in an improbable situation,

* *I said so but I was wrong,*
 because how could I forget
 the Jabba the Hutt playset
 came with A FUCKING BONG?
 —The Philistine, "Errata Slips"

like a Yukmouth record release party at Moses Music deep in East Oakland. My saving grace in these situations, especially at first, was that I *was* the philistine, in the sense that I made no attempt to minimize my own difference from the culture I was visiting. I couldn't have if I tried. When I showed up at that Yukmouth party, it was like a Martian had beamed down onto the blacktop. In a good way; everyone was very friendly. It's not like they'd never seen a white dude; they'd just never seen an idiot like me—who wasn't from the hood, wasn't trying to blend in, and wasn't some type of authority figure—and coming to talk to Yukmouth about *Godzilla* (Rap-a-Lot, 2003) for *Ninevolt*, I might as well have been writing for *Mars Metropolitan News*. By emphasizing my distance from the world I was investigating, the baroque conceit of *The Philistine* was actually more realistic than most writing on rap. The Philistine was always already not down, and made no pretense otherwise. Nonetheless, I also began using the small connection I maintained with Shock-G via email to reach out to DU-related artists for articles, like Oakland's Esinchill and the Reno, NV–based crew Element, who provided tour support for Shock at the time.

All of this was building up to the release of Shock's first solo album, *Fear of a Mixed Planet* (33rd Street, 2004). This was the chance I'd been waiting for. There hadn't been a proper studio release from Digital Underground since 1998's *Who Got the Gravy?* (Jake), and the occasion of his solo debut provided the opportunity to make the case that Shock-G was an overlooked hip-hop genius. I had the line on Shock and an advance copy of the album, all I needed was the right venue to make my case. *The Philistine* wouldn't do; it was too obscure and not online, and the gig was in any case drying up, though I did devote my last column in *Ninevolt* to the album. I needed to aim higher, however, and started querying both the glossy hip-hop magazines and the altweekly *San Francisco Bay Guardian* to see about placing a story on

Shock and *Fear*. After much failure in the magazine department, I managed to convince a relative newcomer, *Rime*, to run an interview with Shock, for which I was never paid. But the real target in my mind was the *Guardian*. I'd been hitting up the *Guardian* here and there over the course of a year, because I was frustrated with the level of hip-hop coverage. I felt that, where the paper would publish articles on the most advanced local white music, its coverage of hip-hop seemed to run only MTV-deep. But the San Francisco Bay Area was home to some of the best rap music in the country, even if this music was being ignored by the Clear Channel radio monopoly and the major record labels. Neglected by the mainstream, Bay Area rap was exactly the sort of local culture an alt-weekly was supposed to cover. Though it had gotten to the point where the music editor had had me into her office to talk about all this, the *Guardian* hadn't yet budged when I came at them yet again with the proposed Shock-G article. Shock at least was famous, MTV-famous, even if the résumé was a mite dusty by rap standards, and he'd done much to foster the scene out here in the early to mid-'90s, though he was now based in L.A. Surely the *Guardian* could get behind this pioneer of Bay Area rap, this discoverer of 2pac, and let me write a feature on his new album, yes?

No.

Not that they didn't consider it, but I still wasn't able to convince them. This was in fall 2004. Yet by spring 2005, I found myself writing my first piece of journalism for the *Guardian*, a cover story about local hip-hop, including a side panel featuring Shock-G's new album and tracing the influence Digital Underground had had on Bay Area rap through the various acts associated with the group over the years. What had changed during that six-month period? Though critically well-received, *Fear of a Mixed Planet* hadn't exactly burnt up the charts.

The difference instead was that, through a modicum of radio play and major label signings, Bay Area hip-hop had suddenly become if not a hot topic, at least not an ice cold one, and a rival weekly, the then–New Times–owned *East Bay Express*, had published a cover story on the so-called New Bay movement. The *Guardian* didn't have anyone in-house to respond so I was tapped for the rebuttal. I called Dotrix of the Mekanix. A former DJ for Digital Underground turned local producer, Dot had shown up at the last DU show I'd attended and later introduced me to Kenny Tweed, the other half of the Mekanix production crew, and the rapper they were working with, J-Stalin. Through Dot's resources, I was able to assemble a very real counternarrative to the "New Bay," which both aired the grievances of older, established Bay Area acts like the Delinquents, who had kept the scene alive through sheer persistence and street popularity, and featured new artists like Stalin, who had a following in the hood and didn't subscribe to the "New Bay" concept. Such activity more or less set the tone for my journalism with the *Guardian*; I was an activist critic, if you will, trying to correct certain misleading narratives in favor of telling the story of various artists whose work was being overlooked. Ignored by the mainstream for nearly a decade, Bay Area rap needed an advocate, and the *Guardian* put me in the position to be one. But too, this self-appointed role was an occasional source of tension between the paper and myself, for is the purpose of a music journalist to report on what is hot or on what he or she knows to be important?

I'll spare you the details of what ensued, other than to say I was extremely lucky. Bay Area hip-hop not only stayed hot, it got hotter. There was something new in the Bay alright, but the name of that something—hyphy—arose from within the hip-hop community instead of being imposed from outside. For three years or so, hyphy had a good run and I managed to turn out nine cover stories plus dozens

of shorter articles. At the time, a cover story basically covered a month's rent for me, and while writing it cost far more in effort, the ratio was just good enough to make it viable. The pay was erratic, sometimes unconscionably so, but I never got stiffed. I entered newspaper journalism at a time when the edifice was rapidly falling apart; you'd try to open a door and the knob would come off in your hand, then the door would fall backwards through the frame and the room on the other side would be empty. Or worse, a gaping abyss. Nonetheless, it was an exhilarating time. As cultural work, documenting the hyphy era in the pages of the *Guardian* felt more important and true than writing about Joyce and Stein, not least of all due to the various Bay Area hoods it caused me to visit and remark upon, but mostly because I thought it needed to be done, and done with some sympathy and sensitivity. And while the stylistic excesses of *The Philistine* were necessarily purged, I somehow managed to maintain a certain manner within the degree-zero newspaper setting primarily through the use of long sentences, which were crucial, for if you can manage your clauses, you can avoid repeating pronouns and this adds up against a tight word count over the course of an article. I was in full Gautier mode, or not quite; I felt the powerful narcotic pull of getting paid to write—practical buzz indeed!—but I soon saw how easily I could lose too much of my writing life in its pursuit, as Gautier himself arguably had. I had things to write that weren't going to pay. It's no good being a poet-critic, in other words, if it prevents you from writing poems, so in the middle of the heaviest period of *Guardian* writing, I managed to publish my second book of poems, *Complications* (2007), eight years after *The Reader*. My poetic output had slowed, it was true, but this was at least partly by design; I'd stopped *trying* to write poems and relied purely on inspiration, and if this resulted in less poetry, I was fine with it, as long as the poems still came every so often.

During this period, I tried to expand my critical activities for the *Guardian* beyond hip-hop, which wasn't easy at first. When you fulfill a role for a newspaper, you may encounter a certain amount of skepticism when you try to branch out. But I eventually got to where they'd let me write the occasional small piece on art or literature; of the writings collected here, the pieces on Victor Segalen, *Martinique*, and John Anderson, and the opening section of "Surrealism and the Abstract Truth," all had their origin in the *Guardian* and there's something to me particularly satisfying in discussing surrealism or symbolism in a newspaper for the general public. You're forced to paint in broad strokes, true, but the lack of subtlety works both ways: what your statements lose in nuance, they gain in boldness. From the standpoint of practical cultural work, the appearance in a newspaper of the original 900-word version of "Surrealism and the Abstract Truth" is probably more effective than its appearance here before the 7,000 words I've added to justify its sweeping claims. Just to be able to raise such a large issue as the relationship between abstract surrealism and abstract expressionism in a newspaper review was fairly luxurious, as was sketching a little portrait of a French symbolist poet like Victor Segalen on the excuse of a new translation of *Stèles*. These aren't exactly typical alt-weekly topics, and I'm grateful to have had editors who let me get away with such pieces.

At the same time, other opportunities unconnected to the paper continued to arise, including one related to my past life as an academic. A Festschrift for one of my former professors gave me the chance to write a major essay on Bloomsbury artist and critic Roger Fry. Fry had invented the whole modern conception of art history as an academic discipline for the English-speaking world—not to mention coining the term "post-impressionism"—yet he'd seemingly

been relegated to the dustbin of history on the word of an early '90s critical theorist, Marianna Torgovnick, due to the success of her book *Gone Primitive*. Never mind that Virginia Woolf held Fry in such esteem that she wrote the first biography of him (1940), as a way of processing his sudden death, and credited him with being a major influence on her aesthetics. Never mind that Fry continually risked his reputation with his advocacy of modern art and African art. And never mind that Torgovnick risked nothing attacking Fry on the premise that his early 20th-century advocacy of African art was somehow wanting according to late 20th-century standards of sensitivity. I'd seen quite enough of such heroics, but I knew too the only way to combat them effectively was on academic ground, which is why the Festschrift was so perfect. I needed the room to *show* why her account is fundamentally wrong; simply saying so wouldn't do. Whether or not the piece has had any effect on rehabilitating Fry's reputation is unclear to me, but I'm happy the essay's out there, for no one, not even Fry partisans, had dared challenge what turned out to be an exceptionally shoddy exegesis of his work. He deserves way more than that.

I'd wanted to write the essay on Roger Fry for several years before I got the chance, and this was an important lesson, for I've learned that much time might pass between the initial desire to write about something and the actual occasion of doing so. The same was true with the essay on Alden Van Buskirk; I'd been reading that poet for a dozen years and felt an almost personal responsibility to write about him. Sometimes it's best to write in the heat of an initial enthusiasm, sometimes not, and with both essays I think I benefited from the delay. I wouldn't have been capable of writing those pieces as well as they needed to be written when I first conceived of them. On the other hand, when I was writing the pamphlet *Quintessence of the Minor: Symbolist Poetry in English* (2010), I realized that *this* should have been the

topic of my dissertation and might well have benefited had it been written earlier. For while I was writing my dissertation, I'd been immersing myself in obscure late 19th-century British and American symbolists for purely poetic purposes that, at the time, I didn't think related to my life as a critic. These days, I wouldn't go so far as to claim my interests as a poet and my interests as a critic are identical, but I would say the former often fuel the latter, whereas before they felt like separate orbits entirely. But in writing *Quintessence*, I was reconstructing this earlier period of reading under the pressure of a deadline and I occasionally feared I was forgetting certain authors or poems or details I otherwise might have included. Formally, I don't think *Quintessence* would have gained anything by being written as a dissertation—indeed, it would have lost much in terms of scope—but it would have been a dissertation worth writing. Yet *Quintessence* probably makes better reading as it stands because it remains a product of poetic life, emerging as it did from a poetry press.

By the same token, several items in *Retrievals* came about through purely poetic channels. The earliest piece in the book, "Philip Lamantia and André Breton," was first written at the request of Will Alexander for a surrealism conference at Beyond Baroque in L.A., then later published by Joseph Donahue at *Titanic Operas*. I'm almost ashamed to say I published this while Lamantia was alive, because it's somewhat personal and was done without full permission. I was calling him up for details, however, like who interpreted for him during his dinner with Breton, so he knew I was up to something and he didn't seem displeased with the result. But I'd proceeded on my own recognizance partly because it was difficult to work with Philip directly on such matters—he'd get so wound up about how he was being presented that things could quickly grind to a halt—and partly because he was in the throes of a years-long depression that made simple

hanging out impossible for him, let alone engaging in anything so psychologically invasive as stirring up his literary past. He'd been depressed for so long I didn't know what to do, so I wrote the piece unsanctioned hoping it'd be therapeutic or even cathartic for him. And too, while I hadn't the faintest intimation that he would die the following year, in the middle of my writing my first piece for the *Guardian*, no less, I was already afraid of the details of his encounter with Breton getting lost. By rights, they should be in Breton's biography, but they're not; Lamantia isn't even mentioned. Yet if you take seriously what poets like Rexroth and Ginsberg have to say, the poems Philip began publishing in 1943 at age 15 were the opening salvo of the New American Poetry, giving surrealism a similarly catalytic role there as it had in the New American Painting, as "Surrealism and the Abstract Truth" suggests. Their personal encounters were brief and few, but the connection between Breton and Lamantia is ultimately quite significant.

In some respects, it may seem odd to have essays on Lamantia and Barbara Guest in a book like *Retrievals*. Both were reasonably well-known poets in their lifetimes; both received obituaries in the *New York Times*, for example, which is some measure of wider recognition. Yet these particular essays—I've published others on both—seemed to demand inclusion inasmuch as they foreground the extent to which Philip and Barbara still haven't been placed in American literature. With Lamantia, the situation's getting absurd; on the one hand, his *Collected Poems* has been published by the University of California, placing him alongside his contemporaries O'Hara, Creeley, Duncan, Berrigan, and so forth, while on the other hand, the various Norton anthologies, even the recent second edition of *Postmodern American Poetry* (2013), act like he doesn't exist. Certainly his work isn't accorded the level of significance Rexroth and Ginsberg insisted it has.

With Barbara Guest, the case is different, as she's definitely made inroads into anthologies and canonicity. But as I wrote in "Barbara Guest in the Shadow of Surrealism," which was solicited by the *Chicago Review* for a posthumous feature issue on her work, she felt continually slighted, as if she always needed to justify the fact that she was a member of the New York School. I remember how furious she was when David Lehman published *The Last Avant-Garde: The Making of the New York School of Poets* (1998), which simultaneously relied on her memories and excluded her from the definition of New York School Poet. Barbara didn't fit the book Lehman wanted to write—the story of four young men running around Manhattan—so, according to him, she's not a member of the New York School. But trimming your subject matter in order to fit your limited preconception of it isn't a reliable critical method. Nor am I interested here in the occasionally proffered suggestion that Guest's work is somehow "too abstract" to be "New York School." The truth is, the New York School originates with five highly various and varying poets and Guest was one of them. Any account of the group that fails to take her work into consideration is simply inadequate, and the fact that, as a married woman in 1950s, she lived a rather different lifestyle than her mostly gay male poet friends is hardly sufficient reason to exclude her. Such treatment, at any rate, convinced me there's room in *Retrievals* for Barbara Guest.

4

My life as a poet-critic is a great deal different now than when it began. As I write this, I'm still on the masthead of the *Guardian* as a contributing writer, but my days running around the hood chasing after rappers are numbered. The rappers are getting younger, I'm getting older, and as of June 2012, the *Guardian* is no longer an independent paper, having been swallowed by a Canadian chain calling itself the

San Francisco Media Company LLC, which owns the *San Francisco Examiner* and the *Guardian*'s former New Times/Village Voice Media rival *SF Weekly*. As a result, both the pay and the space for articles have dwindled considerably. A young journalist now probably couldn't afford to do what I did between, say, 2005 and 2010, which was inhabit a music scene and report on it from the ground up. As I began this section of this essay, I learned the *Guardian*'s longtime editor-publisher Tim Redmond had been fired over his refusal to institute a further gutting of its already bare-bones editorial staff and it's hard not to wonder if the paper will survive. This is no different, of course, than what's going on across the entire newspaper industry, but there's an extra weight to this blow. The *Guardian* was one of the first and one of the last independent alternative weeklies in the United States, as well as one of those progressive institutions that helped define Bay Area culture. For all its hobbyhorses and shortcomings, it was a left-wing paper I was proud to write for. At the moment, however, I can't tell what it will become. But quite aside from the dynamics of the newspaper industry, I'd already shifted an increasing amount of time and energy to another defining institution of progressive Bay Area culture, City Lights. The beginning of this gradual transition is marked by "Mysteries of the Six Gallery," originally published as two separate short introductions for the first book I edited for the press: Pocket Poets 59, *Tau* by Philip Lamantia and *Journey to the End* by John Hoffman (2008). Editing may seem like another activity altogether, but it's had its impact on my poet-critic life, specifically thrusting me back into the thick of the poetry world after several years on the periphery pursuing music journalism. I was still writing and publishing poems, but I hadn't been paying attention to poetry as such. This wouldn't do, however, if I was to be of any use to City Lights, so I had to get back in the swing of things.

At the press, I've been fortunate enough to edit a contemporary poetry series, City Lights Spotlight, and there's really no better form of practical criticism than putting out some books. At the same time, however, the poet-critic in me frequently rebels against the editor's need to stay au courant, instead returning to those favored obscure poets like Hoffman and Van Buskirk. In both cases, I had unrecorded information that I felt responsible for preserving, for so little is known of these shadowy figures. Indeed, with Hoffman, I'd introduced errors into his biography that I was eager to correct, because only after I published my account did his girlfriend Karen Forrest emerge with more accurate information. With Van Buskirk, while I'd known his friend John Ceely for years, the occasion of the 50th anniversary of his death brought out other wonderful friends of his, and I realized they weren't getting younger, so my long-simmering desire to write something on him finally achieved a boil. By the same token, there were other, still-living poets I knew, like Richard Tagett, Richard O. Moore, and even mad Sotère Torregian whose work was significant and connected to major poetic movements and moments, but who were themselves underdocumented. In each of their cases, the appearance of a new volume of selected poems provided opportunity for directing attention their way. With my more occasional art writing, I've attempted to pursue a similar direction; writing about artists like Sylvia Fein, Marie Wilson, or Jean Conner has been more urgent to me than haunting galleries. I'm tired of that upwelling of interest that occurs only on the publication of an obituary. Or, as Shock-G put it in "Heartbeat Props": "Why wait until the heartbeat stops? / Yo, go on and give my man his props."

5

As I was completing these remarks, I received my first advance contributor copy of *The Collected Poems of Philip Lamantia* (2013), which, with his widow Nancy Joyce Peters and my friend Andrew Joron, I edited for the University of California Press. This is in some sense the most important project I've ever worked on, for ultimately any writing I could do about him pales in comparison with the importance of making sure his poems get back out into the world. As with the Hoffman and Van Buskirk essays, but to a greater degree, the appearance of Lamantia's *Collected* has lifted a weight from my shoulders, because I'd felt responsible for making sure the book was done right, as near as I could guess from knowing him and taking into account his mercurial, ahistorical sense of his own poetry versus the need to come to a final historical reckoning of it. Would he have been happy with the result? No way! That is, no earthly version of him from any historical period would have condoned the methods by which we proceeded. But I like to think there's a metaphysical Philip, now at peace, who at least *understands*, even if he doesn't fully approve, the reasons why we did what we did. We basically privileged the published books, except we deferred to his '60s rearrangement of his earliest surrealist work, because he never abandoned this preference after he returned to surrealism, seeing his first book, *Erotic Poems* (1946), as itself a Rexrothian rearrangement of his original surrealist impulse. Otherwise, we included all known published but uncollected poems and a few select unpublished poems. There are plenty of other cool unpublished poems in his archive that we didn't include, because we knew he wouldn't have wanted the unpublished work to overwhelm the published. He had exacting standards about what he put out there, and anything he hadn't published wasn't necessarily finished. In these principles we deferred to him but otherwise we let each period of La-

mantia's work speak for itself, something he could never quite bring himself to do. He might edit some lines when reprinting a poem in a selected, for example, or retitle a poem, based on momentary esoteric qualms, but in all cases, we followed the first book appearance, letting the Lamantia of each period have his due like a succession of Doctor Whos. He was the many in the one. Philip himself was incapable of such a perspective—who wouldn't be?—but I think it was the only way to do any kind of posthumous justice to the full measure of his genius.

Letting people or things speak for themselves, insofar as that ideal is possible, has been one of the guiding principles of *Retrievals*. In the case of people like Alfred Barr or Roger Fry, I wanted to present a more accurate picture of someone whose work had been distorted for someone else's agenda, while in the case of people like Arthur Jerome Eddy or Pamela Colman Smith, my goal was to contribute to a more accurate understanding of a period through a discussion of a neglected figure. I was also interested in people unjustly overshadowed through association with a more famous artist, like Jimmy Ernst or Jean Conner. The book also contains a great deal concerning surrealism, which is unsurprising, given how consistently maligned and misrepresented it's been, but this raises for me the question of whether *Retrievals* is a surrealist book in any broadly philosophical sense. Certainly the book wasn't originally conceived as such and there are plenty of pieces that don't touch on the subject. But if there is a surrealist orientation to *Retrievals*, it lies in the following two principles. First, though I always attempt to bring a logical rigor to support my conclusions, my criticism is largely affect-driven. That is, my arguments are usually motivated by a strong emotional response, be it love, hate, anger, indignation, what have you. Secondly, I try to give love the upper hand in this overall scheme of things. Generally speaking, contemporary commentary on

242

surrealism tends to overemphasize its negativity, relishing its physical skirmishes, intellectual violence, and internal upheavals while overlooking its fundamental positivity. The very origins of surrealism consist in a break with the absolute negativity of Dada, by poets and artists who had gone through Dada and come out the other side. Surrealism remained touched by Dada's negativity, but the positivity it planted in Dada's alchemical corruption has been by far its most potent contribution to culture. Take, for example, André Breton. Who could be more Retrieval-oriented than Breton, the man who copied the one copy of Lautréamont's *Poésies* in the Bibliothèque nationale by hand into a notebook for publication in the pre-surrealist magazine *Littérature*, who reintroduced to the literary public the still-living but nearly forgotten symbolist poet Saint-Pol-Roux, who reestablished the importance of Gustave Moreau after his reputation had faded? Without Breton's intervention, we wouldn't know of figures like Xavier Forneret, Jacques Vaché, and perhaps even Raymond Roussel himself. Though he devoted so much of his life to promoting the work of others, Breton is seldom credited with the sheer generosity of his work as a poet-critic. I admire from a distance other, perhaps grander aspects of Breton—the movement leader, the concept synthesizer— but what I've sought to emulate as a poet-critic is his spirit of generosity to the living and the dead. It's a generosity to which I aspire.

SUMMER 2013

CREDITS

Wittgenstein, a Memoir
first appeared on the website *Evening Will Come* (www.thevolta.com)

A Man of Firsts: Arthur Jerome Eddy
first appeared in *Rain Taxi* as "Widely Unavailable: *Cubists and Post-Impressionism* by Arthur Jerome Eddy"

Pamela Colman Smith at the Dawn of Modernism
first appeared in *The Emerald Tablet*

The Exotic Victor Segalen
first appeared in *San Francisco Bay Guardian* as "Victor Segalen: Empires of Self and Other"

Roger Fry and the Invention of Art History
first appeared in the Peter Lang book *Phantom Sentences* as "The Vitality of Roger Fry"

Vachel Lindsay with the Submerged
first appeared on poetryfoundation.org

Surrealism's Island: Martinique
first appeared in *San Francisco Bay Guardian*

Surrealism and the Abstract Truth
first appeared, in part, in *San Francisco Bay Guardian* as "The Abstract Truth"

A Footnote on Jimmy Ernst
first appeared on blogcitylights.com

Philip Lamantia and André Breton
first appeared in an earlier version on the website *Titanic Operas: Poetry and New Materialities*

Mysteries of the Six Gallery: Philip Lamantia, John Hoffman
first appeared in the City Lights book *Tau* by Philip Lamantia and *Journey to the End* by John Hoffman, Pocket Poets 59 as "A Note on *Tau*" and "A Note on

John Hoffman and *Journey to the End*" [this two-part intro has been combined and factually updated as new info has surfaced from Hoffman's ex-girlfriend]

Apparitions *of Marie Wilson at City Lights*

first appeared on blogcitylights.com as "Hidden Herstories: Marie Wilson at City Lights"

Barbara Guest in the Shadow of Surrealism

first appeared in *Chicago Review*

Circles: Richard Tagett and Richard O. Moore

first appeared in a shorter version on poetryfoundation.org

"Death will be my final lover": The Life of Alden Van Buskirk

first appeared in a shorter version on poetryfoundation.org

The Incorrigible Torregian

first appeared on blogcitylights.com

John Anderson, Master

first appeared, in part, in *San Francisco Bay Guardian* as "John Anderson: A Retrospective"

The Hyphy Hump

first appeared on poetryfoundation.org as "Collaborating with Humpty Hump"

ACKNOWLEDGMENTS

This book is for Suzanne Kleid. And for the hitherto unacknowledged nuclear: Maura, Bill, Matt. And for Martha Early.

The author wishes to thank, first and foremost, those artists and writers whose willingness to meet and talk provided content for this book: John Anderson, Jean Conner, Sylvia Fein, Barbara Guest, James Guetti, Gregory "Shock-G" Jacobs, Philip Lamantia, Richard O. Moore, Gordon Onslow Ford, Richard Tagett, and Sotère Torregian. Shout out to the rest of the Digital Underground crew, especially Money B, the Mekanix (Dotrix4000 and Kenny Tweed), Saafir, Esinchill, the Luniz (Numskull and Yukmouth), Eddi Projex, Element, DJ Fuze, DJ-JZ (a.k.a. J-Beatz), Pee Wee, and Atron Gregory. Also: big shout-out to J-Stalin and Livewire. And the Demolition Men (Devro and Impereal).

Next, I'd like to thank my editor at Wave, Joshua Beckman, for the opportunity to put these essays together as a book, as well as the editorial acumen that coaxed it out of an unthematic pile of prose. Thanks too to Heidi Broadhead and the entire staff at Wave for seeing it through with incredible attention to detail. Thanks to David Caligiuri for the Cadillac proof.

Next, I must thank the editors under whose auspices various individual pieces were published (give it up for the editors!): at *Evening Will Come/The Volta*, Joshua Marie Wilkinson; at *Rain Taxi*, Eric Lorberer; at *San Francisco Bay Guardian*, Cheryl Eddy and Lynn Rapoport, as well as Johnny Ray Huston, Kimberly Chun, and Emily Savage; at the Poetry Foundation, Catherine Halley, Travis Nichols, and Michael Slosek, as well as Ellen Umansky; at *Chicago Review*, Bobby Baird; for *Phantom Sentences*, Robert Kawashima; at *The Emerald Tablet*, Derek Fenner; at *Titanic Operas*, Joseph Donahue; at blogcitylights .com, Layla Gibbon and Dia Vergados; at City Lights, Nancy Joyce Peters, Elaine Katzenberger, and Lawrence Ferlinghetti.

Extra special guest thanks to the entire gang at City Lights Books.

Lastly there are other, unrepayable debts, someone who introduced me to someone or something or gave me crucial information: Will Alexander, Micah Ballard, Ann Banfield, Bill Berkson, Anselm Berrigan, Melanie Cameron,

248 John Ceely, Jeff Clark, Paul Ebenkamp, Steve Fama, Kendy Genovese, Brenda Hillman, Andrew Joron, Peter and Pinky Kushner, Brian Lucas, Peter Maravelis, Michael McClure, David Meltzer, Jasmine Moorhead, Martha Muhs, Rob Norris, John Paige, Rupert Read, Cedar Sigo, Alyson Sinclair, Martha K. Soeldner, Sunnylyn Thibodeaux, Nanos Valaoritis, Rose Vekony, Marie Wilson. Less palpably surmisable yet somehow connected to the thoughts in this book: Stephen Ramsay, June Griffin, Jeff Mellin, Matt Mitchell.

NOTES

Prologue: Wittgenstein, a Memoir

xii *For a* large *class of cases*: Ludwig Wittgenstein, *Philosophical Investigations*, 3rd ed., trans. G. E. M. Anscombe (Macmillan, 1968), §43.

xii *It will soon become clear*: James Guetti, *Wittgenstein and the Grammar of Literary Experience* (University of Georgia Press, 1993), 32.

xii *The consequences of this exclusion*: Ibid.

xiv Hearing *a word*: Wittgenstein, *Philosophical Investigations*, §534.

xiv *We speak of understanding*: Ibid., §531.

xv *What is it all about?*: Ibid., §527.

xv *A sentence is a sound*: Robert Frost, letter to John T. Bartlett, February 22, 1914, in *Collected Poems, Prose, & Plays* (Library of America, 1995), 675.

xviii *The best teaching lasts*: Guetti, *Wittgenstein*, x.

A Man of Firsts: Arthur Jerome Eddy

2 *Because a man buys a few Cubist pictures*: Arthur Jerome Eddy, *Cubists and Post-Impressionism* (A. C. McClurg, 1914), 5.

2 *If it is a plea*: Ibid., 65.

3 *Above all it will be*: Eddy, preface to 1919 edition of *Cubists* (A. C. McClurg, 1919), x.

Pamela Colman Smith at the Dawn of Modernism

5 *the first exhibition not devoted to photography*: Alfred Stieglitz, in appendix to Eddy's *Cubists*, 211.

7 *Smith studied at the Pratt Institute*: Stuart R. Kaplan, *The Artwork & Times of Pamela Colman Smith* (U.S. Games Systems, 2009), 8.

7 *what I see when I hear music-thoughts*: Pamela Colman Smith, "Pictures in Music," *The Strand Magazine*. Article appears in *Artwork & Times*, 75.

The Exotic Victor Segalen

11 *the transfer of the Empire of China*: Letter from Victor Segalen to Henry Manceron, September 23, 1911, cited in *Stèles*, trans. Timothy Billings and Christopher Bush (Wesleyan University Press, 2007), 292.

12 *Their style must belong*: From Segalen's preface, in *Stèles*, 59.

12 "The Abyss" (poem), in Victor Segalen, *Stèles*, 81.

13 investir: Ibid., 107.

13 *desire to see*: Victor Segalen, *Stèles*, trans. Michael Taylor (The Lapis Press, 1987), Nathanael Tarn's translation is "no longer wish to see save at night": *Stelae* (Unicorn Press, 1969), 16.

Roger Fry and the Invention of Art History

17 *For about 100 years*: Roger Fry, "Art-History as an Academic Study," in *Last Lectures*, introduction by Sir Kenneth Clark (Cambridge University Press, 1939), 2, 3.

17 *"Art-History" was issued*: (n. *) Donald A. Laing, *Roger Fry: An Annotated Bibliography of the Published Writings* (Garland, 1979), 28.

17 *"Art-historical" occurs*: (n. *) Roger Fry, *Last Lectures*, 3.

17 *I think we may fairly pride ourselves*: (n. *) Roger Fry's December 1930 letter to *The Burlington Magazine* appears in *A Roger Fry Reader*, ed. Christopher Reed (University of Chicago Press, 1996), 275. See also 244.

18 *Fry had been seeking an English equivalent*: Reed, *Roger Fry Reader*, 243–244.

18 Fry's 1924 essay "Art and the State," which ends with a discussion of *Kunstforscher*, in *Transformations* (Doubleday, 1956 ed.), 71–73.

18 *archaeological illusion* and *We shall never really understand*: Fry, "English Pottery," in *Roger Fry Reader*, 230.

19 *This definition of the* Kunstforscher: Reed, *Roger Fry Reader*, 248 n.27.

20 *a course of comparative applied aesthetics*: Fry, "Art and the State," in *Transformations*, 72.

20 *Nor was Roger Fry a born writer*: Virginia Woolf, *Roger Fry: A Biography* (Harvest, 1976 ed.), 106.

20 For examples of Fry's complaints of his shortcomings as a writer to Virginia Woolf, see letters 547 and 668 in vol. 2 of *The Letters of Roger Fry*, ed. Denys Sutton (Chatto & Windus, 1972).

20 *language in the hands of one who lacks the mastery*: Fry, "Retrospect," in *Vision and Design* (Chatto & Windus, 1928 ed.), 285–286.

20 *curiously alive*: Woolf, *Roger Fry: A Biography*, 105.

21 Reed's discussion of *Kunstforscher*, in *Roger Fry Reader*, 248 n.27, 421, 425.

21 *I have certainly tried to make my judgments*: (n. *) Fry, "Retrospect," in *Vision and Design*, 285–286.

22 *coefficients of a time sequence*: (n. *) Fry, "Art-History," in *Last Lectures*, 3–4.

22 *My aesthetic has been*: (n. †) Fry, "Retrospect," in *Vision and Design*, 285.

23 *By life as contrasted with art*: Fry, "Art and Life," in *Vision and Design*, 3.

23 *surprising want of correspondence*: Ibid., 8.

23 *the great revolutions in art*: Ibid., 3.

23 *What this survey suggests*: Ibid., 9–10.

24 *profound disjunction*: Reed's comparison of formalism in Fry and Greenberg, in *Roger Fry Reader*, 122, 131.

24 *[art] being reduced to its viable essence*: Clement Greenberg, *Art and Culture* (Beacon Press, 1961), 209.

24 *Impressionism marked the climax*: Fry, "Art and Life," in *Vision and Design*, 11–12.

25 *law of modernism*: Greenberg, *Art and Culture*, 208.

25 On the turn from "conformity to appearance," see Fry's "The French Post-Impressionists" (1912), in *Vision and Design*, 237–243.

25 *When once we regard*: Fry, "Expressionism and Representation in the Graphic Arts," in *Roger Fry Reader*, 68–69.

25 *I think I can claim*: (n. *) Fry, "Retrospect," in *Vision and Design*, 288–289.

26 *that the search for an objective standard*: Fry, "Art-History," in *Last Lectures*, 16.

26 *what matters is the intensity*: Ibid., 9.

26 *fundamental difference* and *Nature levies a very heavy tax*: Ibid., 10–11.

26 *And so art is conceived*: (n. *) Fry, "Post Impressionism," in *Roger Fry Reader*, 103.

27 *Art is purely a family matter*: Fry, "Art-History," in *Last Lectures*, 11.

27 *an influential postcolonialist critique*: Refers to Marianna Torgovnick, *Gone Primitive: Savage Intellects, Modern Lives* (University of Chicago Press, 1990).

27 *recognizes and attacks contemporary* and *speaks from within these prejudices*: Torgovnick, *Gone Primitive*, 88.

28 *through the mud*: Ibid., 89.

28 *Fry's discussions of African pieces*: Ibid., 88.

28 Torgovnick, *Gone Primitive*: Renoir mistakenly classed as a post-impressionist (87), misidentifying the original publication date of "The Art of the Bushman" [sic] (85), and Fry as a champion of impressionism (92).

28 *Paraphrasing Woolf*: Torgovnick, *Gone Primitive*, 86–87.

28 *I say, don't you think*: Henry Tonks quote from Frances Spalding's *Roger Fry: Art and Life* (University of California Press, 1980), 129.

29 *ruffled more than a few feathers*: Reed, *Roger Fry Reader*, 234.

29 Clark apologizes in his introduction to *Last Lectures*, xxv–xxvii.

29 *We have the habit*: Fry, "Negro Sculpture," in *Vision and Design*, 100.

30 *reluctance to pronounce African sculpture*: Torgovnick, *Gone Primitive*, 90.

30 *refus[al] to persuade* and *vicious pleasure in being misunderstood*: Fry, "Mr. Whistler," in *Roger Fry Reader*, 22.

30 *he hadn't expected the level of antagonism*: Fry, "Retrospect," in *Roger Fry Reader*, 287–291.

31 *begins by raising the analogy*: Torgovnick, *Gone Primitive*, 94.

31 *The primitive drawing of our own race*: Fry, "The Art of the Bushmen," in *Vision and Design*, 85–86.

31 *a virtual encyclopedia of colonialist stereotypes*: Torgovnick, *Gone Primitive*, 94.

31 For examples of Fry not using "primitive," see *Vision and Design*, 13, 249, 300.

31 *It would be an exaggeration*: Ibid., 96.

32 *By primitive is usually meant*: Fry, "Children's Drawings," in *Roger Fry Reader*, 267–268.

32 For examples of Fry's inconsistent use of "primitive," see *Roger Fry Reader*, 102, 108.

32 *the eye, for example*: Discussion of Fry's descriptions, in "The Art of the Bushmen," in *Vision and Design*, 85–87.

33 *More than any other art*: Fry, "Negro Art," in *Last Lectures*, 83.

33 Torgovnick takes issue with Fry's use of "Bushman," in *Gone Primitive*, 97.

33 *about the near extinction of the Bushman*: Ibid., 89.

33 *quasi-Darwinist conclusion*: Refers to Henry Balfour's preface in Tongue and Bleek's *Bushman Paintings* (Clarendon Press, 1909), 3–4.

34 *mak[ing] no attempt to distinguish*: Torgovnick, *Gone Primitive*, 97.

34 *"Bushman" is still a term of self-identification*: Robert J. Gordon and Stuart Sholto Douglas, *The Bushman Myth: The Making of a Namibian Underclass*, 2nd ed. (Westview Press, 2000), xvi.

34 Torgovnick's discussion of a mask, in *Gone Primitive*, 92–93.

34 *his Cambridge colleague Wittgenstein*: Paraphrased remark, made by Wittgenstein in relation to mathematical logic, in *Philosophical Occasions, 1912–1951*, ed. James Klagge and Alfred Nordmann (Hackett, 1993), 3.

35 *to align art with science*: Ann Banfield, *The Phantom Table: Woolf, Fry, Russell and the Epistemology of Modernism* (Cambridge University Press, 2000), 250.

Vachel Lindsay with the Submerged

38 *The reason my beggar days* and *The poem called "General Booth . . ."*: Vachel Lindsay, introductions to *Collected Poems* (Macmillan, 1925), 19–21.

39 *recited to about one million people*: Ibid., xviii.

Surrealism's Island: Martinique

40 *It is a black man who*: André Breton, *Martinique: Snake Charmer*, trans. David W. Seaman (University of Texas Press, 2008), 88.

41 *unable to distinguish*: Ibid., 89.

41 *lyrical language* and *the language of simple information*: Ibid., 40.

41 *intolerable malaise*: Ibid., 39.

41 *If the light is the least*: Ibid., 59.

Gordon Onslow Ford: Cosmos and Death

44 "Artistic Genesis and Perspective of Surrealism" (1941) appears in Breton's *Surrealism and Painting*, trans. Simon Watson Taylor (Icon Editions/Harper & Row, 1972), 44–82. Matta, Frances, and Onslow Ford are mentioned on page 82.

Surrealism and the Abstract Truth

53 *"Der abstrakte Expressionismus"*: Oswald Herzog's manifesto in *Der Sturm*. Also see Helen A. Harrison, "The Birth of Abstract Expressionism," in *Abstract Expressionism: The International Context*, ed. Joan Marter (Rutgers University Press, 2007), 14.

53 *abstract expressionism*: First use in English, Harrison, "Birth," in *Abstract Expressionism*, 233 n.10.

54 *The early Kandinsky may have*: Clement Greenberg, *Art and Culture: Critical Essays* (Beacon Press, 1961), 228.

55 *There may be a really perverse argument*: Philip Dodd, quoted by Frances Stonor Saunders, *The Cultural Cold War: The CIA and the World of Arts and Letters* (New Press, 1999), 259.

55 *Where Dondero saw in*: Ibid., 254.

56 *at its peak*: Ibid., 1.

56 *Nelson Rockefeller*: Ibid., 258. See also 144–145, 260–261.

57 *the authoritative tastemaker*: Ibid., 266.

57 *the single most important* and *'credentials' as a cold warrior* and *In his battle*: Eva Cockcroft, "Abstract Expressionism, Weapon of the Cold War," in *Pollock and After: The Critical Debate*, ed. Francis Frascina (Harper & Row, 1985), 131.

58 *Those who equate*: Barr, "Is Modern Art Communistic?" *New York Times Magazine*, December 14, 1952, n.p.

59 *fine Italian hand*: Saunders, *Cultural Cold War*, 266.

59 *seeming neglect*: Sybil Gordon Kantor, *Alfred H. Barr, Jr., and the Intellectual Origins of the Museum of Modern Art* (MIT Press, 2002), 237.

59 *the Museum's perceived neglect*: Ibid., 372.

59 *his interest in historical orthodoxy*: Ibid., 319.

59 *Fantastic Art, Dada, Surrealism* (show), discussed by Kantor, Ibid., 356–57.

60 *Fuming about the censorious*: (n. *) Leah Dickerman, ed., *Inventing Abstraction, 1910–1925* (Museum of Modern Art, 2012), 367–368.

61 *Morris Hirshfield*: Kantor, *Alfred H. Barr, Jr.*, 359.

61 *The actual firing*: Ibid., 354.

62 *by 1936, Barr*: Dickerman, *Inventing Abstraction*, 366.

63 *The first purely abstract paintings*: Alfred H. Barr Jr., *Cubism and Abstract Art* (Museum of Modern Art, 1936), 9.

63 *Ten years ago*: Dickerman quoting Barr in a footnote, in *Inventing Abstraction*, 369.

63 *Breton's literary concern*: Anna Moszynska, *Abstract Art* (Thames & Hudson, 1990), III.

64 *the flat picture plane's*: Clement Greenberg, *The Collected Essays and Criticism*, vol. I, *Perceptions and Judgments, 1939–1944* (University of Chicago Press, 1986), 34.

64 *a false dilemma*: Jean-Louis Bédouin, *Vingt ans de surréalisme, 1939–1959* (Éditions Denoël, 1961), 145. My translation into English. See also page 78, n. †.

64 *Faced with the categorical choice*: Ibid., 148.

64 Text in n. †, Bédouin, *Vingt ans de surréalisme*, 148.

65 *Abstract art, it should be*: Barr, *Cubism and Abstract Art*, 179.

65 *The first and more important current*: Ibid., 19.

66 For information on the first group exhibition of surrealist painting, see Patrick Waldberg, *Surrealism*, trans. Stuart Gilbert (Skira, 1962), 8.

66 *analogy of form and method*: Barr, *Cubism and Abstract Art*, 180.

66 *At the risk of generalizing*: Ibid., 200.

67 *the art critic who did most*: Saunders on Clement Greenberg, in *The Cultural Cold War*, 258.

67 *Greenberg was some sort of CIA agent*: Alice Goldfarb Marquis, *Art Czar: The Rise and Fall of Clement Greenberg* (MFA Publications, 2006), 216.

68 *lifelong disdain*: Ibid., 55.

69 *Do I mean that the new American* and *Gorky, Gottlieb*: Clement Greenberg, "Is the French Avant-Garde Over-Rated?": in *Art and Culture*, 125.

69 *Our new abstract painting*: Ibid., 126.

70 *Klee's automatism was a crucial influence*: Breton, *Surrealism and Painting* (also see note for p. 44), 64; *Manifestoes of Surrealism*, trans. Richard Seaver and Helen R. Lane (University of Michigan Press, 1972), 27.

70 *Among the current or future surrealists*: Moszynska, *Abstract Art*, 111.

70 *at least in order to apply it*: Greenberg, *Art and Culture*, 209 n.1.

71 *Despite their seeming convergence*: Ibid., 124.

71 *In some ways Hans Hofmann*: Ibid., 214–15.

71 *The years 1947 and 1948*: Ibid., 219.

71 *Actually, not one*: Ibid., 220.

72 *Kandinsky's New Artists' Federation*: Eddy, *Cubists and Post-Impressionism*, 112. Also see notes on p. 249 for p. 2.

72 *Russian fauves*: Ibid., 47.

72 *illustration*: Greenberg, *Art and Culture*, 112.

75 *mounting* Cubism and Abstract Art *at that moment*: Dickerman, *Inventing Abstraction*, 366.

75 *poignantly strained* and *the grim new facts*: Robert Rosenblum, introduction to Barr, *Cubism and Abstract Art* (The Belknap Press of Harvard University, 1986 ed.), 4.

75 *As this volume goes to press*: Barr, *Cubism and Abstract Art*, 18.

76 *Our knowledge of abstract art*: Kantor, *Alfred H. Barr, Jr.*, 172, 183.

Sylvia Fein and the Death of the White Knight

82 *studied and experimented with ground pigment*: Robert Cozzolino, *With Friends: Six Magic Realists, 1940–1965* (Elvehjem/Chazen Museum of Art, 2005), University of Wisconsin–Madison, 108.

82 *the traditional formulas for canvas preparation*: Janet A. Kaplan, *Unexpected Journeys: The Art and Life of Remedios Varo* (Abbeville Press, 1988), 29.

82 *wood ashes, fish glue, and whale wax*: Fein, quoted by Cozzolino, in *With Friends*, 109.

85 resume[] painting with extraordinary energy: Cozzolino, "Macrocosm
and Microcosm: The Art of Sylvia Fein," in *Wondrous Life: Paintings and Drawings by Sylvia Fein* (Bakersfield Museum of Art, 2007), n.p.

Philip Lamantia and André Breton

93 the standard biography of André Breton: Mark Polizzotti, *Revolution of the Mind: The Life of André Breton* (1st ed.: Farrar, Straus and Giroux, 1995; 2nd ed.: Black Widow, 2009), translated into French as *André Breton* (Gallimard, 1999).

93 "Poem for André Breton" (poem), Philip Lamantia, in *Bed of Sphinxes: New & Selected Poems 1943–1993* (City Lights, 1997), 125. Reprinted in *The Collected Poems of Philip Lamantia*, ed. Garrett Caples, Andrew Joron, and Nancy Joyce Peters (University of California Press, 2013), 401.

94 I was turned on: Philip Lamantia, interview with David Meltzer, ed., *San Francisco Beat: Talking with the Poets* (City Lights, 2001), 134–135.

95 First Poems by Philip Lamantia: Announcement in *View* (December 1943), in *View: Parade of the Avant-Garde, an Anthology of* View *Magazine (1940–1947)*, ed. Charles Henri Ford (Thunder's Mouth Press, 1991), 141.

96 Surrealism proper: Édouard Roditi quoted in Ford's *View: Parade*, xi.

100 [Reverdy's] bringing together of two: Breton, *Manifestoes of Surrealism*, 20.

101 I am at a house: From "Plumage of Recognition," in *Collected Poems of Philip Lamantia*, 5.

102 to appreciate [Rimbaud]: Breton, "Letter to a Young Girl Living in America," in *Free Rein*, trans. Michel Parmentier and Jacqueline d'Amboise (University of Nebraska Press, 1995), 271.

103 "The Islands of Africa": Lamantia poem that appeared in *VVV* no. 4, February 1944, 19. Note: Lamantia's letter appears on page 18, poems appear on pages 19–20.

103 tens of millions of taxpayer dollars: Kim Ives and Ansel Herz, "WikiLeaks Haiti: The Aristide Papers," *The Nation*, August 5, 2011.

104 Breton's talks had a dramatic effect: Michael Richardson, ed., *Refusal of the Shadow: Surrealism and the Caribbean*, trans. Krzysztof Fijałkowski and Michael Richardson (Verso, 1996), 20–21.

104 *December 20, 1945*: René Depestre, "André Breton and Port-au-Prince," in *Refusal*, 231–33.

105 *What Breton said*: Richardson, *Refusal*, 21.

105 *With leonine head, a mane of sun*: Paul Laraque, "André Breton and Haiti," in *Refusal*, 218.

105 *Some people reproach Breton*: Ibid., 220.

105 *For us the surrealist coming to consciousness*: Ibid., 223.

106 *Now, it so happens*: Kenneth Rexroth, "Why Is American Poetry Culturally Deprived?": in *World Outside the Window* (New Directions, 1987), 211.

108 *I can be captivated by a system*: Breton, "Prolegomena to a Third Manifesto of Surrealism or Else," in *What Is Surrealism?: Selected Writings*, trans. Franklin Rosemont (Monad, 1978), 209.

108 *the supreme surrealist*: Breton, *Free Rein*, 102.

108 *Léopold Sédar Senghor*: Melvin Dixon, trans., *The Collected Poetry by Léopold Sédar Senghor* (University Press of Virginia, 1991), xxi.

Mysteries of the Six Gallery: Philip Lamantia, John Hoffman

Parts of this essay originally appeared as "A Note on *Tau*" and "A Note on John Hoffman and *Journey to the End*," in Pocket Poets 59, *Tau* by Philip Lamantia and *Journey to the End* by John Hoffman (City Lights, 2008).

111 *cried out for the Virgin Mother*: Philip Lamantia, in an interview with John Suiter, ed., *Poets on the Peaks: Gary Snyder, Philip Whalen & Jack Kerouac in the North Cascades* (Counterpoint, 2002), 151.

111 *I was going through a crisis*: Ibid.

112 *Found among his papers*: For confirmation of the publication history of the individual poems of both *Tau* and Hoffman's *Journey to the End*, I am indebted to the unstinting generosity of Lamantia's friend and bibliographer Steve Fama.

115 *the San Francisco libertarian-anarchist circle*: Nancy Joyce Peters, "Philip Lamantia," in *The Beats, Literary Bohemians in Postwar America*, vol. 16 of *Dictionary of Literary Biography*, ed. Ann Charters (Gale, 1983).

116 *a great deal of what has happened*: Kenneth Rexroth, *American Poetry in the Twentieth Century* (Herder & Herder, 1971), 165.

117 *Philip throughout his life*: (n. ‡) Nancy Joyce Peters, in conversation with the author, 2008.

117 *drawn to the Trappist order*: (n. ‡) Suiter, *Poets on the Peaks*, 151.

118 *Your poetry . . . has a great drive*: Rexroth, introduction to Lamantia's *Erotic Poems* (Bern Porter, 1946), n.p.

119 *My only sin is promiscuity*: Line from a lost John Hoffman poem recalled during a poetry reading by Philip Lamantia on September 20, 2001.

119 *who got busted*: Allen Ginsberg, *Howl and Other Poems* (City Lights, 1956), 10.

119 *who disappeared into*: Ibid., 12.

119 *the first of these lines is based on an anecdote about Hoffman*: Information from Ginsberg, in *Howl: Original Draft Facsimile . . .* , ed. Barry Miles (Harper & Row, 1986), 124.

119 *The second line alludes*: Ibid., 130.

120 *Delicate Francis DaPavia*: Jack Kerouac, *The Dharma Bums* (Viking, 1958), 14–15.

120 *John Parkman*: (n. *) Kerouac, *Visions of Cody* (McGraw Hill, 1972), 333.

121 *John Hoffman, 1930?–1950*: Carl Solomon's biographical note on Hoffman, in *Howl: Original Draft Facsimile*, 129–130.

122 *the poets met at a North Beach bar*: (n. †) Gerd Stern, *From Beat Scene Poet to Psychedelic Multimedia Artist in San Francisco and Beyond, 1948–1978* (The Bancroft Library, University of California–Berkeley, 2001), 16.

123 *1953, Spring, aged 25*: (n. *) *Howl: Original Draft Facsimile*, 124.

126 *John & I soon moved out*: Karen Forrest, email correspondence with the author, January 8, 2011.

127 *My Darling, I will stay*: John Hoffman, letter to Karen Forrest, January 1951, provided by Karen Forrest.

128 *John got a job*: Karen Forrest, email, January 8, 2011.

129 *unexpectedly encountered Hoffman*: Stern, *From Beat Scene Poet*, 16.

129 *Finally, we got to Rio*: (n. *) Ibid., 21.

130 *Chris & Bob had split up*: Karen Forrest, email, January 8, 2011.

130 *We sat up all night talking*: (n. *) William S. Burroughs, *Junky* (Penguin, 1977), 146–147.

131 *stricken down by paralysis* and *in a hospital in Guadalajara* and *a certificate in Spanish* and *"lost" them*: Lamantia, *Tau / Journey to the End*, 76.

131 *with an unnamed friend in New York City*: Ibid., 71.

132 *His interest in techniques*: Ginsberg's letter is reproduced many places, but I'm looking at it in Alastair Johnston's *A Bibliography of the Auerhahn Press & Its Successor Dave Haselwood Books* (Poltroon Press, 1976), 39.

133 "The Marginal Conducts" (poem), John Hoffman, in *Tau / Journey to the End*, 109–110.

134 Farewell Final Albatross *is the title*: Lamantia, *Tau / Journey to the End*, 78.

134 *the first magazine publications of Hoffman's work*: This bibliographic information was provided by Lamantia's friend and bibliographer Steve Fama.

137 *John was born a few months before*: Karen Forrest, email correspondence with author, March 31, 2008.

Apparitions *of Marie Wilson at City Lights*

141 *in 1955, André Breton included*: The year 1955 (for the gallery L'Étoile Scellée surrealist exhibition) comes from the *Apparitions* pamphlet, though the gallery schedule indicated in the Pompidou Centre's comprehensive study of Breton as collector, curator, and critic, *André Breton: La beauté convulsive* (1991), suggests the exhibition was probably the show of 14 surrealist painters held from November 18 to December 2, 1954 (414). The book also includes a reproduction of an untitled gouache by Wilson that Breton owned (436).

141 *Greece, Paris, and the Bay Area*: Most of my information about Marie Wilson stems from the *Apparitions* pamphlet and anecdotal conversation with Philip Lamantia, Nancy Joyce Peters, and Peter Maravelis. There's one good interview online from "winter 2000": creation-designs.com/gracemillenni um/winter00/html/wilson.htm.

Barbara Guest in the Shadow of Surrealism

143 "Hotel Comfort" (poem), Barbara Guest, in *The Collected Poems of Barbara Guest* (Wesleyan University Press, 2008), 516.

143 This late assertion of her surrealism was first documented by Andrew

Joron at the Barbara Guest Memory Bank (www.asu.edu/pipercwcenter/how2journal/bg_memorybank/bg_memory.html#joron).

147 *disrupts [a] formulaic view of life*: Barbara Guest, "Radical Poetics and Conservative Poetry," in *Forces of Imagination: Writing on Writing* (Kelsey Street, 2003), 16.

147 *I confess that often*: Guest, "The Shadow of Surrealism," in *Forces of Imagination*, 53.

147 *Imagination has its orderly zones* and *hide[s] in boxes*: Guest, "Radical Poetics and Conservative Poetry," *Forces of Imagination*, 15.

Circles: Richard Tagett and Richard O. Moore

151 *made that decision standing*: Richard Tagett, "Mono/graphic Letter—Jack Spicer & Proximities," *Manroot* 10, 160.

153 *I don't want to be portrayed*: Tagett, email correspondence with the author, September 1–12, 2011.

155 *eventually numbered over 100*: See, for example, David Meltzer, ed., *San Francisco Beat: Talking with the Poets* (City Lights, 2001), 139.

156 *I never really felt a part of*: Richard O. Moore, interview with the author, September 21, 2011.

158 Lines from "Scherzo for Jack," Richard Tagett, in *Demodulating Angel* (Ithuriel's Spear, 2011), 45.

158 *Immersed*: "Rivus" (poem, excerpt), ibid., 80.

159 *The lips of old men*: "Triptych for Believers" (poem, excerpt), ibid., 97.

159 *How account*: "Holding On" (poem, excerpt), Richard O. Moore, *Writing the Silences* (University of California Press, 2010), 63.

Becoming Visible: Jean Conner

165 *I'd written a piece a year earlier*: Go to www.poetryfoundation.org/harriet/2011/06/sincerely-bruce-conner-a-final-work-in-progress/.

166 *I decided I was being pushed*: This and other quotes in the essay are from Jean Conner, in conversation with the author, September 26, 2012.

173 *Circa Sixty: Bruce Conner & Jean Conner* (November 2011–January 2012) can be seen online at www.kohngallery.com/conner/shows/sixty/sixty.show.html.

175 Epigraph, Alden Van Buskirk, *Lami* (The Auerhahn Society, 1965), 34.

175 The Van Buskirk memorial can be viewed online at www.archive.org/details/BeatPoetAldenVanBuskirkMemorial.

178 *A passing and incorrect listing*: in Kenneth Rexroth, *American Poetry in the Twentieth Century* (Herder & Herder, 1971), 159.

178 *frontis photo . . . reproduced*: Paul Carroll, ed., *The Young American Poets* (Big Table, 1968), 447.

178 *'who cd be ashamed of their own hair?'*: Van Buskirk, *Lami*, 40.

179 *He would have really loved that*: Martha Muhs, in conversation with the author, February 7, 2012.

179 *a sweeping gesture*: David Rattray, "Van," in *How I Became One of the Invisible* (Semiotext(e), 1992), 10.

179 *Fuck Olson & the crowd*: Van Buskirk, "Poetry now—1961," in *Lami*, 38.

179 *Every one of those three is*: John Ceely, in conversation with the author, February 28, 2012.

180 *terrible dreams*: Peter Kushner, in conversation with the author, February 8, 2012.

180 *the most typical presentation*: James G. Gaither, M.D., "Paroxysmal Nocturnal Hemoglobinuria: A Successful Imposter," *New England Journal of Medicine*, vol. 265, no. 9 (August 31, 1961), 421.

180 *black piss*: Van Buskirk, *Lami*, 14.

181 *I think his literary influences*: Kushner, February 8, 2012.

182 *a reading of works by Rilke and John Wieners*: Rattray, *How I Became*, 8.

182 Letters from Alden Van Buskirk to John Ceely (May 1960 and mid-August 1960), from Ceely's private collection.

182 *Van sauntered in in ink-stained*: Rattray, *How I Became*, 14.

183 *eager to support him* and *wanted her to quit turning tricks*: Ibid., 19.

184 *But it's late &*: Van Buskirk, *Lami*, 51.

184 *The idea of having sex with a boy*: Rattray, *How I Became*, 16.

186 *There were white people in the black neighborhood*: Pinky Kushner, in conversation with the author, February 8, 2012.

188 *crossed the border*: Rattray, *How I Became*, 29.

188 *they nearly got themselves killed*: Ibid., 25, 93.

189 *finds himself "horny"*: Ibid., 60.

190 *sirens in the night—*: Van Buskirk, *Lami*, 15–16

191 *dreamt this city Oakland*: Ibid., 13.

191 *Dr. Lawrence wanted*: Tony Sargent, in conversation with the author, February 28, 2012.

192 *a paper he'd read in German*: An English translation of Albert Hofmann's paper, published 10 years after the German original, can be found at www.erowid.org/plants/mushrooms/references/other/1971_hofmann_bull etin-narcotics.shtml.

192 *I've lived my life*: Van Buskirk, "9-17-61," in *Lami*, 25.

The Incorrigible Torregian

197 *Like Arshile Gorky*: Bill Berkson, introduction to Sotère Torregian's *On the Planet Without Visa* (Coffee House Press, 2012), xv.

198 Torregian biographical quotes from Paul Carroll, *The Young American Poets*, 2nd printing (Big Table, 1968), 438; and 3rd printing (Big Table, 1969), 438.

198 Bio note from *Without Visa*, 267.

199 "Death of a Poet" (poem), Torregian, in *Without Visa*, 1.

200 *the beauty and courage of Woman!*: Torregian, from "To the Reader," a handwritten address reproduced on the front end sheet of *Without Visa*.

201 "An Heiress" (poem), Torregian, in *Without Visa*, 180.

John Anderson, Master

206 *The paintings sold so well*: Ryan M. Jacobs, "John Anderson: 1932–2011," *Point Reyes Light*, December 1, 2011. Go to ryanmcmahonjacobs.word press.com/2011/12/20/john-anderson-1932-2011/.

Theory of Retrieval

226 For full 2pac/Davey D. interview (n. *), see www.daveyd.com/inter view2pacrare.html.

238 The *Guardian* staff's own postmortem on the Tim Redmond situation: "On Guard: The Story behind the Bay Guardian's new ownership and departure of Editor-Publisher Tim Redmond," Steven T. Jones and Rebecca Bowe. Posted June 18, 2013 on sfbg.com.

BIBLIOGRAPHY

Alexander, Will. *Compression & Purity*. San Francisco: City Lights, 2011.

Allen, Donald, ed. *The New American Poetry, 1945–1960*. New York: Grove, 1960.

Banfield, Ann. *The Phantom Table: Woolf, Fry, Russell and the Epistemology of Modernism*. Cambridge: Cambridge University Press, 2000.

Barnes, Djuna. *Interviews*. Los Angeles: Sun & Moon, 1985.

———. *New York*. Los Angeles: Sun & Moon, 1989.

Barr, Alfred H., Jr. *Cubism and Abstract Art*. New York: Museum of Modern Art, 1936. Reprint, Cambridge, MA: The Belknap Press of Harvard University, 1986.

Beaumelle, Agnès Angliviel de la, et al. *André Breton, La Beauté convulsive*. Paris: Éditions du Centre Pompidou, 1991.

Bédouin, Jean-Louis. *Vingt ans de surréalisme, 1939–1959*. Paris: Éditions Denoël, 1961.

Beerbohm, Max. *More*. London: John Lane, 1899.

Berrigan, Anselm. *Free Cell*. San Francisco: City Lights, 2009.

Breton, André. *Break of Day*. (*Point du Jour*, 1934.) Translated by Mark Polizzotti. Lincoln: University of Nebraska Press, 1999.

———. *Free Rein*. (*La Clé des champs*, 1953.) Translated by Michel Parmentier and Jacqueline d'Amboise. Lincoln: University of Nebraska Press, 1995.

———. *The Lost Steps*. (*Les Pas Perdues*, 1924.) Translated by Mark Polizzotti. Lincoln: University of Nebraska Press, 1996.

———. *Manifestoes of Surrealism*. Translated by Richard Seaver and Helen R. Lane. Ann Arbor: University of Michigan Press, 1972.

———. *Martinique: Snake Charmer*. Translated by David W. Seaman. Austin: University of Texas Press, 2008.

———. *Perspective Cavalière*. Paris: Gallimard, 1970.

———. *Surrealism and Painting*. Translated by Simon Watson Taylor. New York: Icon Editions/Harper & Row, 1972.

————. *What Is Surrealism?: Selected Writings.* Translated by Franklin Rose-mont. New York: Monad, 1978.

Buhle, Paul, et al. *Free Spirits: Annals of the Insurgent Imagination.* San Francisco: City Lights, 1982.

Burns, Thom, et al. *Apparitions, Paintings and Drawings of Marie Wilson.* San Francisco: City Lights, 1984.

Burroughs, William S. *Junky.* New York: Penguin, 1977.

Caples, Garrett. *Complications.* Meritage, 2007.

————. *The Garrett Caples Reader.* Angle Press/Black Square Editions, 1999.

————. *Quintessence of the Minor: Symbolist Poetry in English.* Wave Pamphlet #1. Seattle: Wave Books, 2010.

Carroll, Paul, ed. *The Young American Poets.* Chicago: Big Table, 2nd printing, 1968; 3rd printing, 1969.

Charters, Ann, ed. *The Beats, Literary Bohemians in Postwar America.* Vol. 16 of *Dictionary of Literary Biography.* Farmington Hills, MI: Gale, 1983.

Cozzolino, Robert. *With Friends: Six Magic Realists, 1940–1965.* Madison, WI: Elvehjem (Chazen) Museum of Art, 2005.

————. *Wondrous Life: Paintings and Drawings by Sylvia Fein.* Bakersfield, CA: Bakersfield Museum of Art, 2007.

Crosby, Harry. *Shadows of the Sun.* Santa Barbara: Black Sparrow, 1976.

Davidson, Michael. *The San Francisco Renaissance.* New York: Cambridge University Press, 1989.

Dickerman, Leah, ed. *Inventing Abstraction, 1910–1925.* New York: The Museum of Modern Art, 2012.

Eddy, Arthur Jerome. *Cubists and Post-Impressionism.* Appendix by Alfred Stieglitz. Chicago: A. C. McClurg, 1914, 1919.

————. *Ganton & Co.* Chicago: McClurg, 1908.

————. *The New Competition.* Chicago: McClurg, 1912.

————. *Two Thousand Miles on an Automobile.* Philadelphia, London: J. B. Lippincott, 1902.

Ernst, Jimmy. *A Not-So-Still Life.* New York: St. Martin's, 1984.

Fein, Sylvia. *First Drawings: Genesis of Visual Thinking*. Pleasant Hill, CA: Exelrod Press, 1976.

———. *Heidi's Horse*. Martinez, CA: Exelrod Press, 1993.

Ford, Charles Henri, ed. *View: Parade of the Avant-Garde, an Anthology of* View Magazine, *1940–1947*. New York: Thunder's Mouth, 1991.

Fort, Ilene Susan, et al. *In Wonderland: The Surrealist Adventures of Women Artists in Mexico and the United States*. New York: Prestel, 2012.

Frascina, Francis, ed. *Pollock and After: The Critical Debate*. New York: Harper & Row, 1985.

Frost, Robert. *Collected Poems, Prose, & Plays*. New York: Library of America, 1995.

Fry, Roger. *Last Lectures*. Introduction by Sir Kenneth Clark. Cambridge: Cambridge University Press, 1939.

———. *The Letters of Roger Fry*. Edited by Denys Sutton. 2 vols. London: Chatto & Windus, 1972.

———. *A Roger Fry Reader*. Edited by Christopher Reed. Chicago: University of Chicago Press, 1996.

———. *Transformations* (1926). Garden City, NY: Doubleday, 1956.

———. *Vision and Design* (1920). London: Chatto & Windus. Phoenix Library reprint, 1929.

Gascoyne, David. *A Short Survey of Surrealism*. London: Cobden-Sanderson, 1935.

Ginsberg, Allen. *Howl and Other Poems*. San Francisco: City Lights, 1956.

———. *Howl: Original Draft Facsimile, Transcript & Variant Versions, Fully Annotated by Author, with Contemporaneous Correspondence, Account of First Public Reading, Legal Skirmishes, Precursor Texts & Bibliography*. Edited by Barry Miles. New York: Harper & Row, 1986.

Gordon, Robert J., and Stuart Sholto Douglas. *The Bushman Myth: The Making of a Namibian Underclass*. 2nd ed. Boulder, CO: Westview Press, 2000.

Greenberg, Clement. *Art and Culture: Critical Essays*. Boston: Beacon Press, 1961.

———. *Perceptions and Judgments, 1939–1944.* Vol. 1 of *The Collected Essays and Criticism.* Chicago: University of Chicago Press, 1986.

Guest, Barbara. *The Collected Poems of Barbara Guest.* Middletown, CT: Wesleyan University Press, 2008.

———. *Forces of Imagination: Writing on Writing.* Berkeley: Kelsey Street, 2003.

———. *The Red Gaze.* Middletown, CT: Wesleyan University Press, 2005.

Guetti, James. *Action.* New York: Dial, 1972.

———. *Silver Kings.* Self-published on iUniverse, 2005.

———. *Wittgenstein and the Grammar of Literary Experience.* Athens, GA: University of Georgia Press, 1993.

Hiekisch-Picard, Sepp, Gordon Onslow Ford, and Rowland Weinstein. *Gordon Onslow Ford: The Formative Years, Paintings from the 1930's and 1940's.* San Francisco: Weinstein Gallery, 2006.

Hoover, Paul, ed. *Postmodern American Poetry: A Norton Anthology.* New York: W. W. Norton, 2013.

Jarnot, Lisa. *Joie de Vivre.* San Francisco: City Lights, 2013.

———. *Robert Duncan, the Ambassador from Venus.* Berkeley: University of California Press, 2012.

Johnston, Alastair. *A Bibliography of the Auerhahn Press & Its Successor Dave Haselwood Books.* Berkeley: Poltroon Press, 1976.

Joron, Andrew. *The Cry at Zero: Selected Prose.* Denver, CO: Counterpath, 2007.

Kantor, Sybil Gordon. *Alfred H. Barr, Jr., and the Intellectual Origins of the Museum of Modern Art.* Cambridge, MA: MIT Press, 2002.

Kaplan, Janet A. *Unexpected Journeys: The Art and Life of Remedios Varo.* New York: Abbeville Press, 1988.

Kaplan, Stuart R. *The Artwork & Times of Pamela Colman Smith.* Stamford, CT: U.S. Games Systems, 2009.

Kerouac, Jack. *The Dharma Bums.* New York: Viking, 1958.

———. *Doctor Sax.* New York: Grove, 1959.

———. *The Subterraneans.* New York: Grove, 1958.

———. *Visions of Cody*. New York: McGraw Hill, 1972.

Laing, Donald A. *Roger Fry: An Annotated Bibliography of the Published Writings*. New York: Garland, 1979.

Lamantia, Philip. *Becoming Visible*. San Francisco: City Lights, 1981.

———. *Bed of Sphinxes: New & Selected Poems 1943–1993*. San Francisco: City Lights, 1997.

———. *The Blood of the Air*. San Francisco: Four Seasons Foundation, 1970.

———. *Charles Bukowski, Philip Lamantia, Harold Norse*. Penguin Modern Poets 13. London: Penguin, 1969.

———. *The Collected Poems of Philip Lamantia*. Edited by Garrett Caples, Andrew Joron, and Nancy Joyce Peters. Berkeley: University of California Press, 2013.

———. *Destroyed Works*. San Francisco: Auerhahn Press, 1962.

———. *Ekstasis*. San Francisco: Auerhahn Press, 1959.

———. *Erotic Poems*. Berkeley: Bern Porter, 1946.

———. *Meadowlark West*. San Francisco: City Lights, 1986.

———. *Narcotica*. San Francisco: Auerhahn Press, 1959.

———. *Selected Poems 1943–1966*. San Francisco: City Lights, 1967.

———. *Tau* and *Journey to the End* by John Hoffman. Pocket Poets Series 59. San Francisco: City Lights, 2008.

———. *Touch of the Marvelous*. 1st ed., Berkeley: Oyez, 1966; 2nd ed., San Francisco: Four Seasons Foundation, 1974.

Lehman, David. *The Last Avant-Garde: The Making of the New York School of Poets*. New York: Doubleday, 1998.

Lemaître, Georges Édouard. *From Cubism to Surrealism in French Literature*. Cambridge, MA: Harvard University Press, 1941.

Levy, Julien. *Surrealism*. New York: Black Sun Press, 1936.

Lindsay, Vachel. *The Art of the Moving Picture*. New York: Macmillan, 1915.

———. *Collected Poems*. New York: Macmillan, 1925.

———. *The Golden Book of Springfield*. Introduction by Ron Sakolsky. Chicago: Charles H. Kerr, 1999.

Mallarmé, Stéphane. *Divagations: The 1897 Arrangement by the Author Together*

270

with *"Music and Letters."* Translated by Barbara Johnson. Cambridge, Mass.: Harvard University Press, 2007.

Marquis, Alice Goldfarb. *Art Czar: The Rise and Fall of Clement Greenberg.* Boston: MFA Publications, 2006.

Marter, Joan, ed. *Abstract Expressionism: The International Context.* New Brunswick, NJ: Rutgers University Press, 2007.

Meltzer, David, ed. *San Francisco Beat: Talking with the Poets.* San Francisco: City Lights, 2001.

Moore, Richard O. *Writing the Silences.* Introduction by Brenda Hillman. Berkeley: University of California Press, 2010.

Moorhead, Jasmine, ed. *Surrealism: New Worlds.* Exhibition catalogue. Introduction by Mary Ann Caws. San Francisco: Weinstein Gallery, 2011.

Moszynska, Anna. *Abstract Art.* New York: Thames & Hudson, 1990.

Nesbit, Gogo. *Graffiti.* San Francisco: Bern Porter, 1955.

Onslow Ford, Gordon. *Painting in the Instant.* New York: H. N. Abrams, 1964.

Polizzotti, Mark. *Revolution of the Mind: The Life of André Breton.* 1st ed., New York: Farrar, Straus and Giroux, 1995.

Rattray, David. *How I Became One of the Invisible.* Los Angeles: Semiotext(e), 1992.

Reed, Christopher, ed. *A Roger Fry Reader.* See Fry, Roger.

Rexroth, Kenneth. *American Poetry in the Twentieth Century.* New York: Herder & Herder, 1971.

———. *An Autobiographical Novel.* Rev. ed. New York: New Directions, 1991.

———. *World Outside the Window.* New York: New Directions, 1987.

Richardson, Michael, ed. *Refusal of the Shadow: Surrealism and the Caribbean.* Translated by Krzysztof Fijałkowski and Michael Richardson. London, New York: Verso, 1996.

Saunders, Frances Stonor. *The Cultural Cold War: The CIA and the World of Arts and Letters.* New York: New Press, 1999.

Segalen, Victor. *Essay on Exoticism.* (*Essai sur l'exotismse,* 1978.) Translated and edited by Yaël Rachel Schlick. Durham, NC: Duke University Press, 2002.

———. *The Great Statuary of China.* (*Chine: La grande statuaire,* 1972.) Trans-

lated by Eleanor Levieux. Edited by A. Joly-Segalen. Chicago: University of Chicago Press, 1978.

———. *A Lapse of Memory. (Les Immémoriaux,* 1907.) Translated by Rosemary Arnoux. Brisbane, Australia: Boombana Publications, 1995.

———. *René Leys.* Translated by J. A. Underwood. New York: New York Review Books, 2003.

———. *Stèlae.* Translated by Nathaniel Tarn. Santa Barbara, CA: Unicorn Press, 1969.

———. *Stèles.* Translated and annotated by Timothy Billings and Christopher Bush. Middletown, CT: Wesleyan University Press, 2007.

———. *Stèles.* Translated by Michael Taylor. Santa Monica, CA: The Lapis Press, 1987.

Senghor, Léopold Sédar. *The Collected Poetry by Léopold Sédar Senghor.* Translated by Melvin Dixon. Charlottesville, VA: University Press of Virginia, 1991.

Smith, Pamela Colman. *Annancy Stories.* New York: Russell, 1899.

———. *Chim-Chim: Folk Stories from Jamaica.* London: The Green Sheaf, 1905.

Solomon, Carl. *Emergency Messages: An Autobiographical Miscellany.* New York: Paragon House, 1989.

Spalding, Frances. *Roger Fry: Art and Life.* Berkeley: University of California Press, 1980.

Stern, Gerd. *From Beat Scene Poet to Psychedelic Multimedia Artist in San Francisco and Beyond, 1948–1978.* Berkeley: The Bancroft Library, University of California–Berkeley, 2001.

Stoker, Bram. *The Lair of the White Worm.* London: W. Rider, 1911.

———. *Sir Henry Irving and Miss Ellen Terry in Robespierre, Merchant of Venice, The Bells, Nance Oldfield, The Amber Heart, Waterloo, and Other Dramatic Works.* New York: Doubleday & McClure, 1899.

Suiter, John, ed. *Poets on the Peaks: Gary Snyder, Philip Whalen & Jack Kerouac in the North Cascades.* Berkeley: Counterpoint, 2002.

Tagett, Richard. *Demodulating Angel.* San Francisco: Ithuriel's Spear, 2011.

Tongue, M. Helen, and Dorothea Bleek. *Bushman Paintings.* Preface by Henry Balfour. Oxford: Clarendon Press, 1909.

Torgovnick, Marianna. *Gone Primitive: Savage Intellects, Modern Lives.* Chicago: University of Chicago Press, 1990.

Torregian, Sotère. *Amtrak Trek: Being Poems Written Cross-Country from California to New York.* New York: Telephone Books, 1979.

——. *The Golden Palomino Bites the Clock.* New York: Angel Hair, 1967.

——. *On the Planet Without Visa: Selected Poetry and Other Writings, AD 1960–2012.* Minneapolis: Coffee House Press, 2012.

——. *The Wounded Mattress: Poems.* Berkeley: Oyez, 1970.

Van Buskirk, Alden. *Lami.* San Francisco: The Auerhahn Society, 1965.

Waite, Arthur Edward. *The Pictorial Key to the Tarot.* London: W. Rider, 1911.

Waldberg, Patrick. *Surrealism.* Translated by Stuart Gilbert. Geneva: Skira, 1962.

Wieners, John. *The Hotel Wentley Poems.* San Francisco: Auerhahn Press, 1958.

Williams, Jonathan. *The Magpie's Bagpipe.* San Francisco: North Point, 1983.

Wittgenstein, Ludwig. *Philosophical Investigations.* 3rd ed. Translated by G. E. M. Anscombe. New York: Macmillan, 1968.

——. *Philosophical Occasions, 1912–1951.* Edited by James Klagge and Alfred Nordmann. Indianapolis and Cambridge: Hackett, 1993.

Woolf, Virginia. *Roger Fry: A Biography* (1940). New York: Harvest, 1976.

INDEX

Abercrombie, Gertrude, 81, 82

abstract expressionism, 45, 53–55, 57, 59, 61, 66–68, 70–73, 78, 79, 82, 233

Abstraction-Création group, 70

abstract surrealism, 53–55, 62–67, 68, 73, 78, 233

African American poets, 178, 197, 198

African art, 27–34, 234

Alexander, Will, 142, 223

Allen, Donald, 151

Allison, Mose, 186

Alpert, Richard, 172

American Committee for Cultural Freedom, 67

Amram, David, 117

anarchism, 2, 30, 39, 54, 74, 115, 155, 156

Anderson, John, 203–207, 233

Angle (periodical), 162

anti-communism, 55–58, 61, 74

Antonioni, Michelangelo, 222

Apollinaire, Guillaume, 2, 64n

Aragon, Louis, 191

Aristide, Jean-Bertrand, 103

Armory Show, 1, 3

Arp, Hans, 63n, 64, 66, 70

Artaud, Antonin, 108, 118, 177, 181, 200

art history: abstract surrealism effaced from, 51, 53, 54, 57, 67, 68, 70, 78; and Barr's work, 61–63, 66–67; Fry's conception of, 16–27, 34–35, 233–234

Art Institute of Chicago, 4

Ashbery, John, 93, 156

Auerhahn Press, 131, 134, 139

Avery, Milton, 69

Balfour, Henry, 33–34

Banfield, Ann, 16

Barnes, Djuna, 221

Barr, Alfred H., Jr., 53, 57–67, 71, 74–77, 241

Barrie, J. M., 8

Bataille, Georges, 101

Baziotes, William, 53, 54, 73, 79

Beat literature, 123, 134, 155, 168, 179, 181, 194

Beck, Jeff, 222

Bédouin, Jean-Louis, 64

Beerbohm, Max, 221

Berkeley Poetry Conference, 153, 160

Berkson, Bill, 185, 197–198, 199

Berman, Wallace, 135, 173

Berrigan, Anselm, 206

Berrigan, Ted, 199, 236

Beyond Baroque, Los Angeles, 235

Billings, Timothy, 11–14

Black Sparrow, 151

Blaser, Robin, 153

Bleek, Dorothea, 33

Bogzaran, Fariba, 47–48

Boucher, François, 201, 202

Bourgeois, Louise, 73

Braden, Thomas W., 57

Brauner, Victor, 64

Bremser, Ray, 185

Breton, André, 40–41, 51, 53, 63, 69, 70, 74, 93–109, 141, 145, 147, 191,

199, 221, 242; and relations with Lamantia, 93–104, 235–236; and revolution in Haiti, 103–105
Broadhead, Heidi, 198n
Brown, Bill, 168
Brown, Joan, 168, 170
Brubeck, Dave, 186
Buber, Martin, 157
Büchner, Georg, 181
Burroughs, William S., 130n
Bush, Christopher, 11, 12, 13–14

Calder, Alexander, 70
Carrington, Leonora, 64, 81
Carroll, Paul, 178, 198
Cassady, Neal, 183
Catholicism, 111, 113, 116, 117n, 124
Ceely, John, 177, 179, 181–185, 187–190, 193, 195, 239
Celtic Revival, 6
Ceravolo, Joseph, 199
Césaire, Aimé, 40–41, 199
Cézanne, Paul, 65, 66, 70
Charles, Ray, 186
Chaucer, Geoffrey, 157
Chicago Review, 237
CIA, 55–58, 67
Cimabue, 32
City Lights, 84, 93, 120, 122n, 135, 136, 139–140, 142, 170, 173, 238–239
Clapton, Eric, 222
Clark, Jeff, 223
Clark, Kenneth, 29
Clark, Stephen C., 61
Clark, Tom, 201
Clinton, George, 227
Coates, Robert M., 70
Cockroft, Eva, 57–58, 59, 67

Codrescu, Andrei, 162
Coffee House Press, 197
Cold War, 55–59, 62, 63, 67, 72, 74, 76
Coltrane, John, 186
communism, 40, 54–58, 60, 74, 181
Congress for Cultural Freedom, 56, 67
Conner, Bruce, 165–173
Conner, Jean, 165–174, 239, 241
Conrad, Joseph, 93
Cozzolino, Robert, 82
Crane, Stephen, 134
Creeley, Robert, 93, 132, 158–159, 236
Crevel, René, 108
Crosby, Harry, 224
Crowley, Aleister, 7
cubism, 1–4, 66, 69–70, 71, 72

Dada, 63n, 65, 242
Dalí, Salvador, 64, 94
Darger, Henry, 202
Davidson, Michael, 161
Davis, Miles, 186
death, 46, 48
de Chirico, Giorgio, 64, 66, 143
DeFeo, Jay, 168, 170
de Kooning, Willem, 69, 70
della Francesca, Piero, 32
Depestre, René, 104
Deren, Maya, 97
Desmond, Paul, 186
De Stijl, 70
Dickerman, Leah, 60n, 62–63, 75, 76
Digital Underground (DU), 209–210, 212–217, 225, 226, 227, 229, 230, 231
di Rosa Gallery, Napa, California, 174
Dodd, Philip, 55
Domínguez, Óscar, 52, 53

Donati, Enrico, 51, 52, 53, 73, 99, 102
Dondero, George, 55, 58
Dot (Dontrell Mayfield), 209–212, 215–217, 231
Dove, Arthur, 1, 2, 4
Dow, Arthur Wesley, 7
Du Bois, W. E. B., 37
Duchamp, Marcel, 1, 52, 63n, 96
Duchamp-Villon, Raymond, 76
Duits, Charles, 93
Duncan, Robert, 93, 153, 157, 161, 162, 182, 185, 236
Dunlap, Barbara, 172
Dynaton, 45, 141

Eddy, Arthur Jerome, 1–4, 5, 55, 72, 241
Eliot, T. S., 37, 40, 106, 157
Ellington, Duke, 161
Éluard, Paul, 53, 141
Ernst, Jimmy, 51, 52, 73, 78–79, 240
Ernst, Max, 52, 53, 64, 66, 78, 95, 96

Falkenstein, Claire, 174
fascism, 106
Fauvism, 66, 71, 72
Fein, Sylvia, 49, 81–91, 239
Ferlinghetti, Lawrence, 49, 139, 140
Ferus Gallery, Los Angeles, 170
Fini, Leonor, 52
Ford, Charles Henri, 95, 101, 102
formalism, 16, 24, 25, 27, 33, 34–35, 149
Forneret, Xavier, 242
Forrest, Karen, 126–130, 135–137, 239
Fort, Ilene, 84
Fourier, Charles, 94
Frances, Esteban, 44, 51
Francis, Sam, 170
Frankenthaler, Helen, 174

Freud, Sigmund, 16
Frost, Robert, xv
Fry, Roger, 2, 16–35, 233–234, 241
Fry, Varian, 40

Gaither, James, 178, 183
The Gambler (film), xviii
Gascoyne, David, 94, 102, 115n, 199
Gauguin, Paul, 9, 66, 70
Gautier, Théophile, 221, 225, 228, 232
Gechtoff, Sonia, 168
George, Stefan, 181
Ginsberg, Allen, 110, 113n, 119–120, 123n, 132, 177, 179, 182, 185, 193, 194, 236
Glasier, Marshall, 82
Gleizes, Albert, 1
Gorky, Arshile, 64, 69, 70, 197
Gottlieb, Adolph, 69
Graham, John, 73
Greenberg, Clement, 24–27, 54, 64, 67–73
Gregory, Lady, 6
Guest, Barbara, 143–150, 221, 223, 236–237
Guetti, James, xi–xviii
Guravich, Donald, 47
Gutmann, Gerrie, 81

Haiti, 103–105
Harnoncourt, René d', 59
Hart, Howard, 117
Harvey, Andrew, 10
Haselwood, Dave, 194
Hedrick, Wally, 168
Herzog, Oswald, 53, 71, 72
Highsmith, David, 175, 195
Hill, Lewis, 155

Hillman, Brenda, 161
hip-hop / rap, 209–217, 225–232
Hirschman, Jack, 177, 181, 185
Hirshfield, Morris, 61
Hoffman, John, 110, 119–137, 238, 239
Hofmann, Albert, 192
Hofmann, Hans, 69, 70, 71–72
Hopper, Dennis, 170
Howard, Richard, 132
"Howl" (Ginsberg), 110, 113n, 119–121,
 123, 132, 179, 181, 190
Hoyem, Andrew, 194
Huncke, Herbert, 120
Hunt, Elizabeth, 195
Huppler, Dudley, 82
Huysmans, Joris-Karl, 225, 228
hyphy, 209–217, 231–232

impressionism, 24, 25, 28
In Wonderland exhibit, 81–82, 84, 89,
 140
Irving, Henry, 6, 7

Jacobs, Ryan M., 206
Jarnot, Lisa, 84, 161
jazz, 116–117, 186
Joans, Ted, 185
Johnson, Jacqueline, 45
Jones, LeRoi, 185
Jones, Leslie, 73
Jordan, Larry, 168
Joron, Andrew, 43, 47, 131, 196, 221,
 223, 240
Joyce, James, 116, 223, 224
J-Stalin, 209, 216, 231

Kamrowski, Gerome, 51, 52, 53, 73, 79
Kandinsky, Wassily, 1, 53, 54, 58, 66, 71,

72, 73
Kantor, Sybil Gordon, 59
Kaplan, Janet, 83n
Kaplan, Stuart R., 5, 7, 8
Kelly, James, 168
Kern, Jerome, 186
Kerouac, Jack, 117, 119, 120, 122, 125n,
 126, 130n, 153, 185
Klee, Paul, 66, 69, 70
Kline, Franz, 69, 71
Koch, Kenneth, 156
Kochnitzky, Léon, 96, 98
Kohn Gallery, Los Angeles, 173
Kolourmeim Press, 135
KPFA, 155, 156
KQED, 156
Krowswork Gallery, Oakland, 91n
Kusama, Yayoi, 81, 89
Kushner, Peter, 177, 180, 182, 195
Kushner, Pinky, 177, 183, 186, 187, 195
Kyger, Joanne, 47

Lafitte, Jose, 162
Lamantia, Philip: Alexander's The
 Brimstone Boat dedicated to, 142;
 and Catholicism, 111, 113, 116, 117n,
 124; Collected Poems of, 236, 240–
 241; and composition of Tau, 112–
 113, 116–118; death of, 112, 236; in
 Deren's film At Land, 97; Ginsberg's
 defense of, 132; and Ginsberg's
 "Howl," 110, 113n, 119–120, 123, 132;
 and jazz, 116–117; last reading by,
 120; and literary canon, 236; num-
 ber of publications by, 111–112; on
 Onslow Ford, 45–46; in photo-
 graphs, 92, 196; and publication of
 Tau, 238; and relations with Breton,

93–104, 235–236; and relations with Caples, 223; and relations with Hoffman, 110, 119–127, 130–131, 134; and relations with Jean and Bruce Conner, 171; and relations with Kerouac, 117n; and relations with Rexroth, 106, 111, 114, 115, 116, 118–119, 240; and Six Gallery reading, 110, 113, 119, 120, 131; and surrealism, 101, 114–115, 118, 123, 132, 236, 240; and Tagett's work, 159; and Marie Wilson's work, 141; as youth, 114–115, 236

Lamba, Jacqueline, 81

language poetry, 149, 157

Laraque, Paul, 105, 106

Lautréamont (Isidore Ducasse), 129, 242

Lawrence, John, 191

Leary, Timothy, 171, 172

Le Gallienne, Richard, 228

Lehman, David, 147, 237

Leite, George, 118n, 126

Lemaitre, Georges, 94, 115n

Levy, Julien, 94, 115n

Lindsay, Vachel, 37–39

Los Angeles County Museum of Art, 73, 81, 140

Lucas, Brian, 162, 163, 223

Lucid Art Foundation, 45, 47, 205

Mabille, Pierre, 104, 105

Mac Low, Jackson, 95

magic realism, 82, 86

Magloire-Saint-Aude, Clément, 108

Malevich, Kasimir, 76

Mallarmé, Stéphane, 221

Manroot (periodical), 141, 151, 162

Maravelis, Peter, 142

Mariah, Paul, 141, 151

Marinetti, Filippo, 40

Marquis, Alice Goldfarb, 67

Marx, Karl, 16

Marxism, 56, 58, 162, 200

Masefield, John, 6

Masson, André, 41, 52, 53, 64, 66, 69, 70

Matisse, Henri, 66, 71, 72

Matson, Clive, 194, 195

Matta Echaurren, Roberto, 44, 45, 51, 52, 53, 64, 73

Mayakovsky, Vladimir, 181

McCarthyism, 55, 57, 58

McClure, Joanna, 168

McClure, Michael, 110, 131, 132, 168, 179

McCray, Porter A., 57

McKinney, Eleanor, 155

meaning, Wittgenstein's concept of, xii–xvi

Mekanix, the, 209, 211, 215, 216, 231

Mellin, Jeff, 228

Meltzer, David, 94, 116

Merritt, Gary, 185, 195

Micheline, Jack, 153

Miles, Josephine, 115

Miller, Lee, 74, 77

Milone, Joe, 61

Miró, Joan, 64, 66, 69, 70, 94

modernism, 14, 25, 51, 52, 55, 72, 106

Mondrian, Piet, 69, 70

Monk, Thelonious, 186

Monnin, Patrick, 162

Monroe, Harriet, 39

Moore, Henry, 66

Moore, Richard O., 49, 154–157, 159–163, 239

Moreau, Gustave, 242

278

Moszynska, Anna, 63
Motherwell, Robert, 69
Muhs, Martha, 177, 179, 181, 186, 187, 189, 193, 195
Mullican, Lee, 45
Museum of Modern Art (MoMA), New York, 56–57, 59–63, 73–76

Nabokov, Nicolas, 67
Nazism, 40, 53, 58, 60n, 61, 77, 108
Nesbit, Goldian, 113, 121, 123n, 134n
New Bay movement, 231
Newman, Barnett, 69
New York School, 147, 156, 197, 199, 237
Nin, Anaïs, 126
Norse, Harold, 162
Notley, Alice, 201

O'Hara, Frank, 93, 156, 197, 199, 236
O'Keeffe, Georgia, 7
Olson, Charles, 179, 182
Onslow Ford, Gordon, 43–49, 51, 52, 53, 54, 64, 73, 84, 142, 203, 205, 207
Oppen, George, 158
Oyez Press, 138

Paalen, Wolfgang, 45, 64, 70, 141
Padgett, Ron, 146
Page, Jimmy, 222
Parkinson, Thomas, 155
Parra, Nicanor, 158
Pasternak, Boris, 199
Penrose, Roland, 74
Persky, Stan, 153
Peters, Nancy Joyce, 112, 115, 136, 240
Picabia, Francis, 64n

Picasso, Pablo, 64n, 66, 69, 74
Pike, Lauren, 175, 195
Poetry (Chicago), 39
Polizzotti, Mark, 93
Pollock, Jackson, 54, 69, 70, 73, 78
Porter, Bern, 102, 112, 131, 134
post-impressionism, 1–4
Pound, Ezra, 14, 37, 40, 106, 157
Pousette-Dart, Richard, 73
Priebe, Karl, 82
"primitive" art, 27–34
progress, in art, 24–26

Qin Shihuang, 10, 11
Quay Gallery, San Francisco, 173
Quinn, Freddie, 176, 178, 185
Quinn, John, 1, 4

Rahon, Alice, 81
Rattray, David, 177, 178, 179, 181–189, 191–195, 221
Ray, Man, 63n, 66, 95
Read, Herbert, 157
Redmond, Tim, 238
Reed, Christopher, 18–21, 24, 29
Rembrandt, 4
Reverdy, Pierre, 100
Rexroth, Kenneth, 106, 107, 110, 111, 114, 115, 116, 118–119, 131, 155, 156–157, 160, 178, 179, 236, 240
Richardson, Michael, 41, 104, 105
Rilke, Rainer Maria, 181
Rimbaud, Arthur, 9, 102, 103, 181
Rivers, Larry, 185
Rizzoli, A. G., 202
Rockefeller, Nelson, 56, 59, 60
Rodchenko, Alexander, 76

Rodia, Simon, 109

Roditi, Édouard, 96

Roosevelt, Franklin D., 76

Rose, Barbara, 67–68

Rosenblum, Robert, 75, 76

Rothko, Mark, 69, 73

Rousseau, Henri, 52

Roussel, Raymond, 242

Roy, Pierre, 66

Sage, Kay, 81

Saint-Pol-Roux, 242

Sakolsky, Ron, 39

San Francisco Bay Guardian, 91n, 206,
 229–233, 236–238

San Francisco Chronicle, 225

San Francisco Museum of Modern Art
 (SFMOMA), 94, 165, 168, 171, 174

San Francisco Renaissance, 155, 157, 159,
 160, 161, 194

Sargent, Tony, 191–194, 195

Saunders, Frances Stonor, 55–59, 67, 74

Saussure, Ferdinand de, xii, 16

Saussy, Haun, 13

Scheuber, Bill, 84, 86, 88, 90

Segalen, Victor, 9–15, 233

Seligmann, Kurt, 53, 64, 70

Senghor, Léopold, 108, 199

sentence-sounds, Frost's concept of,
 xv–xvi

Seurat, Georges, 65

Shakespeare, William, 15

Shapiro, David, 146–147

Shelley, P. B., 107

Sherrill, Johnny, 183, 184, 185, 186, 188,
 195

Shock-G, 210–217, 225–230, 239

Six Gallery, San Francisco, 110, 113, 117,
 119, 120, 131, 134

Small Press Distribution (SPD), 139

Smith, Dean, 166

Smith, Pamela Colman, 2, 5–8, 241

Smith Andersen Editions, 174

Snyder, Gary, 110

Solomon, Carl, 121, 129, 135n

Soviet Union, 55–56, 58, 72

Spatsa Gallery, San Francisco, 168, 173

Spicer, Jack, 151, 153–154, 158, 159, 160,
 162, 185

Spotlight Poetry Series, 142, 239

Stanley, George, 153

Stein, Gertrude, 223, 224

Stern, Gerd, 122, 129

Stieglitz, Alfred, 2, 5, 6, 7

Stiles, Knute, 126

Stockwell, Dean, 166, 170

Suiter, John, 110

surrealism: and abstract surrealism, 53–
 55, 63–67, 68, 73, 78, 233; at Beyond
 Baroque conference, 235; and Bre-
 ton's work, 40–41; and Fein's work,
 86; and Gascoyne's work, 94, 102;
 Greenberg's antipathy toward, 54,
 68–70, 73; and Guest's work, 143,
 145, 147–150; imagery in, 99–100; at
 LACMA, 73, 91, 140; and Lamantia's
 meetings with Breton, 96–102; and
 Lamantia's work, 101, 114–115, 118,
 123, 132, 159, 236, 240; at MoMA,
 59–61; and multiculturalism, 108;
 and Onslow Ford's work, 44–46, 51,
 54; and retrieval, 241–242; style tran-
 scended in, 101; and Tagett's work,
 159; and Torregian's work, 197, 198,

199; at Weinstein Gallery, 51–54, 73, 78–79; and Marie Wilson's work, 140–142

Swan, Bill, 126

symbolism, 14, 37, 158, 233, 235, 242

Synge, J. M., 98

Tagett, Richard, 141, 151–154, 158–163, 239

Tanguy, Yves, 53, 64, 94, 99

Tanning, Dorothea, 52

Tarn, Nathaniel, 10, 13

tarot cards, 2, 5–8

Taylor, Michael, 10, 13

Terry, Ellen, 6, 7, 8

Thiebaud, Wayne, 166

Toker, Bram, 6

Tongue, M. Helen, 33

Tonks, Henry, 28

Torgovnick, Marianna, 27–34, 234

Torregian, Sotère, 197–202, 239

translation, of Segalen's work, 12–14

Trouille, Clovis, 224

Tweed, Kenny, 209, 211, 214, 216, 231

2pac, 210, 212, 214, 217, 226–227, 230

Tzara, Tristan, 64n

Underground Railroad, 226–227

Vaché, Jacques, 242

Valaoritis, Nanos, 140–142

Van Buskirk, Alden, 175–195, 221, 234, 239

Van Buskirk, Robert, 195

Van Doesburg, Theo, 70

Van Gogh, Vincent, 70

Varda, Jean, 141

Varo, Remedios, 64, 82–83, 85

Velvet Underground, 222

Verlaine, Paul, 181

View (periodical), 95, 101

VVV (periodical), 95–103

Waara, Richard, 142

Waite, A. E., 5, 7

Waldman, Anne, 201

Watrous, James S., 82

Watson, Iain, 10

Watts, Alan, 192

Weinstein Gallery, San Francisco, 203, 206; Surrealism: New Worlds exhibit at, 51–54, 73, 78–79

Whalen, Philip, 110, 132

Whistler, James, 1, 30

White Rabbit Press, 139

Whitman, Walt, 134, 191

Wieners, John, 179, 182, 184, 185

Wilde, John, 82

Wilde, Oscar, 10

Williams, Jonathan, 224

Williams, William Carlos, 157

Wilson, Marie, 140–142, 239

Wittgenstein, Ludwig, xi–xviii, 34, 157

Wölfli, Adolf, 202

Woolf, Virginia, 20, 29, 234

Yardbirds, 222, 223

Yeats, W. B., 6, 8

Yukmouth, 229

Zen Buddhism, 45, 46, 51, 124, 203